# INTRODUCTION TO *Photography*

# INTRODUCTION TO
# *Photography*

## THIRD EDITION

## Robert B. Rhode
*School of Journalism, University of Colorado*

## Floyd H. McCall
*Formerly Director of Color Photography Department*
*The Denver Post*

**Macmillan Publishing Co., Inc.**
NEW YORK

**Collier Macmillan Publishers**
LONDON

Copyright © 1976, Macmillan Publishing Co., Inc.

Printed in the United States of America

Earlier editions copyright © 1965 and 1971 by Macmillan Publishing Co., Inc.

Macmillan Publishing Co., Inc.
866 Third Avenue, New York, New York 10022

Collier Macmillan Canada, Ltd.

Library of Congress Cataloging in Publication Data

Rhode, Robert Bartlett, (date)
 Introduction to photography.

 Bibliography: p.
 Includes index.
 1. Photography. I. McCall, Floyd Haley,
(date)       joint author. II. Title.
TR145.R5   1976        770        75-4958
ISBN 0-02-399621-8

Printing:  4 5 6 7 8        Year:   9 0 1 2

# Preface

"Photography," we have heard, "is a snap!" Photography does involve the snap of the shutter and it does appear to be easy, deceptively so. But photography is not something to be mastered in one, or even ten, easy lessons.

Photography, as a medium of communication or as an art, would profit if more photographers were willing to subject themselves to discipline similar to that endured by the practitioners of the traditional creative arts. It is only through such voluntary submission to discipline that artistic expression can be mastered.

This book is intended as a beginner's guide to such discipline. It is more, we think, than a handbook, a how-to-do-it manual. We hope it is also a serious but not unreasonably difficult discussion of the how and why of photography, how it works and why it works as a truly remarkable means of expression in the hands of the informed and skilled. Both knowledge, born of consciously directed study, and skill, born of disciplined practice, are essential. A photographer must know his medium thoroughly if he is to use it with maximum effectiveness.

We are indebted to many persons who, over the years, have shared experiences and ideas with us. We cannot list them all but we are grateful to them. For specific help and criticism, we are especially indebted to Glen Martin, photographer at *The Denver Post;* Professor John Mitchell, School of Journalism, Newhouse Communications Center, Syracuse University; Professor William Love, Department of Physics, University of Colorado; Professor R. Smith Schuneman, School of Journalism, University of Minnesota, and Professor Dwight R. Dixon, Department of Physics and Astronomy, Brigham Young University.

R. B. R.
F. H. McC.

# Contents

# 1

# What Is Photography?

Photography, clearly, is a process of producing images, a process that involves two basic steps:

1. The optical—catching light, controlling its intensity, and directing it.
2. The chemical—recording the image that has been optically created.

It took approximately 900 years after the discovery of the first step until the second was uncovered and the two successfully wedded to create the photographic process.

An Arab, Alhazen of Basra, observed sometime in the tenth century that light passing through a small round hole, perhaps in a tent flap or wall, would create an image of the outdoor scene on an interior wall or screen. He used this to observe eclipses of the sun. Many others, including Aristotle, had observed this optical phenomenon, which was later used in what the Italians called the *camera obscura* (literally dark room). From this we got our word camera. Inevitably experimenters learned they did not need a dark tent or room; a box would serve as well, especially when fitted with a frosted or ground glass at one end and a lens, in place of the round hole, at the other. The use of the lens probably developed from experiences with magnifying glasses, which were known at least as early as the eleventh century. By 1700 the portable *camera obscura* had become standard equipment for amateur and even many professional artists; they traced the image the lens cast on the ground glass. No one knew of any simpler method of recording the image.

# Earliest Processes

Then, in 1727, Johann Heinrich Schulze, a German university professor, revealed that he had discovered that the blackening of silver salts (such as silver iodide, silver bromide, and silver chloride), observed by others before him, was caused by light, not by heat or air. Thus the two basic steps needed for the development of photography were known: light could be used to cast an image on silver salts that would be chemically changed by the light, thereby recording the image. But a century more elapsed before anyone successfully created a permanent image with the photochemical reaction. (A photochemical reaction is one produced by light; the prefix photo means light, as in photograph, writing or drawing produced by light, and photoelectric, electricity produced by light.)

## The Daguerreotype

About 1822 a Frenchman, Joseph-Nicephore Niepce, had some degree of success in permanently fixing the image created by a camera. Louis

Jacques Mande Daguerre was one who learned of Niepce's experiments and the two eventually formed a partnership. Niepce died in 1833 but Daguerre continued the experiments and in 1839 he revealed the daguerreotype process. In brief, the daguerreotype was made by coating a copper plate with silver, which was then polished and exposed to iodine fumes. This iodized silver surface was then placed in a camera and exposed to light projected by the lens. The image on the exposed plate was developed (made visible) by placing it over a pot of heated mercury; the bright mercury adhered to parts of the plate in proportion to the amount of light exposure each part had received. The visible image thus created was fixed (made relatively permanent) in a solution of sodium thiosulphate and, finally, washed.

The daguerreotype had two major disadvantages: it was a positive, in photographic terminology of today, not a negative. (Each picture was unique; it could not be duplicated.) And exposures were long, usually many minutes. In about a year this latter disadvantage was overcome to some extent as other men developed better lenses that passed sixteen times more light than the simple lens used in Daguerre's original camera, and still others discovered the use of the accelerator, or in the daguerreotypist's terms, "quickstuff." This simply involved exposing the silvered plate to bromine fumes as well as iodine fumes. These two improvements reduced exposure times under good light conditions to less than a minute and made possible photographic portraiture, the great rage of the daguerreotype era.

## The Negative-Positive Process

While Daguerre was at work in Paris, an English scientist, William Henry Fox Talbot, was also busy. Talbot was producing pictures on paper

saturated with light-sensitive silver salts. As they came out of the camera, these were developed into reversed images, negatives, but when copied they produced positives. Thus Talbot established a concept basic in modern photographic technique: the negative-positive process.

Talbot's early pictures were faded, misty images compared with the daguerreotype, although by 1841 he had invented improvements, which he controlled stringently by patents. This restriction on the use of the process variously called calotype and talbotype kept it from equalling the tremendous popularity of the daguerreotype. But there were other reasons for the daguerreotype's supremacy. Talbot's process was slower and required longer exposure times. In addition, the fibers of the paper negative were reproduced in the print and obscured some of the image detail. An attempt to popularize Talbot's process in the United States failed, as Americans flocked to daguerreotypists for the brilliant and precisely defined portraits that photographers produced by the thousands.

But another development, based on the negative-positive method, was to make the daguerreotype almost a curiosity by about 1860. This was the wet-collodion process, or more simply the wet-plate process, discovered by Frederick Scott Archer, an English architect. To make a wet-plate negative the photographer flowed an even coating of collodion, to which an iodide and often a bromide had been added, on a glass plate. The coated plate was then soaked in a bath of silver nitrate; the silver iodide or bromide thus formed by chemical reaction made the plate light sensitive. It was put, still wet, into a light-tight holder, the holder positioned in the camera, the lens cap removed for an exposure of several seconds, the cap replaced. The plate had to be developed immediately with pyrogallic acid or ferrous sulphate and fixed.

These wet-plate negatives were frequently converted into positives by simply placing the glass against black material or painting the back of the glass black. By using thin metal plates japanned black or chocolate color, instead of glass, photographers produced tintypes.

Daguerreotypy continued to flourish despite this new competition until a third modification of the collodion process was developed. This was the *carte-de-visite* photograph, a portrait approximately the same size as a visiting card. Using multiple-lens cameras and movable plateholders, photographers took eight or a dozen poses for *carte-de visite* portraits on a single negative, which could be printed as one exposure and then the finished print cut into the separate portraits. Cheap mass-production had been achieved.

The daguerreotype was doomed. The advantages of the wet-plate negative-positive process were great. It offered an easy means of fast, cheap duplication. Unlike the easily damaged surface of the daguerreotype, the image on the finished paper print would not rub off; it did not have to be kept under glass. And this image on paper was without the metallic glare that obliterated the daguerreotype image if the angle of the light

were wrong. But above all, *carte-de-visite* photographs were cheap, a dozen such portraits costing less than one daguerreotype.

But the wet-plate process had serious disadvantages, too. It was a clumsy, messy, and exacting technique; miscarriages could and often did strike at any stage of the process. The glass had to be coated, sensitized, and developed at the time and place the photograph was taken. Under average conditions the useful life of a wet plate was approximately ten minutes; it had to be exposed and developed while still wet. A delay of only a few minutes on either side of the exposure in the camera could mean a serious, even disastrous, loss in the image quality. If the photographer took his camera into the field, his darkroom (usually a tent) went, too.

## A New Language

Photography's early history shows, for one thing, that photography is an application to human purpose of known physical phenomena. Light is reflected in varying amounts by objects around us. By controlling this reflected light and directing it onto tiny grains of silver salts, we can create a change in each grain proportionate to the amount of light energy that strikes it. Under chemical processing this change in the silver salts can be expanded until images of the real objects are formed and preserved.

Niepce, Daguerre, and Talbot produced photography from this fascinating combination of optical and chemical principles. They regarded photography as a method of copying nature, a mirror of reality. It was a thrill for them to produce an image of anything. But the feeling for reality soon got partially lost as photographers hurried into the business of producing a product for sale—portraits. These were often so stylized and cluttered with fake scenery as to seem unreal. And a few turned away from pure portraiture to imitate other forms of the painter's art, producing elaborate scenes, often allegorical, by multiple printing with five or many more wet-plate negatives.

Other photographers recognized that photography could be something more than a cheap and easy substitute for the portrait painter's brush and paint. They made photography a means of extending human understanding. Some avoided the stylized poses and elegant backgrounds to produce sensitive portraits that went beyond mere likenesses and into the realm of revelations of personality and character. One daguerreotypist photographed the moon through a telescope; others produced descriptions of the human environment in landscapes and cityscapes and reports of events, as in a daguerreotype of a burning mill at Oswego, N.Y., in 1853.

So photography was for them (and can be for us) a language, a method of expressing and communicating feeling, thought, and happenings. Like any language, photography can be affected and enriched by the user's attitude of mind and, consequently, personal style, largely indefinable but

nevertheless as real as in writing, entered early into photography. Because photography is two things:

1. *Craftsmanship*—the mastery of the peculiar photographic process of reproducing what was seen.
2. *Seeing*—the awareness of what is significant and meaningful in visual terms.

Photography as a craft is largely standardized and predictable. Photography as a way of seeing is largely personal and unpredictable. As fascinating (and essential) as the tools and techniques of the craft may be, the real excitement lies in photography as a way of seeing and communicating what one sees.

## Early Camera Reportage

An unknown daguerreotypist took a few pictures (not action scenes) of the war between Mexico and the United States (1846–1848) but they received almost no attention since there was no way to reproduce them. Perhaps the first serious war photographer was Roger Fenton, who equipped a wagon as a traveling darkroom, with chemicals and sheets of glass for making wet-collodion plates, and set out for the Crimea in 1855. He returned with more than three hundred negatives of the Crimean War's campsites and battlefields, including one showing "The Valley of the Shadow of Death" littered with cannonballs after the charge of the Light Brigade.

Fenton's achievement was overshadowed a few years later by an American photographer, Mathew B. Brady, who had started in photography as a daguerreotypist and, like most others, had switched to the wet-plate process. By 1860 he was the most fashionable American photographer, operating palatial studios in New York and Washington. But he virtually abandoned this lucrative business to cover the Civil War because "I felt I had to go." Friends predicted his war venture would bring financial ruin and their prediction proved correct. There was no extensive market for his war pictures; no way for magazines or newspapers to reproduce them except by costly engravings made by artists copying his photographs. Brady was not a press photographer, but he and a number of his assistants, notably Timothy O'Sullivan and Alexander Gardner, were camera reporters. The end of the war found Brady with 7,000 glass-plate negatives, including 30 of Abraham Lincoln made between 1860 and 1864. Many of these negatives have survived in a collection now being preserved by the Library of Congress. (See Figure 1.) The achievement of Brady and his staff of photographers is made even more remarkable by the fact that they had to work with the clumsy, frustrating wet-plate process in traveling darkrooms, called "Whatisit Wagons" by the soldiers.

Two Brady employees, Gardner and O'Sullivan, went West after the Civil War. Gardner left to do a photographic documentary of the building of the eastern division of the Union Pacific Railroad. O'Sullivan joined

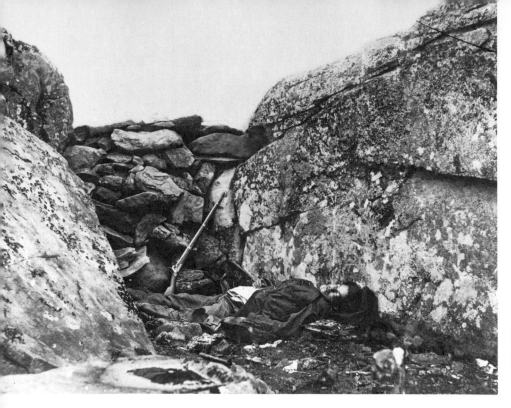

the government exploration parties to Nevada, Panama, and New Mexico. In Nevada he took pictures by magnesium flares hundreds of feet down in the Comstock Lode mines.

Camera reporters covering the advance of the frontier from the Mississippi River across the Rocky Mountains usually took several cameras and, of course, the inevitable darkroom equipment because they were still tied to the wet-plate process. They needed more than one camera, as insurance against accident, for one thing, and also so that they could shoot negatives of various sizes. Enlarging was possible but not practical and seldom used. The vast panoramas, moreover, frequently demanded large size pictures.

Probably the biggest camera taken to the West was the one that produced negatives 20 by 24 inches, owned and operated by William Henry Jackson, the most indefatigable of the frontier photographers. (See Figure 2.) Jackson needed one mule alone to carry that huge camera on a Hayden survey of 1875 to the Rocky Mountains and the Southwest. On other mules or in a wagon went other cameras, lenses, plateholders, 400 glass plates, a "darktent," chemicals, trays, and even water.

Jackson and his darktent accompanied the famous Hayden survey of 1871 that explored the region now known as Yellowstone National Park. His photographs of that area were the principal evidence used in persuading Congress to establish the nation's first national park.

Other photographers were engaged at the same time in similar activities

in the Alps of Switzerland, in Egypt and the Holy Land, in India and China, and in Australia, where one photographer, Charles Bayliss, produced what is believed to be the largest wet-plate negative ever made. The negative, a view of the Sydney harbor, measured five feet by three and one-half feet. It was exposed in a 10-foot camera with a 100-inch lens, mounted atop a 74-foot tower.

These photographers were producing documents, in the sense that their photographs provided evidence of historical events or of scenes of the physical world. Their photographs were persuasive eyewitness reportage, accepted then, and now, as truthful; the authenticity of photographs is seldom questioned, even though photographs can lie.

**Figure 2. Jackson photograph. William H. Jackson took this photograph with a large camera that used glass plates near Buena Vista, Colo.**

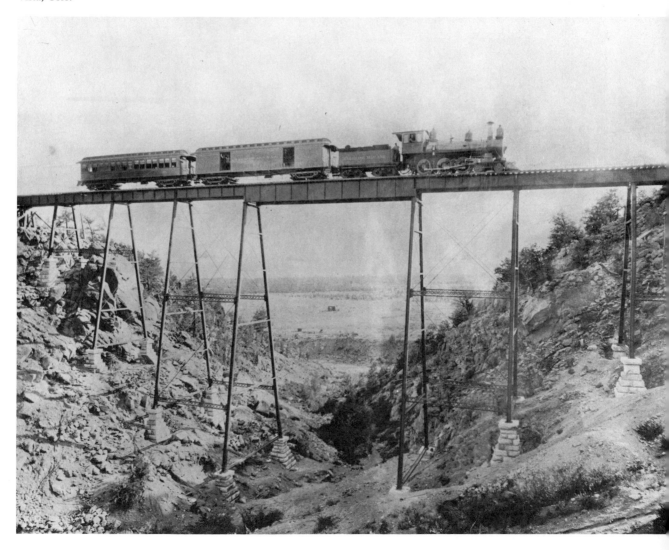

## Photography for Millions

Photography became much easier, and a popular art form, with technical improvements late in the nineteenth century. In 1871, a British physician and amateur photographer, R. L. Maddox, freed all photographers from the burden of making and processing their own wet-plates in traveling darkrooms. He did this by showing that gelatin could be substituted for collodion in preparing emulsions and, with proper preparation, the gelatin emulsion remained light sensitive even after it dried. This discovery resulted

in the development of a new industry that specialized in supplying ready-made dry plates (and, later, films) that photographers bought, exposed at leisure, and developed themselves, or, if they wished, delivered to a commercial lab for processing.

These dry gelatin emulsions were many times more sensitive to light than the old wet collodion emulsions, so exposures were soon reduced to fractions of a second. The "ripening" process made this possible: the gelatin emulsion was heated and this greatly increased its light sensitivity. The fast gelatin emulsions could also be spread on paper for making prints

(negatives were still on glass). Enlarging was thus made practical by artificial light.

In 1884 George Eastman and W. H. Walker, Americans, found a way to stick the gelatin emulsion to a roll of paper. This led to the roll film camera, the first Kodak, marketed in 1888 with the slogan "You press the button, we do the rest." The camera was supplied loaded with enough film for 100 shots. Exposed film and camera went back to the manufacturer for processing. The reloaded camera was returned to the owner with his finished prints, which were circular. By 1889 a flexible film base of celluloid replaced the paper base and the day of the amateur snapshot photographer arrived. All one needed was a Kodak or similar "hand" camera (so-called because a tripod was no longer needed on account of the shortened exposure times) and a roll of film. This brought informality and spontaneity to photographic images—unposed or candid pictures, often shot with what were called "detective" cameras because the cameras were disguised as derby hats, books, cane handles, or other things one might logically carry or wear.

How did the changes affect photography?

1.  Anyone could now take pictures.
2.  Candid (unposed) and even action shots became common.
3.  Mass production of photographic equipment became possible because the market was vast and this meant lower prices for cameras and films.
4.  Photography as a hobby became popular and has remained so ever since.

## Social Documentary

The last years of the nineteenth century and the first decades of the twentieth brought a rise of social consciousness, an increased awareness of the impact on human beings of social and economic conditions. This period saw the rise of the Populist revolt, the labor movement, the social gospel, the social worker, realism in literature, and journalistic crusading or muckraking. Some persons who were involved in this general welling up of protest and reform turned to photography as a method of documenting conditions, in the streets and slums of Paris, London, and New York, among other places.

Two of these men were Jacob A. Riis, a New York newspaper reporter who took up photography to help him tell the story of "how the other half lived," and Lewis W. Hine, a sociologist who used a camera to document his research. Riis's work as reporter with pencil and camera brought about housing reforms and an improved lot for the denizens of New York slums. He said he used the camera to show "as no mere description could, the misery and vice" that other New Yorkers were unaware of or found it convenient to ignore. Hine's photographs exposed the exploitation of child labor in American factories and were instrumental in the crusade that

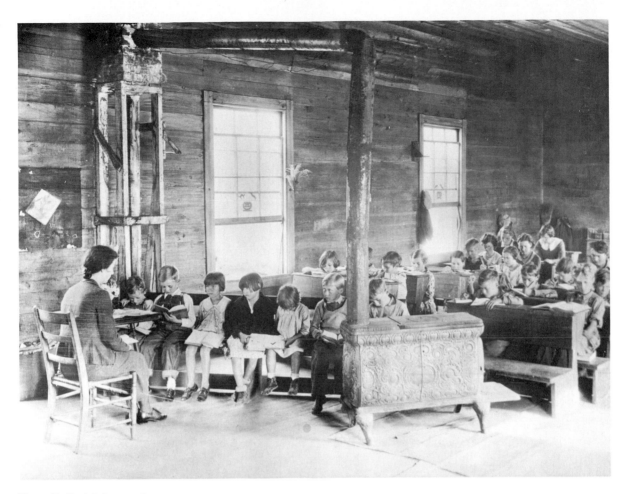

Figure 3. Social documentary. This interior view of a schoolhouse at Crossville, Tenn., was taken about 1935 and is from the Farm Security Administration collection in the Library of Congress. The photographer is not known.

culminated in child labor laws. He also turned his lens on the thousands of immigrants and their problems and on the working man and his work. He wanted, he said, to show "the things that had to be corrected and the things that had to be appreciated."

The depression years of the 1930s brought renewed need to describe and interpret social problems. Roy E. Stryker of the U.S. government's Rural Resettlement Administration (later called the Farm Security Administration) hired photographers to report depression conditions. (See Figure 3.) Among the first hired were: Walker Evans, whose photographs of the South's land, homes, and sharecroppers show remarkable dignity in the midst of squalid poverty; Dorothea Lange, who specialized in the problems of the migratory worker; and Arthur Rothstein, who documented conditions in the drought-produced dust bowl of the Midwest.

Social documentary is not always concerned with conditions the photog-

rapher thinks should be corrected, but, as Dr. Hine noted, often with things that should be more widely appreciated.

## Photojournalism

Photojournalism had been nourished by early news illustrations with woodcuts and hand-drawn engravings, by the early camera reportage of the nineteenth century war and frontier photographers, and by the social documentary at the beginning of the twentieth century, a particularly fertile time for change. Changes in photography stemmed largely from technical developments and their application to purpose. Two developments that radically affected photography were the photoengraving process and the miniature camera. As a result of these inventions, journalistic photography became one of the most vital and influential aspects of photography.

The photoengraving process, perfected shortly before 1900, produces halftones from which photographs can be printed in newspapers and magazines. Halftone engravings only gradually replaced hand-drawn art, primarily to illustrate word stories, until periodicals began to use true photojournalism, which is photographs and words used as approximately equal partners in reportage.

The addition of the small camera with wide-aperture lens to the tools of photography spurred the development of photojournalism, because this camera made it much easier for the photographer to record events as they happened without rearranging either subjects or lighting. An early example of the partnership between journalist and small camera was that of Erich Salomon and the Ermanox camera. Salomon roamed much of Europe recording conferences of prominent statesmen. The Ermanox used small (4.5 by 6 centimeters) glass plates or sheet film. It was soon replaced by cameras that used roll film, 35 millimeters wide, the same width as movie film. These were the Leicas and other 35-mm cameras, destined to be the most popular of all cameras.

By 1927 German magazines were publishing the reportage of photographers such as Salomon, Martin Munkacsi, Andre Kertesz, and others under the guidance and encouragement of editors such as Stefan Lorant. This new photojournalism declined in Germany after 1933, with the rise of Naziism, but found a new home in magazines in other countries (such as *Vu* in France, *Picture Post* in England, and *Life* and *Look* in the United States) to which many of the Hungarian and German photojournalists migrated.

The photoessay or photo story bloomed in these magazines until the publications lost advertising support as audiences turned to the film reportage on the television screen. But still photography continued to play a vital role in newspapers of general circulation and magazines designed for specialized audiences, stimulated by the dramatic photoreportage of modern warfare and of the upheavals in human society created by social change.

## Art Photography

Other photographers in the twentieth century turned to photography as an art form, an interest also displayed by photographers of the nineteenth century. But the earlier photographers were often searching for fanciful and allegorical compositions or for techniques that could simulate the effects of painting. In the twentieth century attention turned to naturally aesthetic subjects and images produced by straight photographic techniques. Alfred Stieglitz formed a rallying point in the United States for those who sought recognition for photography as art. He found effective compositions in everyday scenes and exhibited his photographs at the Photo-Secession gallery at 291 Fifth Avenue, New York, along with similar photos by others and with drawings and paintings. This Photo-Secession movement, coupled with the objective images being produced by documentary and journalistic photography, led to what has been called the "New Objectivity" movement of the 1920s. The images of this movement could be almost brutal in their uncompromising directness, as in the photos of Paul Strand, who said: "Objectivity is of the very essence of photography, its contribution and at the same time its limitation . . . accomplished without tricks of processes or manipulation, through the use of straight photographic methods."

Others sought expression via darkroom manipulations. The artists Man Ray, American, and Laszlo Moholoy-Nagy, Hungarian, made "photograms" by placing objects on light-sensitive paper before exposing it to light. Others made prints that looked like negatives or pure black-and-white images, eliminating all or most of the grays, or images that suggested the bas-relief of sculpture. Other manipulations included cracking the emulsion (reticulation) by rapid changes in temperature to produce fragmented images, similar to mosaics, and prints in which the image tones have been partially reversed (solarization), a sort of hybrid positive-negative. (See Chapter 13 for details on these techniques.)

## Summary and Review

What is photography? It is all of these things:

Technique, in application of tools and processes to produce images.

Translation, of an individual's way of seeing.

Documentation, of environment, way of life, social relationships, and social problems.

Reportage, of the human condition.

Persuasion, in presentation of a point of view.

Art, the aesthetic image, either for itself alone or as part of an image with another central purpose.

Photography is a welding of craftsmanship—the mastery of the controls that manipulate the characteristics of photography—with mastery of seeing.

The result can be a sharing of experience, because photography is, above all, communication. And the history of photography seems to show that the successful photographers have been those who, first of all, mastered the craft, secondly, developed great visual acuteness, and, thirdly, concentrated upon some aspect of photography that especially interested them.

# 2

# The Camera

The simplest camera is the pinhole camera: a box that is light-tight except for a pinhole at one end, a recreation of the *camera obscura* of 300 years ago. (See Figure 4.) The film is placed at the end opposite the pinhole. Some sort of flap over the hole is added to time the exposure manually.

All other cameras are merely refinements of this basic design. Two important refinements are the lens and the shutter. The lens makes it possible to use many more rays of light than can get through a pinhole, thus reducing the exposure time needed, and it focuses all the rays from a single subject point on a single image point, thus giving a much sharper image than a pinhole. The shutter automatically controls the amount of time the light is allowed to act on the film.

Figure 4. The pinhole camera. A few rays of light reflected from each point on the subject get through the pinhole to create a more or less diffused (unsharp) image, depending on the size of the pinhole. The diffusion results because the rays from a common subject point diverge as they travel and thus do not strike the film at precisely the same point. Since the rays travel in a straight line, those from different subject points cross at the pinhole and the image is inverted and transposed (left to right).

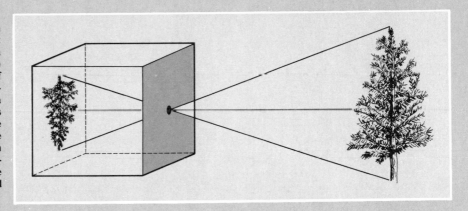

# The Lens

Often the most costly single part of any camera is the lens. The simplest and cheapest lens may be made of only one or perhaps two pieces of glass, but a fine quality lens for the sharpest images may contain six or eight pieces of glass carefully assembled in a single mounting.

Sophistication of the camera (and expense) roughly increases with increased flexibility in the way the lens is mounted on the camera:

*Fixed Focus.*   On the least expensive cameras the lens is permanently mounted on the camera and focused at a fixed distance for average snapshooting. Images of subjects six feet or more from the lens will be in relatively sharp focus.

*Zone Focus.* A few camera lenses can be focused at two or three "zones," such as five to seven feet, ten to fifteen feet, and infinity.

*Full Focus.* Most camera lenses are mounted so that they can be focused at any distance from perhaps five feet or less to infinity, by a footage scale, by a rangefinder built into the camera, or by focusing the image projected by the lens on a ground glass in the camera.

*Interchangeable Lenses.* On a good many cameras, generally the fairly expensive ones, the lens can be removed from the camera and any one of a number of other lenses substituted for it.

# The Shutter

Shutters range from the very simple spring-actuated flap to bafflingly complex types. Complexity (and price) increase in proportion to the number of timings the shutter will provide. An intricate gear train placed under spring tension by cocking the shutter can provide automatic timings ranging from one full second down to 1/500 or even 1/2,000 of a second. In some recent model cameras, the shutter is controlled by electrical current from a small battery in the camera; these are sometimes called electronic shutters. The time the shutter stays open depends on how long it takes the current from the battery to fill an electrical storage unit—a capacitor. Changing the shutter setting changes the resistance in the circuit, thus changing the time needed to fill the capacitor.

Leaf-type shutters (Figure 5) are usually mounted between the lens elements, often right next to the diaphragm. This kind of shutter is constructed of thin metal blades pivoted so they overlap and block all light when the shutter is closed but snap open to let light pass during exposure. Another shutter is the focal-plane type (Figure 6), located in the back of the camera just in front of the film, thus very close to the plane at which the image is focused. Focal-plane shutters are slotted curtains of cloth or metal that move across in front of the film. The focal-plane shutters fitted in small cameras, such as the 35-mm single-lens reflex type, are formed of two separate curtains, actually, and they give a range of high speeds and a range of low speeds. When the shutter is fired at high speed, the first curtain starts to rush across the film gate. A short interval later the second curtain follows so that an open slit between the two crosses the film. At slow shutter speeds, however (1/60 of a second or slower), the first curtain flips across the film gate to uncover the entire negative area before the second curtain even starts. After a time interval established by the shutter setting, the second curtain makes its trip to close the opening and end the exposure of the film. These shutters are of the self-capping type; that is, they automatically cap or close the slit after an exposure and the curtains keep the slit closed when the shutter is recocked, which involves pulling the two curtains back across the film.

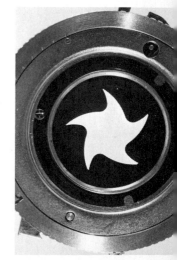

**Figure 5. Leaf-type shutter. The five blades of the shutter are shown part way open.**

Figure 6. Focal-plane shutter. The shutter is shown from the back of the camera. At top, the opening between the two parts of the curtain is moving from left to right for an exposure of 1/125 of a second. At bottom, the shutter is shown as it would be for slower shutter speeds when the entire frame is cleared by the curtain.

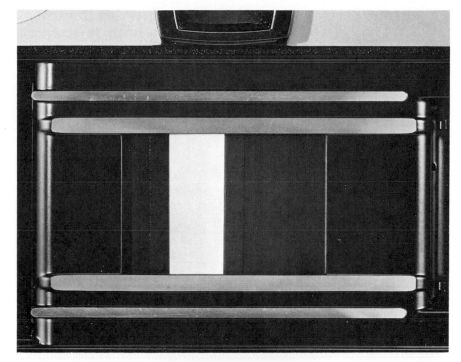

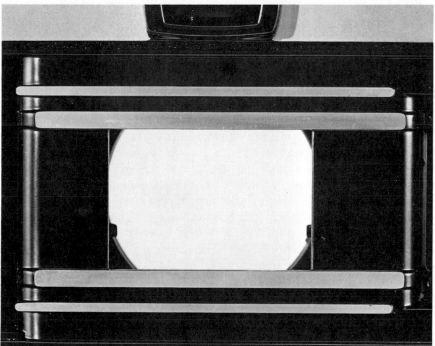

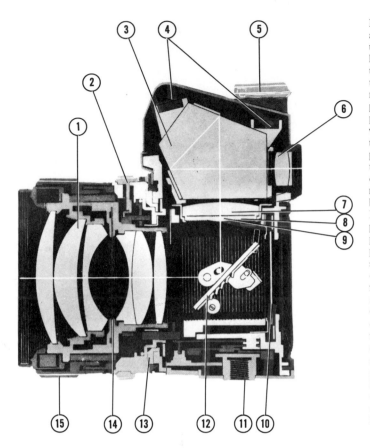

Figure 7. This cutaway view of a single-lens reflex camera shows the path of the light through the lens (1) to a mirror (12), th ... to a focusing screen formed by the condenser lens (7), the fresnel lens (8), and the fine microprism (9). Here the image appears and the photographer views and focuses this image through the prism (3), which presents a right-side-up image to the finder eyepiece (6). He focuses by turning the focusing ring (15) that moves the lens back and forth in its mount (13). He sets the aperture of the diaphragm (14) by turning the diaphragm ring (2). When he presses the shutter release (not shown), the mirror flips up out of the path of the light, the focal-plane shutter (10) opens and the film behind it is exposed. Other parts shown include two cadmium-sulfide battery cells (4) for exposure readings, the accessory shoe (5), and the tripod socket (11). Most 35-mm, single-lens reflex cameras are similar in general construction but details will vary. (Adapted from a Minolta Camera Corporation illustration.)

## Other Refinements

Other refinements of the basic box with a pinhole can include a viewfinder and an exposure meter. Viewfinders tell you what part of the scene in front of you and your camera will be in the picture. These may be simple framing devices built on top, on one side, or in the body of the camera. An optical finder (a sort of inverted telescope) contains two lenses to present a reduced image to the eye approximating what the picture will be. With other cameras the photographer views the scene on a ground glass as it is projected there by the camera lens. Typical of these are the single-lens reflex cameras (SLRs). (See Figure 7.) Light meters are also commonly built into modern cameras, at least the smaller ones, to help photographers establish correct exposures.

Cameras also vary in the size (format) of the negative images they produce. To provide a summary we have divided cameras into three general categories based on format: small, medium, and large. Approximate or average statistics and descriptions have been used.

# Small Format Cameras

## Miniature and Subminiature Cameras

Negative sizes:     8 by 11 millimeters (Minox film cartridges); 13 by 17 milli-
meters (Pocket Instamatics, 110 film cartridges);
28 by 28 millimeters (Instamatic type 126 cartridges);
28 by 40 millimeters (828 roll film); and
40 by 40 millimeters (127 roll film).

Lenses:     Fixed (not interchangeable).

Focusing:     Most are fixed focus; a few have zone focusing; still fewer
have full focusing range from minimum of 2 feet to
infinity.

Shutters:     Least expensive cameras have one fixed shutter speed,
usually around 1/70 to 1/100 of a second; more expensive
ones give shutter speeds that can range from 10 seconds
to 1/1000 of a second.

Viewfinders:     Optical mostly; usually eye-level finder built into camera
body, often with a bright-line frame outlining picture
area.

Exposure meters:     Most are equipped with built-in meters and a number offer
automatic exposure. The meter selects proper exposure
for the lighting conditions.

Examples:     Minox, Kodak Pocket Instamatics, GAF and Minolta
Pockets.

**Figure 8. Instamatic camera.**

## 35-mm Single-Lens Reflex Cameras

Negative size:     25 by 35 millimeters (about 1 by 1½ inches); film in cassettes
or magazines (20 to 36 exposures).

Figure 9. 35-mm, single-lens
reflex camera.

Figure 10. 35-mm nonreflex
camera.

| | |
|---|---|
| Lenses: | Interchangeable. |
| Focusing: | Through the lens on ground glass of pentaprism from 1½ feet to infinity with normal lens. |
| Shutters: | Focal plane; some travel vertically, most horizontally when camera held in normal position; speeds from B (bulb) to 1/500 of a second, many to 1/1000 and a few to 1/2000. |
| Viewfinders: | Eye-level pentaprism; focusing and viewfinding done through same eyepiece. |
| Exposure meters: | Behind the lens meter most common, operating off battery. |
| Examples: | Canon, Pentax, Konica, Minolta, Nikon, Nikkormat. More different models in this classification than in any other. |

## 35-mm Nonreflex Cameras

| | |
|---|---|
| Negative size: | 25 by 35 millimeters; film in cassettes or magazines (20 to 36 exposures). |
| Lenses: | Most have fixed lenses; a few (Leica is notable example) have interchangeable lenses. |
| Focusing: | With rangefinder; some have fixed focus or zone focus. |
| Shutters: | Most have leaf-type, between-the-lens shutter; many have automatic (electronic) shutters; speeds from 4 seconds to 1/800 of a second. (Leica has focal-plane shutter.) |
| Viewfinders: | Optical; may or may not be combined with rangefinder. |
| Exposure meters: | Common; meters sometimes operate the automatic shutter or the automatic diaphragm, or both. |
| Examples: | Konica, Leica, Olympus, Rollei 35. |

# Medium Format Cameras

## Twin-Lens Reflex Cameras

| | |
|---|---|
| Negative size: | 6 by 6 centimeters (2¼ by 2¼ inches), most common; 120 or 220 roll film (12 or 24 exposures). |
| Lenses: | Two lenses: top lens for focusing and viewfinding, bottom lens for projecting image on film; usually fixed but some cameras take accessory lenses. |
| Focusing: | On ground glass screen in top of camera; image projected by the top lens. |

| Shutters: | Leaf type between elements of bottom lens with speeds of B and 1 to 1/500 of a second. |
| Viewfinders: | Combined with focusing through top lens; usually used with camera at waist level. |
| Exposure meters: | With a few but not most. |
| Examples: | Mamiya (interchangeable lenses), Rolleiflex. |

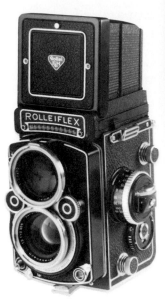

## Single-Lens Reflex Cameras

| Negative size: | 6 by 6 or 6 by 7 centimeters; 120 or 220 film. |
| Lenses: | Interchangeable. |
| Focusing: | Through picture-taking lens on ground glass. |
| Shutters: | Leaf type between the lenses or horizontal focal plane; T or B and automatic settings from 1 second to 1/1000. |
| Viewfinders: | Combined with focusing through taking lens. |
| Exposure meters: | Most do not have meters. |
| Examples: | Bronica, Hasselblad, Pentax 6 by 7, Rolleiflex SL 66. |

**Figure 11. Twin-lens reflex camera.**

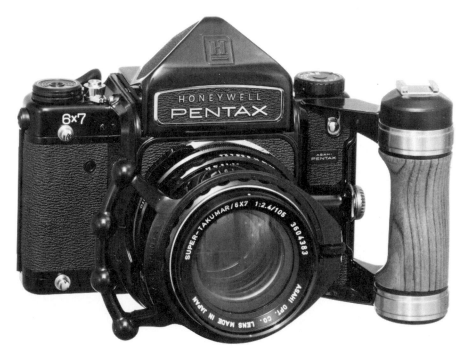

**Figure 12. Medium-format, single-lens reflex camera.**

# Large Format Cameras

## Press-type Cameras

| | |
|---|---|
| Negative size: | From 6 by 7 to 12.7 by 17.8 centimeters (2¼ by 2¾ to 5 by 7 inches) on roll film, sheet film or glass plates. |
| Lenses: | Interchangeable. |
| Focusing: | Rangefinder coupled to movement of lens. |
| Shutters: | May have between-the-lens leaf shutter or focal-plane shutter with speeds of T and 1 to 1/2000. |
| Viewfinders: | Optical with parallax correction or wire frame finder. |
| Exposure meters: | Usually no exposure meter is built into the camera. |
| Examples: | Calumet Horseman, Linhof, Rapid Omega. |

Notes: Many of these cameras also offer bellows extension for closeup work and copying, and lens board shifts and tilts for perspective and depth of field control for architectural and table-top photography.

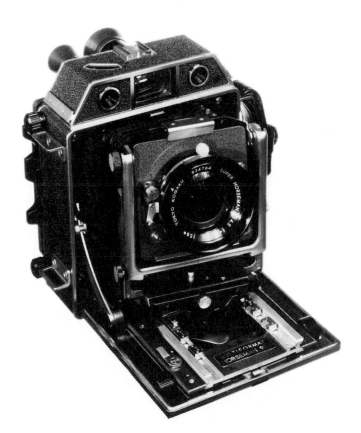

**Figure 13.  Press-type camera.**

## View Cameras

Negative size:        6 by 7.5 to 28 by 35 centimeters (2¼ by 3¼ to 11 by 14 inches) on sheet film or glass plates.

Lenses:        Interchangeable.

Focusing:        Bellows between lens and film with image projected by taking lens focused on ground glass at rear of camera; can focus down as close as 3 inches (about 75 millimeters).

Shutters:        Between-the-lens leaf shutters with T, B, and 1 to 1/400 of a second.

Viewfinders:        Combined with focusing on ground glass through the lens.

Exposure meters:        Not built into these cameras.

Examples:        Calumet, Deardorff, Linhof, Sinar.

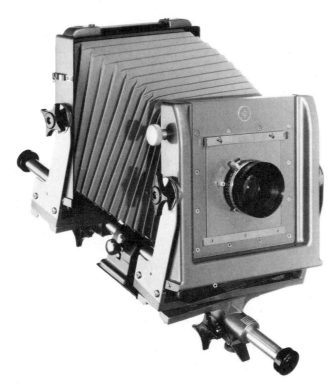

**Figure 14. View camera.**

Notes: Maximum shifts and tilts at both the lens and the film positions for scenics, architecture, studio work, tabletops, copying. These cameras are almost invariably used with a tripod.

## Special Cameras

Extremely popular in recent years have been the self-processing cameras, particularly those produced by Polaroid Land, the major pioneer in this field. These cameras with their special films produce finished black-and-white or color prints in seconds or minutes without a darkroom.

Other special types are aerial cameras, sequence cameras, panoramic cameras or cameras with special lenses that give exceptionally wide angles of view, underwater cameras, and stereo cameras that, with two lenses, produce two views of each picture to provide a three-dimensional effect when the two pictures are viewed simultaneously.

## Cameras Compared

The miniature cameras are mostly intended for the casual snapshooter, since they are designed to make picture taking easy and, as nearly as possible, error-proof, for vacation trips and memorable family affairs. (The small 110 negative format in the Pocket Instamatic cameras was made possible by improvements in the grain size of Kodacolor-X color negative film. Pocket sized negatives make good quality 3 by 5 color prints and Kodak will enlarge them up to 5 by 7 on request. Color transparency slides are also made with the 110 pocket size cameras, and there is a special 110 size slide projector.)

Similar in size to the larger instamatics are the nonreflex types of 35-mm cameras. These also feature some of the same sorts of automatic features that one finds on the instamatics, simplifying the problems in picture taking since the camera often performs the task of figuring out the correct exposure.

The 35-mm single-lens reflex camera comes in the widest variety of models and prices. The cameras in the medium and high price ranges offer many accessories (such as a variety of interchangeable lenses) and attachments (such as extension bellows) that make them extremely flexible tools. Many exposures can be taken, and rapidly if necessary, on a single film loading. A number of them are built with motor drives or have a motor drive accessory capable of shooting up to three frames per second for sequence action photos or to provide a greater selection of individual frames. Because of the lenses available with these cameras they can capture images in normal indoor lighting and in other relatively low-light-level situations.

With the medium format camera, some of them only a little larger and heavier than the bulkiest of the 35-mm type, the photographer gets a negative that is more than three times larger. (In general, the larger the negative the easier it is to get sharp, detailed images in the final print.) However, the square negative that measures 2¼ inches on each side does not match the rectangular space of standard-size printing paper, so very often part of the negative image is not used in making the positive print image. A few medium format cameras produce negatives that measure

2¼ by 2¾ inches or 2¼ by 3¼ inches on 120 or 220 film, exactly or very nearly matching the proportions of standard paper sizes.

The medium format cameras of the single-lens reflex design offer virtually the same flexibility (in extra lenses and other attachments) as the 35-mm SLRs, but at higher cost usually. The twin-lens reflex types are much less flexible, but are also often much less expensive.

Still larger cameras have two principal advantages: the large negative can provide color transparencies and enlarged (or contact) prints in both color and black and white that are dramatically sharp and detailed. Adjustments at the lens and film planes make it possible to control composition and focusing to a much greater extent with these cameras than with the smaller ones. The view camera, particularly, is a basic tool of many commercial (advertising) photographers, but they are bulky, require a tripod, and cannot match the 35-mm camera in capturing images in candid or low-light-level situations.

# 3

# Exposure

Image-making with photography always involves light. The process begins when minute particles of a light-sensitive chemical compound are exposed to light. The light causes a very subtle change in these particles, a change so subtle as to be invisible. We call this invisible image a *latent image*. The development process, which follows exposure, produces the visible image. Control of the image must, then, involve control of the light and control of the development. We will consider light control in this chapter and development in Chapter 4.

## The Reciprocity Law

The first step in light control is determining proper exposure—the right amount of light to produce the image we want. The amount of light will be determined by its intensity (or brightness) and the total amount of time it is allowed to strike the light-sensitive particles. Stated as a formula or "law" it amounts to this:

Exposure (E)
is the product of ($=$)
Intensity (I)
multiplied by ($\times$)
Time (T).

This is the reciprocity law of photochemistry:

$$E = I \times T.$$

In this law I and T are reciprocals because they are inversely related; if you increase one and decrease the other to the same degree the result (E) is unchanged. If intensity is 2 and time 4, the product is 8; if intensity is doubled and time halved, the product is still 8. For the vast majority of the photographs taken the reciprocity law holds.

### The Shutter

We can control time with camera shutters. A typical shutter may offer a series of automatically timed exposures ranging from a maximum time of 1 second down to 1/500 (or 1/1000) of a second, proceeding from one to the other in equal steps; each step reduces the time by one-half. The shutter-scale markings, for example, may be 1, 2, 4, 8, 15, 30, 60, 125, 250, 500. The first number in this series stands for 1 full second, but all others are fractions of a second; 2 is ½ and 4 is ¼, and so forth. The numbers may vary from this example, but each shutter setting gives one-half

the time of the preceding number and twice the time of the following one.

The shutter may also have a T or a B setting, or both. The T stands for time exposure, and when the shutter is set at this point it will stay open until the operator trips it a second time. The shutter is also set at B for exposures longer than one second, but this setting is customarily employed only with a flexible cable shutter release. By depressing a plunger at one end of the cable, which has been attached at the other end to the shutter release button, the photographer holds the shutter open as long as he wants. The shutter closes when he releases the plunger. The flexible cable is necessary to avoid moving the camera while the shutter is open. (This setting is labeled B for "bulb" because shutters were once commonly tripped by air pressure applied by squeezing a bulb at the end of a hose leading to the shutter.)

## The Aperture

We can control intensity by varying the size of the aperture (hole) the light goes through; a small aperture lets through less light than a large one. A range of aperture sizes can be provided by a diaphragm formed of thin metal blades, mounted usually between the glass elements of the lens. These blades overlap to form a nearly circular opening. Turning a ring or lever on the outside of the lens swings all the blades simultaneously outward or inward, thus expanding or contracting the size of the aperture. (See Figure 15.)

But the same amount of light can be spread over a small area, thus creating a bright image, or it can be spread over a large area, creating a relatively dim image. The distance the light travels from aperture to film determines how much the light spreads out and, thus, if the aperture is constant, distance from aperture to film determines if the image will be bright (high in intensity) or dim (low in intensity). In fact, the intensity

Figure 15. The aperture is formed by a diaphragm of rotating metal leaves that give a continuously variable opening for light to pass through to the film. At left the diaphragm is at its widest aperture, in center it is at midpoint, and at right it is stopped down to its smallest aperture. The diameter of this opening divided into the focal length of the lens gives the $f/$ number.

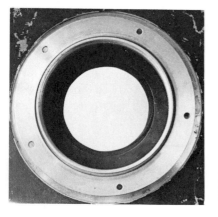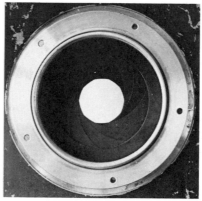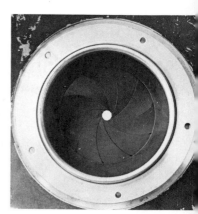

of the light decreases at twice the rate of the increase in distance. (This is known as the inverse square law, illustrated in Figure 92.)

So the intensity of the light hitting the film inside the camera is established by two factors:

1. By the diameter of the light beam allowed through the lens by the aperture.
2. By the distance the light travels from aperture to film.

A small aperture and a short distance can give the same light intensity as a large aperture and a relatively long distance.

### Aperture Numbers and Lens Speed

We are now ready to consider a bit of photographic jargon: the *f/* number. But to understand *f/*number we must first have at least a nodding acquaintance with *focal length.* The focal length of a lens is established on the basis of light rays that enter the lens on parallel paths. The lens bends (focuses) these rays to a point, thus creating a sharp image. The distance from the lens to this focal point is the lens focal length. But we must remember this applies only when the entering light rays are parallel. Rays from a subject at infinity would be traveling parallel to each other. Therefore we can give this definition:

*Focal length is that distance from the lens to the image (or film) plane when the lens is focused at infinity.* (See Figure 16.)

Figure 16. Focal length. The distance from the lens to the image (or film) plane when the lens is focused at infinity is the lens focal length.

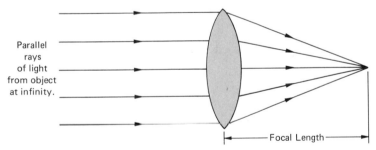

Parallel rays of light from object at infinity.

Focal Length

We can then express the intensity factor in exposure, which is the relationship or ratio between aperture size and distance the light travels from aperture to film, as a ratio between aperture size and focal length. Of course, for many pictures the lens is focused at distances less than infinity. If we focus a lens at 10 feet the distance between the lens and the image (film) plane is actually greater than the focal length, but the difference is not enough to affect exposure calculations significantly. It only becomes significant when a lens is focused for extreme closeups.

So it is the diameter of the aperture compared to the focal length that matters. We can compare the two by means of a fraction: the diameter

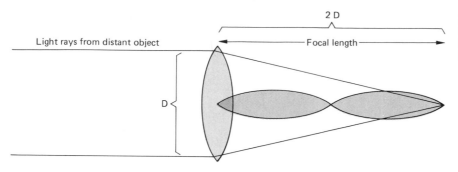

of the aperture is what fraction of the focal length? The answer to that question gives us what we call the *f*/number:

$$f/\text{number} = \frac{\text{focal length}}{\text{aperture diameter}}$$

An example: if the focal length of the lens is 50 millimeters (2 inches) and the effective aperture diameter is 25 millimeters (1 inch), then the *f*/number is 2, often expressed as *f*/2. (See Figure 17.) The *f* denotes that it is a measurement of the aperture in terms of or as a fraction of the focal length. This permits us to make direct comparisons between apertures irrespective of the actual sizes and focal lengths of different lenses. All lenses set at the same relative aperture (for example at *f*/8 or at ⅛ of the focal length in each case) will give the same intensities of light on the film.

We should also note that the smaller the number following *f*/ the larger the aperture. This is true because the *f*/numbers represent fractions of the focal length of the lens, and ½ is greater than ¼, ¼ is greater than ⅛, and so on.

Similar to the shutter speeds, the apertures will be marked on the lens in what appears to be a simple series of numbers, and each step on the *f*/number scale gives one half the exposure of the preceding number and twice the exposure of the succeeding one. The aperture is a round, or nearly round, hole, and the amount of light it admits is related to its total area. Since the area of a circle is proportional to the square of the diameter, if we double the diameter we quadruple the area; to get only double the area, and thus double the intensity of the light, we need only multiply the diameter by the square root of two (1.4). An examination of the *f*/number series shows that this is exactly what has been done.

The normal sequence of these *f*/numbers (sometimes called *stops*) is:

1, 1.4, 2, 2.8, 4, 5.6, 8, 11, 16, 22, 32, and so on.

Only a portion of this series of numbers will appear on any given lens; aperture diaphragms rarely open up all the way to 1 (which is an aperture

diameter exactly equal to the focal length) nor do they always "stop down" all the way to $f/32$. However, the diaphragms of some lenses can be stopped down to apertures even smaller than $f/32$.

A lens for a 35-mm camera may be designed with a 50-mm focal length and diaphragm settings ranging from $f/2$ (the widest aperture) to $f/16$ (the smallest aperture). But each photographic lens is described only by its widest aperture and by its focal length, so this would be a 50-mm, $f/2$ lens, or $f/2$, 50-mm. If the lens was made in Japan or Germany the markings on the front of the lens might be: "50-mm 1:2." This is the same information in somewhat different form, because the widest aperture is given not as an $f$/number but as 1:2; interpret that as ½ or one-half the focal length.

Another lens may have a larger aperture, as for example, an $f/1.8$ lens. Others may open no further than $f/3.5$ or $f/4.7$. A maximum aperture is controlled by the design of the lens, and in many cases the maximum falls at some point between the numbers in the normal $f$/number series. That would be the case with $f/1.8$, $f/3.5$, and $f/4.7$ lenses.

This maximum aperture, the largest opening of the diaphragm, is also known as the *speed of the lens.* The closer the widest aperture comes to 1, or to being equal in diameter to the focal length of the lens, the faster the lens. A high-speed lens by today's standards is one that has a maximum aperture of at least $f/2$, and such a lens makes it possible to take pictures indoors in relatively dim light without using shutter speeds of large fractions of a second, or even of several seconds, and without adding flash or flood lights to the existing light.

*Special note:* Lens speed and shutter speed are quite different things: the speed of a lens refers only to its largest aperture and not to any shutter speed.

## Solving the Exposure Problem

Because exposure doubles (or halves) with each step on either aperture or shutter scale, changing the shutter speed in one direction and changing aperture in the opposite direction will mean no change in exposure if an equal number of steps are taken on each scale. Remember: $E = I \times T$ and if we double I but halve T the product (E) must remain unchanged. Note that all the aperture-shutter speed pairings in the following list will give the same exposure:

| | |
|---|---|
| $f/32$ | 1/30 |
| $f/22$ | 1/60 |
| $f/16$ | 1/125 |
| $f/11$ | 1/250 |
| $f/8$ | 1/500 |

These settings would all give the same exposure in a series of pictures taken of the same subject with one kind of film under unaltered lighting.

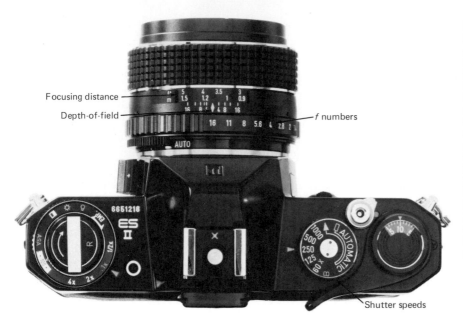

Focusing distance

Depth-of-field

f numbers

AUTO

6651216

ES II

Shutter speeds

Figure 18. Exposure controls on the camera. This camera's shutter can be operated in the automatic mode (in which case it computes a shutter speed for the light coming through the lens at a given aperture) or by manually selecting a shutter speed ranging from 1/1000 of a second down to 1/60 of a second, plus bulb (B). The aperture is shown set at f/16 and the lens is focused at a little more than 3½ feet. Depth of field will range from the 16 on the right side of the depth of field scale to the 16 on the left side of the same scale. Thus, depth of field will be from approximately 3 feet to nearly 5 feet.

But the images would not be the same. We will discover how and why in the next section.

## Which Settings to Use?

A good photograph does not depend solely upon proper exposure; there are other factors involved. Few pictures, however, will achieve distinction if the film exposure is incorrect. Proper exposure is essential if the picture is to have fine detail in important highlight and shadow areas. Any exposure that comes close to this objective will give printable middle tones in the negative, but only accurate exposure of the film (and correct development) will produce the delicate tone separations in highlights and shadows that are the mark of most fine photographic prints.

Exposure of the film in the camera really poses two problems, not just one. The first of these we are already familiar with: What combination of shutter setting and aperture setting will give a negative from which the best print shows detail in both important highlights and important shadows as well as in the middle tones between highlights and shadows? But we have already discovered that there is not just one combination of shutter and aperture that will give the proper answer; any one of half a dozen or more combinations will be correct. And this poses the second problem.

Should we use f/32 at 1/30 or f/8 at 1/500? We must decide this question on the basis of what sort of image we want in the final picture. An aperture of f/32 will give relatively great depth of field; that is, all

objects from the near foreground to the far background may appear to be in sharp focus in the final print. An aperture of $f/8$ will give a relatively shallow depth of field. (Depth of field will be discussed more fully in Chapter 8.) On the other hand, a shutter set at 1/30 is very likely to give a blurred image of a moving subject and even a blurred image of stationary objects if the camera is not held steady. A shutter set at 1/500 will give a sharp image of many moving subjects.

The choice is yours. The photographer must decide which of the combinations of aperture and shutter speed will give the proper exposure and at the same time give the kind of image he wants.

*Special note:* It is generally best to avoid, if possible, changing the shutter speed between the time the shutter is cocked and the time it is released. Changing speeds while the shutter is cocked can cause damage to the delicate mechanism that holds the shutter on the proper tension for precise timing. Since shutters vary this may not be true for your camera. Check the instruction book. Usually it is possible to wait to cock the shutter until you are ready to snap the picture; by that time you should have established the shutter setting.

## Film Speed

The word speed is used for a number of concepts in photography, like shutter speeds and lens speed. Also, there is film speed, meaning the light sensitivity of the film. For a given subject under particular lighting conditions, film A may need an exposure of $f/16$ at 1/125, but film B may need only $f/16$ at 1/500. Film B is "faster" than film A, four times as fast.

In the United States each film is rated for speed according to standards approved by the American National Standards Institute (formerly known as the American Standards Association), so each film has what is called an ASA speed. Any film that is rated at ASA 400 or higher is generally regarded as a "fast" film, one rated at ASA 125 is considered "medium," and ASA 25 is "slow."

The film manufacturer supplies information on film speed. Once the film speed is known, exposure can be determined most accurately with an exposure meter. There are, however, more than a few times when an exposure meter is not available or cannot be used under the circumstances. Photographers should be prepared to make reasonably accurate exposure calculations without the aid of a meter.

This can be done by this three-step method:

1. Whatever the speed rating (ASA number) of the film, use that number (or one as close to it as possible) as your shutter speed. If the film is ASA 125 set 1/125 of a second as the shutter speed; if the film is ASA 400, set 1/400 or 1/500. (Do not set the shutter between two numbers; electronic shutters can provide intermediate settings, automatically, but mechanical shutters cannot.) This is done because the film with the highest

ASA number needs the least exposure and a doubling of the ASA number means the exposure required is cut in half, and, conveniently, each step up to a higher shutter speed cuts exposure by one-half.

2. Find the lighting condition in the table below and read the recommended *f*/number

3. Change to another shutter speed-*f*/number combination to meet demands of movement or depth of field.

DAYLIGHT EXPOSURE TABLE (For average subjects, using a shutter speed equal to the ASA speed of the film.)

| | *f*/number |
|---|---|
| Bright or hazy sun on light sand or snow | 22 |
| Bright sunshine or hazy bright, with distinct shadows | 16* |
| Hazy, half-hidden sun, ill-defined shadows | 11 |
| Cloudy bright, no shadows | 8 |
| Heavy overcast | 5.6 |
| Open shade (subject shaded from the sun but lighted by a large area of sky directly overhead) | 5.6 to 8 |
| Deep shade, as under porch roof | 4 to 5.6 |

*For back-lighted, close-up subjects set the aperture at *f*/8.

Example: Suppose you are using ASA 125 film and shooting on a cloudy bright day. Set the shutter at 1/125 of a second and the recommended *f*/number of *f*/8 for a cloudy bright day. However, you may want more depth of field than *f*/8 will give. Stop the aperture down to *f*/11 and change shutter speed to 1/60—same exposure but more depth of field. For even greater depth of field, stop down to *f*/16 and reset the shutter to 1/30—same exposure. If you want a higher shutter speed than 1/125, shift to 1/250, reset aperture to *f*/5.6. Basically, this is a practical application of the reciprocity law.

This table is only a guide; it does not guarantee perfect exposures. Variables not adequately considered in the table are time of day, geographical latitude, time of year, direction of the light, and type of subject, but it can provide quite satisfactory exposures for a majority of outdoor pictures. Do keep in mind that different types of subjects reflect different amounts of light, and the table represents only "average subjects." (See Figure 19.) If conditions leave you doubtful, then bracket: shoot first at your best exposure guess, based on the table, then shoot at least twice more, once at the next higher *f*/number and once at the next lower *f*/number, and you can extend this to two more exposures at either side if you wish.

Figure 19. High quality prints begin with proper exposure of the film.

The decision on what exposure to use can be arrived at by various methods:

1. Shoot and hope for the best. May be better than not shooting at all.
2. Refer to data sheet that comes with the film or to our tables, such as "Daylight Exposure Table."
3. Use a circular slide rule, a pocket calculator. This puts the table in a convenient form.

4. Make up your own chart or table from experience. Do keep a record of exposures. From this you can develop a mental file that will be invaluable in future situations.
5. Use an exposure meter. Most accurate method if used correctly.
6. Rely on the camera's automatic exposure feature, if available. Accurate most of the time but can be fooled by lighting conditions.

No exposure calculation method is infallible. You must learn to recognize and correct for unusual conditions and to make adjustments to achieve particular effects you want in the print.

### Exposure Value System

Exposure Value (EV) numbers (sometimes called Light Value numbers) provide another way of calculating exposures instead of using the traditional $f$/numbers and shutter speeds. This EV system is not extensively used but you might encounter it on some camera lenses and some meters.

A single EV number, taken from a table or from an exposure meter reading, represents an exposure (both intensity and time) and this number is set on a scale of EV numbers on the camera, thus setting both aperture and shutter speed. Lenses marked for use with the EV system will have a coupling that interlocks aperture with shutter speeds; as one is changed the other automatically changes, too, to keep exposure constant. All combinations of aperture and shutter speed that give the same exposure will have the same Exposure Value. The EV scale usually ranges from 2 (the most exposure) to 18 (the least exposure). Each EV number gives one-half the exposure given by the preceding (smaller) number and double that given by the succeeding (larger) number. Thus, EV11 is one-half the exposure of EV10 and twice the exposure of EV12.

The exposure value numbers are logarithmic and thus cover an enormous exposure range with a comparatively limited series of numbers. The series 2 to 18 is sufficient for normal use and represents an exposure range from 1 second at $f$/2 to 1/500 of a second at $f$/22, a range of 65,000:1.

# Exposure Meters

Photoelectric meters can measure the light incident (falling) upon or the light reflected from a photographic subject. So we have two general types of meters: the incident-light meter and the reflected-light meter. There are also two types of cells used in these meters. One is the barrier-layer cell, which generates its own electrical current, and the other is the photoconductive cell, which uses current from a battery.

The barrier-layer cell, usually made of selenium, releases an electrical current when it is struck by light; the stronger the light, the larger the current. A galvanometer measures this current, its pointer indicating an exposure recommendation that the meter's scale translates into shutter

speeds and lens apertures, based on the speed of the film being used. The photographer must make the final decision on the particular combination of shutter speed and aperture.

As increasing film speeds made photography possible at low illumination levels, photographers found their standard selenium photocells too insensitive. The lighting was so low that the meter did not respond. Booster (larger) cells were made available, but the real answer came with the development of the photoconductive cell, made of cadmium sulfide (CdS).

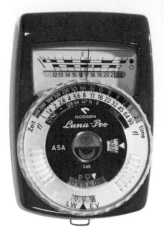

Figure 20. An exposure meter.

## The Cadmium Sulfide Meter

Whereas selenium cell meters depend upon the tiny current generated when light strikes the cell, CdS meters monitor the current from a battery. The more light, the more current from the battery the CdS cell passes. Readings in extremely low light levels are thus possible. These meters are equipped with switches to turn the current from the battery on and off. Thus the current from the battery—usually a mercury battery no bigger than a button—is used only when a reading is being taken and the battery lasts for about a year, sometimes longer.

CdS meters are excellent for most situations, and especially so when the illumination level is low, as for pictures with existing light indoors. And because these meters can be quite small they are the type built into cameras.

However, the CdS meters have a few shortcomings that the photographer should know about. They can be stricken by "fatigue" if they are exposed to a very bright light. This happens, for example, if they are pointed directly at the sun. It may take hours for a meter to recover from such an experience. Also, hasty readings with a CdS meter can be inaccurate because it takes a second or two for its needle to settle down after the battery current is turned on. Finally, these meters tend to "remember" a high brightness reading and this may affect an immediately following reading of low brightness.

## Using the Meter

Because the incident-light meter reads the light falling on the subject it takes no account of the reflection capabilities of the subject; it assumes the subject is a middle gray. Actually, the incident meter is calibrated for an average subject; and for this kind of meter *average* means a subject that reflects 18 per cent of the light.

The light-sensitive cell of the incident meter is usually covered by a dome-shaped diffuser, so that it reads all the light from every source on one side of the subject. For accurate measurements it should be used near the subject, not at the camera position, unless lighting on both subject and camera position is obviously the same.

The reflected-light meter is the most common and the most useful for

most photographers. Conventional procedure with a reflected-light meter simply involves standing at camera position, meter in hand, with meter aimed at the scene to be photographed. Outdoors the meter is generally tilted slightly downward to offset the inflated reading a bright sky background may give. The meter strikes an average from all the light intensities reflected from the scene. It does not matter to the meter whether the subject is a bright snow scene, a gray alley on a dull day, or the dark shadows of a forest. The meter scans the scene and reports only one suggestion, an exposure that would give a middle gray print tone for the average brightness value of the scene.

Success then depends upon the tones or brightness values of the scene being distributed fairly evenly above and below this midpoint or average. If the principal subject of the photograph is in front of a bright-sky background, the meter will suggest a quite different exposure than it will for the same principal subject posed before a background of dark shadows or foliage. The meter might show four to eight times as much exposure for one situation as for the other, and yet the principal subject is the same in both.

The average of the brightness values that the meter settles upon will depend, of course, on how much of the scene the meter reads, that is, on its *acceptance angle*. Taking close-up readings of the subject will give greater accuracy and will avoid the chance that reflection from a sky area or from some other exceptionally bright (or dark) area within the meter's acceptance angle may upset the average. But with the close-up method the photographer must do the averaging, and this usually means taking a reading of two or more areas of the subject, ranging from important shadows to highlights.

If moving in close with the meter is not possible, the substitution method may work. The meter reading can be taken from the photographer's own hand, with the hand held so the light falls on it in the same way as it falls on the intended subject. For close-up readings the meter should be held as close as possible without casting a shadow on the area being scanned by the meter.

Spot meters make possible accurate readings of small areas of a distant subject that cannot be conveniently approached for close-up measurements. Because of their narrow acceptance angles, these meters read only a small section of the subject, even when used at a considerable distance.

## The Gray Card

Especially useful when correct exposure is particularly critical is the Kodak Neutral Test Card. This simple device is most often used for determining exposures with color film but can also be used with black-and-white film. It is used more with color film only because exposures for color are more critical.

The test card is a piece of cardboard, measuring 8 by 10 inches, gray

on one side, white on the other. The gray side reflects 18 per cent of the light and the white side 90 per cent. This card is used mostly indoors with floodlighted subjects where the light can vary strongly from one area to another, but it can also be used outdoors.

Most exposure meters are calibrated for a scene having an average reflectance of 18 per cent, so the gray side of the card is a fairly accurate substitute for an average scene. The card must be placed for a close-up or spot reading so that it has the same illumination as the subject. As a generally useful guide, place the card so it faces halfway between the camera and the light source. The white side of the card can be used to get a meter reading in very dim light, but since this side reflects 90 per cent of the light (five times as much as the gray side), the exposure reading must be reduced by a factor of five.

## Built-in Meters

Most new cameras are being equipped at time of manufacture with built-in CdS type exposure meters. Those with single-lens reflex cameras usually read the light coming directly through the lens. This eliminates any problems that might be created by meter and lens having different acceptance angles. However, the built-in meter suggests an exposure based on the average of all the reflections it receives from the scene, with the exception of those that read only a spot or small part of the total scene. The averaging system can lead to error. For example, if the meter "reads" a direct light source or bright area, such as the sky behind the subject, it is likely to give an underexposure. (See Figure 21.)

Two final cautions about using exposure meters of all kinds: Don't forget to program the meter, which is a kind of computer, with the speed of the film being used, and remember that the meter can compute but it cannot think; you have to do that. But let the meter's computations guide your judgment.

Figure 21. Built-in exposure meters are not infallible. These two prints resulted from negatives produced by exposures based on meter readings through the lens of the camera. Neither exposure was right. At left the bright background resulted in an underexposure for the main subject. At right the dark background resulted in an overexposure of the main subject.

Exposure of the film in the camera depends upon five basic factors. Two of these are external, that is outside of the camera, and three are internal, within the camera.

The external factors are:

1. The level of illumination on the subject.

The light falling on the subject can vary radically, as in bright sunlight and heavy overcast, or whether the subject is in direct sunlight or in the shadow of a building.

2. The light reflective capacity of the subject.

## Summary and Review

Some subjects reflect a great deal of light (a smooth, white wall), others relatively little (a furry, black dog).

The internal factors are:

1. The speed (ASA number) or other exposure index of the film.

Sometimes photographers use an exposure index that is different from the ASA film speed. We recommend that beginners use ASA numbers.

2. The intensity of the light reaching the film.

This is controlled by the aperture in the lens diaphragm as set by the photographer or by the automatic controls in some cameras.

3. The time the light acts on the film.

This is controlled by the shutter speed selected by the photographer or by automatic controls built into some cameras.

So, considering or measuring the external factors and the film speed, the photographer selects a combination of f/number and shutter speed, taking into consideration two additional factors that affect the image:

1. Motion of the subject or of the camera while the shutter is open.

High shutter speeds will give sharper images of moving subjects than slow shutter speeds, and shutter speeds of at least 1/60 of a second (higher if possible) are recommended to avoid general blurring of the image caused by moving the camera while the shutter is open.

2. Depth of field.

The smaller the aperture the greater the depth of field.

## Questions for Review

Cover the list of words at the right with a sheet of paper or your hand. Then read the first question and fill in the blank. Lower the mask on the right until answer No. 1 is revealed. Continue in this way through the list of questions. If you do not know the answer to a question, review the material involved.

1. The reciprocity law can be stated as _____ .    $E = I \times T$
2. The shutter controls the _____ the light is allowed to act on the film.    time
3. The diaphragm aperture controls the _____ of the light that hits the film.    intensity
4. Most shutter settings are fractions of a _____ .    second
5. Apertures, also called f/numbers, are fractions of the _____ of the lens.    focal length

Figure 22. The negative reproduced at top left was underexposed; tone separations in the shadows and dark areas have been lost and there is a general lack of contrast throughout the image. Such a negative is described as "flat." The top right negative was correctly exposed; it will give adequate contrast with tone separations in all but the deepest shadows. A print made from this correctly exposed negative is reproduced below. The bottom left negative was overexposed, so tone separations are lost in the highlights. It seems "contrasty," but actually it is flat or lacking in contrast in what would be the brightest areas of the print (the darkest areas of the negative). Printing manipulations can improve the images obtained from underexposed and overexposed negatives, but the best prints come from negatives that have had correct exposure.

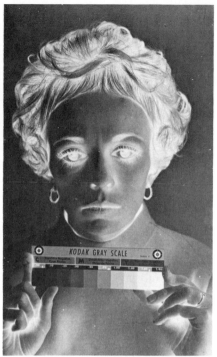
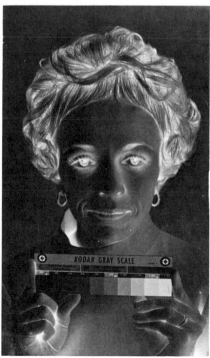

The photographer makes his selection from the following f/numbers and shutter settings available on his lens and camera:

| f/numbers: | 2 | 2.8 | 4 | 5.6 | 8 | 11 | 16 |
|---|---|---|---|---|---|---|---|
| Shutter speeds: | 8 | 15 | 30 | 60 | 125 | 250 | 500 |

6. In the f/number series above, the greatest exposure will be given by 2 or 16?

2

7. The stop 5.6 will let in _____ as much light as 8.

twice

8. If the lens opening of your camera were set on f/16 and you wanted to double the amount of light striking the film, you should change the lens opening to _____ .

f/11

The traditional method of expressing an exposure is to give both f/number and shutter speed, as f/8 at 1/250 of a second, or, abbreviated, 8 at 250.

9. An exposure of 16 at 125 is the same as 250 at _____.

11

10. Changing shutter speed from 125 to 250 will decrease the exposure by _____.

one-half

11. Changing the lens opening from 16 to 11 will increase the exposure by a factor of _____.

two

12. The combination of the two changes in Questions 10 and 11 will leave the exposure _____.

unchanged

13. Given a choice between f/16 and f/11 to get the greater depth of field, I should use _____.

16

14. Given a choice between 1/125 and 1/250 of a second for a shutter speed, for the best chance of avoiding image blur caused by motion, I should use _____.

1/250

15. Assume the correct exposure is 8 at 125. Give four combinations of f/numbers and shutter speeds that would give the same exposure.

16 at 30
11 at 60
5.6 at 250
4 at 500

# 4

# Developing
# the Negative

After the camera work is done, moving to the final picture is generally a two-step process:

1.  Production of the negative from the exposed film.
2.  Production of the positive, or print, from the negative.

Both operations, if performed in the usual manner, require a darkroom. The darkroom and its equipment need not be elaborate, but the room must be truly dark for handling today's films, which are often highly sensitive to light and usually *panchromatic*, which means they are sensitive to all colors of light. Basic equipment should include a tank for developing films, trays for print processing, an accurate thermometer, a timer, a graduate for measuring liquids, bottles for storing solutions, a safelight, a printing frame or printing box, and if enlargements are wanted (and they usually are), an enlarger. A timer for the enlarger is not essential but it is handy and desirable. Some timers will function as both an interval timer for negative development and as an enlarger lamp control for printing exposures.

# Film
# Development

The beginner should start with one of the many excellent prepared developers that come as liquids to be diluted with water or as mixtures of powdered chemicals packaged in cans, boxes, or packets and need only be poured into water and dissolved according to instructions on the labels. Start with a developer recommended for the film you have exposed. Film comes packaged with development recommendations, and these should be followed, unless other reliable and reasonable instruction is available, at least until enough experience has been accumulated to make experimental changes meaningful and productive. Recommendations from film manufacturers and developer suppliers are based on both scientific knowledge and practical tests. These recommendations are, of course, intended for average conditions, and it makes sense to alter procedures only if experience proves the need. So that we can learn to recognize and meet this need, it is important in the beginning to adhere to one film and one developer.

For any one film-developer combination the results (leaving exposure aside for the moment) depend upon three factors:

1.  *Temperature*
2.  *Time.*
3.  *Agitation.*

Control of these three factors reduces film development to the approximate level of boiling one's breakfast egg. It is possible to guarantee a predicted result by developing the film for a known time at a fixed temperature with controlled agitation.

## Temperature

The ideal temperature for most standard developers is 68° F or 20° C (sixty-eight degrees Fahrenheit, twenty degrees centigrade or Celsius). In a few cases 70° F (21° C) may be the recommendation. It is best to develop at the recommended temperature, if possible, but most of the popular developers will perform well over a fairly wide range of temperatures, from 65° F (18° C) to as high as 80° F (27° C), if the time factor is altered in an inverse relationship. That is, the lower the temperature, the longer the development time; the higher the temperature, the shorter the development time. How much time change is needed to compensate for abnormal temperatures is best determined by consulting a time-temperature chart for the film-developer combination involved. (See the printed data sheet packaged with the film.) It is inadvisable to develop at temperatures higher than 80° F because the possibility of damage to the emulsion layer becomes great. High temperatures may soften and swell the emulsion gelatin of the film and thus make it especially susceptible to

**Figure 23. A darkroom designed and built by Gene Wentworth at the Denver plant of Honeywell, Inc.**

damage. At temperatures substantially less than 65° F the developer solution may not function properly.

Accurate measurement of the developing solution temperature is important; the laboratory thermometer must be accurate. It should be checked regularly with a second standard thermometer or with a medical thermometer kept just for that purpose. Inaccuracies in darkroom thermometers are not uncommon.

Ideally, all solutions in black-and-white film processing, including the final wash water, should be kept near the same temperature as the developer. Generally this means ±5° F (about 3° C), although some darkrooms attempt to hold to ±2° F (about 1° C). Variations in temperatures between solutions, if relatively large, may cause what is called reticulation, a cracking of the emulsion, and in the case of small negatives a quite small degree of reticulation seems to show up as graininess in the print. However, without a temperature control device on the water tap, maintaining close temperature tolerances is difficult and you will find that reticulation is not a major danger except when temperature changes are sudden and in excess of 10° F (5° to 6° C).

## Time

The time factor is variable, depending primarily upon the particular film-developer combination involved. Here we must again refer to recommendations supplied with the film and/or the developer. And even these are only guides; they are not absolute values. There is no such thing as a correct development time for all workers under all circumstances. The variables are personal preference, equipment, and agitation. We can, however, begin with the recommended times and modify them as experience dictates to meet individual requirements. A rough guide for alterations: If negatives consistently emerge with too much contrast, cut the development 20 to 30 per cent; if they are consistently too soft (lacking in contrast), boost the development time about 25 per cent. The longer the development time, the more silver is formed and the blacker the negative image. Contrast, or the difference between highlights and shadows, also increases with time, but only up to that point where chemical fog level begins to overtake the increase in the highlight density; then flatness or low contrast results.

## Agitation

Careful and consistent agitation is as important as time and temperature. It is too often neglected. Fresh developer must be worked into the emulsion layer while the exhausted developer and by-products of the development reaction are swished out and away from the surface of the film. Agitation also keeps the solution uniform so that streaks on the negative caused by exhausted solution flowing across the emulsion do not occur. Agitation should begin the moment the film is placed in the developer and should continue for the first 5 seconds of the development period. After that

agitation is usually advisable for about 5 seconds out of every 30 for the remainder of the time.

Some photographers, however, agitate less than this, perhaps only for 5 seconds out of every minute, or only twice, once at the beginning and again midway through the development period. Generally the less the agitation the lower the contrast, but some photographers contend that reduced agitation also gives less graininess in the image. You may want to experiment to establish your own preference.

## Development Procedure

To prepare for film developing, place the film, the developing tank, the tank lid, the timer, and all other equipment you will need in the dark where you can lay hands on it without a fumbling search. Be certain you have all chemicals needed, minimally: developer and fixer (or hypo). We also recommend a washing aid (such as Kodak Hypo Clearing Agent) and a wetting agent (such as Kodak Photo-Flo).

The following is an outline of film developing procedure:

1. *Check the temperature of the developer.* Raising or lowering the temperature can be accomplished by setting the developer container in warm or cool water for a few minutes, but be sure to stir to get a uniform solution.

2. *Set the timer.* See the film data sheet for the time recommended for the given temperature.

3. *Turn off all lights.* Check for and plug any light leaks.

4. *Remove film from its paper covering or container.* The inner end of roll film is taped to its paper covering; you must strip the film loose from this tape; 35-mm film must be removed from its cassette (sometimes called magazine) by sharply rapping the projecting spool end on a counter top or by prying off the opposite end with a bottle-opening end of a beer-can opener. (The ends of Eastman Kodak 35-mm cassettes are generally crimped so that only the prying technique will work. A special opener for mounting on wall or counter is available.) Use scissors to cut off the leader (narrow) end of 35-mm film and to cut the film free from the spool.

5. *Wind the film on a clean, dry plastic or stainless steel reel.* (See Figure 24.) Handle the film by its edges to avoid fingerprints on image areas and be careful not to crimp the film.

6. *Place the reel with film in the tank; development begins.* The developer may be poured into the tank either before or after the film. If the film is put in first, the tank lid can be put in place and the light turned on, since the lid permits pouring solutions in and out while a baffle blocks the light. However, pouring the developer in after the film is in tends to create two problems: (1) development begins on some parts of the film before it does on others, so the pouring must be done rapidly; and (2)

this method increases the possibility of air bubbles forming on the emulsion surface. Generally, slipping the loaded film reel into the tank already filled with developer gives better, more consistent results.

7. *Place lid on the tank and agitate for approximately 5 seconds; continue to agitate for 5 seconds every 30 seconds.* Lights can be on now. Gentle tapping of the tank against the counter or sink helps dislodge air bubbles. Tanks that can be inverted are best for roll films. Then, during agitation the tank can be lifted and inverted two or three times, gently, in 5 seconds. Agitation swirls fresh developer across the emulsion so development proceeds steadily. If multiple-reel tanks for roll film are used for only one roll of film, it is wise to put an empty reel (or reels) in the tank to prevent too vigorous agitation caused by a single reel shooting the full length of the tank with each inversion.

8. *When development time is up, pour the solution out of the tank.* We recommend what is called "one-shot" development—that is, use the developer once, then pour it down the sink drain. However, in school darkrooms where many persons are using the facilities, undiluted solutions can be poured back into the original storage bottle and reused a number of times, especially if the proper developer replenisher is added. But if the solution from the storage bottle is diluted for use, never pour the used developer back into the storage bottle.

This photograph was taken by George Crouter of Denver, Colo., with a 35-mm camera, 105-mm lens, Tri-X film developed in D-76 1:1 (regular solution diluted with equal parts of water) for 7½ minutes at 70° F.

9. *Fill the tank with water to rinse the film and pour out immediately.* Some photographers prefer to use a stop bath, usually a weak solution of acetic acid, rather than a plain water rinse. An acid stop bath stops development instantly (since most developers do not function in an acid solution), and converts the emulsion to an acid state before it goes into the fixer, giving the fixer longer useful life. The first purpose of the stop bath is not vital with most films and a 10-second rinse in plain water leaves so little of the developer in the emulsion that it has small effect on the fixer. A weak acid stop bath may be advisable after a high-speed developer has been used. Development does continue if the rinse is plain water, and this added development may be significant with strong developers. Also, a stop bath is usually recommended with ultrafast films, to check chemical fog.

10. *Pour fixer in the tank and agitate.* The fixer (also called hypo) has one principal job to do and that is to clear out the unexposed and undeveloped crystals of silver halide in the emulsion. Fixing time is generally defined as twice clearing time, twice the time needed to clear the milky look the film has before it goes into the fixer. However, you will find it more practical and convenient to simply follow the fixing time recommended for the particular film and fixer you are using. Film should be left in most standard fixers, with some agitation, for 5 to 10 minutes. If, after removing the tank lid, you find the film still has a milky appearance, return it to the fixer, to a fresh batch of fixer if possible; the fixer you used first may be exhausted.

11. *Remove the tank lid and rinse the film with running water.* After fixation, the lid of the tank can be removed, since all the light-sensitive halides not used in forming the image have been dissolved. Pour the hypo back into its storage bottle; it can be reused until clearing time becomes excessive. Filling the tank once or twice with water will rinse off most of the hypo.

12. *Pour in the washing aid and agitate.* The washing aid, a hypo neutralizer or hypo clearing agent, forms chemical compounds from the hypo residue that are relatively harmless to the permanence of the image and are also easily washed away in water. Leave the film in the washing aid for approximately 2 minutes, or for whatever time is recommended in the instructions that accompany the product. Usually this solution can be poured back into its storage bottle for future use.

13. *Wash the film for 5 minutes in running water.* If the film is left in the developing tank for washing, the tank should be emptied of water several times during the wash period. There are special tanks, "rapid-wash" units, specifically designed for washing roll film. If a washing aid is not used (step 12) the film should be washed for at least 30 minutes. Using the washing aid saves time, saves water, and gives greater assurance that chemicals harmful to the image have been eliminated. Thirty seconds in a neutralizer or hypo clearing agent is the approximate equivalent of 20 minutes of washing in running water.

14. *Immerse the film for about 30 seconds in a solution of wetting agent or detergent.* The wetting agent (such as Kodak Photo-Flo, a solution of ethylene gylcol) breaks the water into small molecules and leaves a thin, even layer of water on the film; this eliminates water-spotting. Using distilled water to make the wetting agent solution makes it even more effective.

15. *Remove film from the reel and hang it up to dry.* Hang the film with a clothespin or film clip and attach another pin or clip to the bottom end as a weight to keep the film from curling as it dries. The film can be wiped gently on both sides with a chamois cloth or sponge that has been dampened in the wetting agent solution, but this can be risky. Wiping the film can scratch or streak it if the chamois or sponge is not kept

scrupulously clean and free of foreign matter. The film should be kept as free from dust as possible while it is drying.

16. *Place dry negatives in envelopes.* Glassine and plastic envelopes are marketed in standard sizes for filing and protecting your negatives. Cut the film into strips to fit the envelopes, handling the film only by the edges.

It has been traditional to think of most film developers as falling into three categories: all-purpose, fine-grain, and high-energy types. The dividing lines seem to be less clear today because of changes in the chemistry of films and developers. It is sometimes difficult to tell any difference between negatives produced in different developers, even developers from two different categories. After a few months in photography, most people find a favorite developer. A beginner who must choose his own is advised to use one of these that can be roughly classified as all-purpose:

## Some Processing Tips

### Kodak D-76

Often used as a standard against which to judge other black-and-white film developers. About as close to being "all-purpose" as it is possible to get.

Packaged form: powder.
Latitude: good.
Grain: moderate.
Shadow detail: good.
Contrast: average.
Speed: fairly slow (Plus-X at 68° F, about 7 minutes).
Stability in storage: good.

Tops for economy and good for one-shot development, especially if normal stock solution is diluted 1:1 (one part stock solution to one part water) for use.

### Kodak HC-110

A fairly high-energy developer that comes close to producing the same results as D-76.

Packaged form: liquid.
Latitude: good.
Grain: moderate, especially in 1:31 dilution.
Shadow detail: good.
Contrast: average.
Speed: fast to moderate depending upon dilution (Plus-X at 68°, 3 to 7 minutes).
Stability in storage: very good.

Conveniently stored in stock solution to be diluted for use; excellent for one-shot development.

### Ethol UFG

Product of Plymouth Products Company, Chicago. "UFG" stands for "ultra fine grain."

Packaged form: powder.
Latitude: good.
Grain: fine.
Shadow detail: average.
Contrast: average.
Speed: fast (Plus-X at 68° about 3 minutes).
Stability in storage: very good.

### GAF Hyfinol

A good developer of moderately high energy often overlooked. (GAF stands for General Analine and Film, ·ccessor to Ansco.)

Packaged form: Powder or liquid (Hyfin ·L)
Latitude: good.
Grain: fine.
Shadow detail: average to good.
Contrast: moderately high.
Speed: medium (Plus-X at 68° about 7 minutes).
Stability in storage: very good.

Maintains its strength exceptionally well when used over and over again, pouring the full-strength solution back in storage bottle after each use, if bottle is kept full or very nearly so.

### Storage

Developer solutions should be kept in tightly capped brown glass or plastic bottles to protect them from light and air. Some technicians believe glass bottles are better because there is some danger that air can filter through some plastics. Developers keep longer if the storage bottle is full, since this reduces the opportunity for the chemicals to react with the oxygen in the air. The solution level in bottles can be raised and air eliminated by dropping glass marbles into the bottles or, if the bottles are plastic, by squeezing them to remove the air and then capping them tightly. Caps or corks should be rubber or plastic, because these do not shrink or rust. All solutions should be stored at 65 to 75° F (18 to 24° C). The solutions deteriorate more rapidly at high temperatures and some of the chemical ingredients may crystallize at low temperatures.

When a solution is used over and over again, constant developer activity can be maintained by replenishment. Prepared replenishers are available for standard developers with instructions for use. However, replenishment

54

Figure 25. Film development. All photos were taken with Tri-X film (ASA 400). For the top photo, the film was given an exposure index of 600 and developed normally in D76 undiluted. For the next photo, the exposure index was 800 (twice ASA), and development time was increased 25 per cent in undiluted D76. For the next photo, the exposure index was 1600, and for the final one, 3200; the film for both was developed for 3½ minutes at 80° F in Acufine developer, with gentle agitation in the middle of the developing time.

seems practical only when the developer is being used frequently. Anyone using a home darkroom for only occasional film development should use the one-shot development system.

Nearly exhausted developers should never be used. Developers stored for long periods (more than one month in partly full bottles or more than six months in full bottles) are all suspect. A fresh developing solution is normally clear and has only a slight color tint. After use it will become somewhat cloudy and the color will deepen. If it becomes badly discolored, perhaps a dirty brown, it should be discarded. The manufacturer provides data on the keeping qualities of each developer and on the amount of film that can be safely processed with a specific quantity of it.

### Forced Development

At times photographers shoot pictures under conditions that make underexposure and/or low contrast unavoidable. Limited improvement in the negative can be achieved by extending the development time (forced development). Contrast, particularly, is influenced by development time. But forced development, sometimes referred to as "pushing the film speed," gives only a limited increase in film speed. (See Figure 25.) Numerous experiments have shown that films rated at or near their recommended speed or ASA number (that is to say, given normal or near normal exposure) and given normal development will give the best prints. Only when exposure is one-fourth of the normal (setting the meter for example, at four times the ASA number) or less will forced development be of much help. Extending development times can help build contrast: if the subject lacks contrast, underexpose about one stop and then extend development time 25 to 50 per cent. If you must "push," then try doubling developing time or develop for the time specified at 68° F (20° C) but warm the developer to 80° (27° C).

Figure 26. This photograph was shot on Tri-X film rated at 1600 and developed in Acufine.

Picture-taking in low-light levels that demand a push for the film speed is usually best tackled by planning to process the film in a special developer, such as Acufine, manufactured by Baumann Photo-Chemical Corporation. (See Figure 25.) Specific speed ratings or exposure indices have been established for films to be processed in such developers. The result is generally a higher effective film speed, about three times the ASA speed in Acufine, with relatively little loss in quality.

# 5

# Making the Print

By the time the photographer has his finished negative in hand he has applied many skills—a selective eye, precise judgment of light and angle of view, and careful handling of the film during processing. But the job is not yet done. The final step in the production of an outstanding photograph has yet to be taken. The value of a photograph lies in the finished print (or transparency).

Making a print from the negative is basically a simple process. It involves, first of all passing light through the negative image so that the light will form a corresponding positive image on another sensitive emulsion, which, this time, is coated on paper. Like the negative image formed in the camera on film this positive image is invisible, or latent, until it is developed. The four basic steps taken with the film must be repeated with the paper: development, fixing, washing, and drying. We can work under a dim yellowish light now, a safelight, because paper emulsions are slow relative to film emulsions and are sensitive, usually, only to blue light.

Print-making divides conveniently into two processes: contact printing and projection printing (enlarging). In contact printing the emulsion side of the negative is placed in tight, uniform contact with the emulsion side of the paper in either a printing frame or box; the light then passes through the negative to the paper. The image passed to the paper is exactly the same size as that in the negative. Contact prints of small format negatives are used only for editing (deciding which ones to enlarge and how to crop them) and for filing. (See Figure 27.)

Most prints today, are enlargements of a negative image, or, in many cases, only part of a negative image. Enlarging places an extra emphasis on the need for care in the entire process of producing the negative, from composition in the viewfinder of the camera, through exposure and development to drying. Enlarging exaggerates, because it enlarges, all imperfections in the negative, including image blur, grain, pinholes, scratches, specks of dust and lint, or other flaws.

## The Enlarger

Essentially, the enlarger is a camera used to make a picture of a negative or, in other words, to make a copy of a negative. And in the process, of course, we reverse the image from a negative to a positive and we magnify or enlarge it. A source of light on one side of the negative (usually above) sends rays of light through the negative to a lens. The lens focuses a sharp image of the negative on an easel below it, where the paper is placed.

The magnification of the image occurs because the distance from the enlarger lens to the printing paper is greater than the distance from the

enlarger lens to the negative. Magnification is the relationship between the size of the object photographed and the image of it formed by the lens. In the camera, the image formed by the lens is normally smaller than the object because the distance from lens to object is greater than from lens to image. So the magnification is actually a reduction: the image is, perhaps, one tenth the size of the object. In enlarging, the relationship between the two distances is reversed: lens to image distance is greater than lens to object (negative) distance, so the print image will be 2 or 10 or maybe 20 times the size of the negative image. (See Figure 28.)

The enlarger must be designed so that it distributes the light uniformly over the negative. Two methods are commonly used to achieve uniform illumination: (1) diffused light or (2) condensing lenses.

Diffused illumination of the negative is achieved by scrambling the rays of light in the housing around the light source and by placing an opal glass between the light source and the negative. The problem of even illumination of the negative is solved in the condenser enlarger by using a condensing lens or lenses to gather the rays of light and direct them down through the negative to the focusing lens below. This makes maximum use of the light and gives the brightest illumination of the negative.

The diffusion enlarger: (1) gives softer contrast and (2) lessens the effect of blemishes in the negative, but (3) it makes less efficient use of the light and (4) requires longer exposures and/or a more powerful light source. The condenser enlarger: (1) makes more efficient use of the light, (2) gives greater contrast in the print image, (3) gives sharper and clearer detail

**Figure 28. Magnification. In the camera, the image is smaller than the object because image distance (I) is smaller than object distance (O). In the enlarger, the image (the print) is larger than the object (the negative) because I is larger than O. In either camera or enlarger if I and O are equal the image will be the same size as the object.**

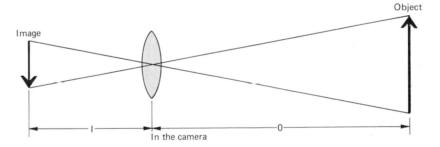

In the camera

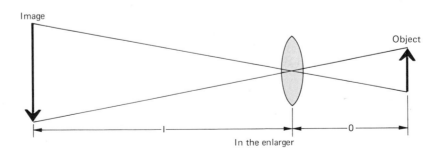

In the enlarger

in the print image, but (4) exaggerates the blemishes caused by grain, scratches, dust, and lint in or on the negative.

The most common light source in enlargers is a tungsten filament in an opal or frosted glass bulb. It is not a good idea to use an ordinary household lamp bulb in an enlarger, because the maker's name is usually printed on the end of the bulb and this can show up as a shadow image on the paper.

The customary printing papers for black-and-white photographs vary in seven general characteristics. Four of these involve the paper base; three of them involve the emulsion coated on the paper base.

## The Printing Paper

The paper base characteristics are:

1. *Texture.* The surface of printing papers varies from smooth to rough, including special surfaces such as silk, velvet, pebble, canvas, and even something called tiger tongue. Smooth surfaces are best for fine detail and are generally used for prints intended for reproduction in newspapers or magazines.

2. *Brilliance.* Printing papers vary in their ability to reflect light; the higher the light reflectance the higher the brilliance. We can roughly classify all papers into four general categories ranging from high brilliance to low (with the approximate brightness range or difference between blacks and whites in average prints given in parentheses): glossy (1:50), semiglossy or luster (1:40), semimatte (1:30), and matte (1:15). High gloss emphasizes crisp blacks, brilliant whites, and fine detail. If the picture is intended for publication in a newspaper or magazine, then a glossy or semiglossy luster combined with smooth surface will be best.

3. *Tint.* The color of the paper on which the emulsion is coated will control its tint, varying from a white to a buff. White is most common, but whites vary from one brand of paper to another. Tints impart a cold or a warm quality. "Cold" as used here means white with a very slight blue cast; "warm" refers to a white with a slight brownish hue. Generally the photographer tries to match the tint to the picture subject: white for a snowscape, buff or ivory for a warm, sunlit summer scene. But white is used for photos intended for reproduction.

Paper tint is strongly related to emulsion tone (see below).

4. *Weight.* Many papers come in either single weight or double weight, referring to the thickness of the paper base. Double weight is more durable and lies flatter, but it is also more expensive. A few papers come in a medium weight and a few in what is called document or light weight, a thin base that can be folded without cracking.

The emulsion's characteristics are:

1. *Contrast.* The contrast of a print is the impression it gives of brightness differences between various parts of the image. A print that appears

to be formed of mostly middle gray tones, without any clear whites or blacks, will be low in contrast; most photographers would probably call it a flat print. A print with good contrast, that is, having a full or nearly full range of tones from black to white, is sometimes called a full-scale print. A high contrast print usually means one that has full blacks and clear white highlights with a short scale of halftones between the extremes. (See Figure 29.)

The contrast of a print is the result of the interaction of a number of factors, including:

1. The character of the original scene, including the lighting.
2. The type of film used.
3. The exposure and development of the film.
4. The type of enlarger used.
5. The kind of printing paper used.

Such a complex characteristic of the print as contrast cannot be precisely defined or described. A certain degree of contrast has been established by a number of factors by the time the photographer prepares to make the final print; at this moment he has another factor within his control. Most printing papers are available in several contrast grades, so the photographer can select the grade that matches his negative. A desirable match depends not only upon the contrast of the negative, which can range from hard to soft, but on the preference of the photographer.

Paper contrast grades are usually classified according to the following scale:

No. 0: extra soft
No. 1: soft
No. 2: normal or medium
No. 3: hard or contrasty
No. 4: extra hard or extra contrasty
No. 5: extremely contrasty

Choosing the correct contrast grade for a particular negative is one of the most difficult problems the darkroom poses. Experience is really the only method of learning to solve this problem. If a negative printed on No. 2 paper gives a print that is flat, and this is usually revealed by shadow areas that should be black but turn out to be muddy dark gray, then a higher contrast grade is needed. A few negatives may give prints on No. 2 paper that contain full blacks and whites, but little in between. This indicates a need for a softer grade of paper.

To judge a negative for contrast, examine it against a diffused light source, such as light reflected from a white painted wall, or against the ground glass of a light box. Sometimes the contrast of a negative can be judged by laying it down on a page of a book printed on white paper. The normal negative will show good tone and detail with some density

in the thin (shadow) areas and the print of the book should be barely readable through the most dense (highlight) areas.

Variable contrast papers are also available. To make these the manufacturer puts two emulsions on the paper, either in two layers or mixed in a single layer. One is a high-contrast emulsion and the other low-contrast. To change image contrast the photographer exposes the paper with plastic filters held in the path of the light (either above or below the lens). The color of the filter changes the color of the light and thus alters the relative responses of the two emulsions. Used without a filter, the variable contrast papers give approximately normal contrast, about the same as a No. 2 paper.

In the 1970s a new paper became popular. It is called RC paper; the RC stands for resin coated. The paper base is medium weight; the emulsions are the same as emulsions on other papers, but the paper base is coated top and bottom with a plastic that greatly reduces the amount of processing solutions soaked up by the paper base. This makes it possible to reduce processing time, particularly washing time, and the RC papers can give a high gloss without the necessity of ferrotyping during drying. (See section on drying prints in this chapter.)

2. *Speed.* The emulsion's sensitivity to light is its speed, and paper emulsions are broadly categorized as slow, medium, and fast. The slow papers are usually silver chloride emulsions and are mostly used for contact printing, which generally does not require high sensitivity. Medium speed paper emulsions are usually chlorobromide emulsions, a mixture of silver chloride and silver bromide. The higher the proportion of bromide the higher the speed. These are used for normal projection printing (enlarging). The high-speed papers are silver bromide emulsions, eight to ten times as sensitive to light as some of the slower papers. They are especially useful for large blowups, such as photomurals.

In 1966 the American National Standards Institute (ANSI) established a more practical and more informative method of expressing paper speeds through a series of numbers, analogous to the ASA speed numbers for films. However, film and paper speeds are measured differently and therefore there is no direct relationship between them.

The ANSI paper speed numbers indicate the relative speed of different papers and the difference between any two consecutive numbers represents an exposure change of 1/3 of an $f$/number. In the following series of ANSI paper speed numbers (only part of the complete series):

$$20, 25, 32, 40, 50, 64, 80, 100, 125, 160, 200, 250, 320, 400,$$

if the speed difference between two papers is three intervals—say from 100 to 200—the exposure difference is one stop, or the 100 paper needs about twice the exposure time that the 200 paper needs at the same $f$/stop. In other words: if you first make a print with a paper rated at 200 but then decide to try a paper rated at 160, increase exposure time one third;

for a paper rated at 125, increase exposure two thirds; and for a 100 paper, increase exposure three thirds or 100 per cent.

These speed numbers are most useful when you change from one contrast grade of paper to another, because with many papers the speed changes as the contrast changes. If the exposure for a No. 3 paper (or for a variable contrast paper with a No. 3 filter) was 15 seconds and the paper speed was 320, what would be the exposure time for a No. 4 paper (or filter) with a speed number of 200? Obviously the exposure time will be longer because the speed number is smaller. Multiply the known exposure (15) by the speed number of the paper used (320) and then divide the result by the speed number of the paper you wish to use (200). Thus:

$$15 \times 320 = 4800 \div 200 = 24 \text{ seconds.}$$

If these ASNI paper speed numbers are given in the data sheets with the papers you buy, you will have a way of comparing different papers and a starting point in figuring exposures, but exposures calculated with these numbers may not be exact for three reasons:

1. Exposure in printing is critical and photographic papers do not have wide exposure latitudes.
2. Paper emulsions may change during storage.
3. The desired print image is often a matter of subjective judgment.

3. *Tone.* The emulsion tone can vary from the blue-blacks or cold papers through neutral-blacks to warm-blacks and browns. Emulsion tone is generally related to paper tint; that is, a cold emulsion tone is usually combined with a cold (white) paper tint. Photographers may select a blue-black tone for snowscapes, cityscapes, street scenes at night, but a warm-tone for early morning or evening outdoor scenes and for indoor scenes under artificial light. The tone of the emulsion is largely a result of the size of the metallic silver grains that form the image and partly a result of the kind of halide used. Large grains give a blue-black (cold) tone and silver chloride tends to produce cold tones.

When the negative is ready to be placed in the enlarger, put it in the negative carrier, emulsion side down, or emulsion side toward the lens. If the negative is emulsion side up, the image will be reversed in the print. The emulsion side is the side with the dull-looking surface and the side to which the negative tends to curl.

## Making an Enlargement

With the aperture of the lens wide open, raise or lower the enlarger to change lens-to-easel distance and thus change the size of the enlarged image. This way you can crop out parts of the image and arrange the margins of the print the way you want them. Focus accurately, still with the lens wide open. Precise focus is important. Focusing aids are available

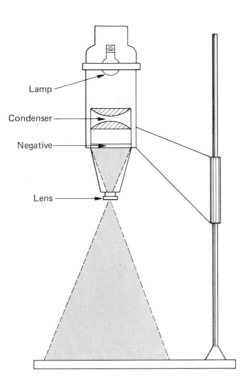

Lamp

Condenser

Negative

Lens

Figure 30. The condenser en-
larger.

to magnify a small section of the projected image, sometimes enough so you can focus on the grain of the silver deposit in the negative. When the negative is annoyingly dense, you can substitute a focusing negative for the one you intend to print after you have positioned the enlarger for correct composition and approximate focus. This focusing negative is made by fogging a piece of film, developing and fixing it, and then scratching a fine line in the emulsion to focus on. An old, unwanted negative can also be used for this purpose.

Now stop the lens down to approximately the halfway point, about $f/8$. With an especially dense negative it may be necessary to leave the lens wide open, or nearly so, to keep exposure times within reason. Or if the negative is quite thin you may need to stop down further than $f/8$ to avoid an unreasonably short exposure time. A middle $f/$stop range is recommended because it is generally the point at which the lens gives its best image resolution and because if you have made a slight error in focusing, stopping down two or three $f/$stops may hide that error because smaller apertures increase the zone of focusing movement within which the image appears sharp to the eye.

Switch off the enlarger light and place a test strip of the enlarging paper on the easel where it will catch a key part of the image. A test strip is a strip of paper 2 or 3 inches wide. With the test strip in place on the easel, switch on the enlarger for 5 seconds. Then cover one third

of the strip with a piece of cardboard and switch on the light for another 5 seconds. Move the cardboard so that two thirds of the strip are covered, being careful not to move the test strip, and expose for another 5 seconds. Now you will have three exposures, at 5, 10, and 15 seconds, on one strip. Develop the strip to see if one of these is the correct exposure. If not, use it as a guide to run further tests until you get the correct exposure. The test strip can also provide a guide to contrast; if the contrast appears too high or too low in the test strip you can switch to the indicated grade of paper (or filter, if variable-contrast paper is being used). Lengths of time other than 5-second intervals can be used. Estimate the exposure from the brightness of the image projected on the easel, then bracket that estimate on the test strip. The objective is to find the correct exposure as quickly as possible with a minimum expenditure of paper. Develop the test strip the full recommended time (see the instructions that come with the paper) and leave it in the hypo for a few seconds before you turn the room lights on to make a close inspection.

Beginners generally tend to make prints that are a little flat and a little underexposed. This may be because prints tend to lose contrast slightly as they dry and because beginners tend to be satisfied with a minimum of print development time. The best practice is to develop for the maximum, not the minimum, time to achieve a full, rich gradation of tones. Prints will look darker under the safelights than they will under ordinary light.

## Processing the Print

Once exposure time and contrast grade have been determined, a full-sized sheet of paper is placed on the easel and exposed. Place the full sheet in the developer quickly and all at once so that all parts begin developing at the same time. Rock the tray constantly during development for agitation or flop the print over and over. And don't forget to watch the time.

A stop bath is recommended for prints because we usually want to stop development quickly, and the stop bath will help avoid stains and development streaks and will extend the life of the hypo bath that follows. Agitate the print in the stop bath for about 10 seconds and then transfer it to the hypo tray. A stop bath can be made by adding one ounce of 28 per cent acetic acid to 32 ounces of water. Or an excellent choice is Kodak's Indicator Stop Bath, mixed according to directions on the bottle. This bath is recommended because it tells you when it is exhausted by changing color.

If you have sufficient room for the extra tray it is a good idea to use two hypo baths. Agitate the print in the first tray for about 30 seconds and then let it soak there for 2 to 4 minutes, with occasional additional agitation. Then transfer it to the second hypo bath and repeat the foregoing procedure for the same lengths of time. The advantages of this system are that your hypo lasts longer and you are certain of adequate fixing.

Most, if not all, of the unexposed silver halides are dissolved in the first bath and left there. The second bath provides insurance that any remaining nonimage silver will be in compounds that are readily soluble in water and easily removed by washing. You can fix about two hundred 8 by 10 prints using two one-gallon baths of hypo. Mix two hypo baths to start with, then as the first nears exhaustion, pour it out and replace it with the second bath. Mix up a fresh second bath. A hypo bath nearing exhaustion becomes cloudy and foams readily. Or you can check more accurately with a strip of fogged but undeveloped film. Drop the film strip into the hypo and leave it there, with occasional agitation, for five minutes. If it has cleared to transparency in that time the hypo is still usable; if not, better discard the hypo for a fresh batch.

Total time in the hypo should not exceed 10 minutes because hypo can dissolve some of the image silver if it is given enough time. Actually, with agitation, fixing should be adequate in about half this time, but we usually fix for about 10 minutes to be sure, and also to give the hardener in the bath a chance to work. Hardener is sometimes omitted from the print-fixing bath, especially for prints that are to be toned.

After it is fixed the print should be washed in running water for a minimum of 30 minutes. An hour wash is better if you want the print to last for many years. Washing time can be reduced drastically by using a hypo neutralizer or clearing agent, such as Kodak Hypo Clearing Agent. After a 2-minute soak in a solution of this agent, washing can be reduced to about 15 minutes. A clearing agent is especially recommended if the wash water is cold.

## Drying the Print

Prints can be dried, face down, on a clean white photographic blotter, in a photographic blotter roll, or on stretched cheesecloth. This is the technique for nonglossy surface prints or for producing a semigloss with a glossy surface paper. If you want high gloss from the glossy surface paper the print must be dried face down on a ferrotype plate, squeezed so all the air and water are removed from under the print. (A ferrotype plate is a thin, flat sheet of steel that has been chromium-plated, usually, or sometimes black-enameled. It is this smooth surface that imparts high gloss to prints. Glass, preferably mirror plate glass, can be used if it is uniform, free from surface defects, and has been thoroughly cleaned.) Prints will dry if you simply place the ferrotype tin on edge or lay it flat, print side up. The prints ordinarily pop off of their own accord when dry. Print dryers, electrically heated, greatly shorten drying time, but rapid drying at high temperatures can have disadvantages. Prints may stick to the surface of the plate or they may have a poor gloss. Various chemical solutions are available for preparing a final rinse that will promote gloss and prevent sticking and uneven drying. A 5 to 10 per cent solution of glycerin promotes even drying and reduces curl.

Glossy RC papers do not need ferrotyping to achieve high gloss; just let the RC prints dry in the open air with the prints lying on a counter or hanging from a line. Be cautious about drying RC papers on regular print dryers; you may not only ruin your prints but you might ruin the surface of the dryer as well. You can use warm air blowing over the prints to speed drying after you have removed surface water with a squeegee, clean soft sponge, or chamois. If you put an RC print on a dryer be certain the temperature is low, below 140° F (60° C).

# Tips on Printing

For high-quality prints the enlarger lens (and the condenser lenses in condenser enlargers) must be clean. A dirty enlarger lens will produce prints that lack full brilliance. Dust and lint must also be removed from the negative. Use a soft brush gently; vigorous brushing may develop static electricity in the negative, and that attracts dust. In dry air, film can easily develop a charge of static electricity and dust can also collect in the enlarger. Clean it frequently. If dust spots persist, try grounding the enlarger with a copper wire from enlarger frame to a cold water pipe. Some photographers use a static-eliminator brush on negatives, or static-eliminator cleaning fluids, or cans of compressed air to blow off the dust. The best prescription against dust and lint is: handle negatives with care; keep them in envelopes; do not place unprotected negatives down on counters.

Electric timers are available for timing print exposures and they are well worth the investment required. With them you can repeat an exposure exactly or make small but precise changes in an exposure.

The temperature of the processing solutions in print-making is not so critical as it is with film processing. The developer should ordinarily be close to 70° F (21° C). Variations between the temperature of the developer and that of subsequent solutions are not important if the variations are not great. The thin paper emulsion is firmly bonded to the paper base and is not likely to reticulate.

Care is essential to avoid contaminating the developer. If you use tongs to handle the print in the solutions and to move it from one tray to the next, keep one set of tongs for the developer tray only. If you handle the paper with your hands, be sure to rinse your hands after they have been in the stop bath or hypo before you dip them in the developer again. And always rinse and dry your hands thoroughly before touching negatives, dry paper, the enlarger, or any other equipment. Some developers tend to stain fingernails; you can avoid this by always rinsing off the developer, first in hypo and then in water, before you dry your hands.

During the first few moments in the developer, nothing seems to happen to the paper. This delay is the induction period, the time the solution needs to penetrate the gelatin layer, reach the exposed silver halide crystals, and develop enough silver to be visible. The image begins to appear in

Figure 31. Print quality. Fine print quality stems from correct exposure of film, careful processing of film, correct exposure of the paper, and careful processing of the paper. The result can be sparkling whites, rich blacks, a full range of intermediate tones, extreme sharpness to emphasize detail and textures. This photo was taken by Joseph K. Lange of Lakewood, Colo.

15 to 20 seconds with most papers and developers if the exposure has been a proper one. Don't be in a rush to yank the print from the developer; give enough time for full contrast to appear, including the local contrast in highlight areas that will provide the detail in those light areas.

If two or more prints wind up in the same tray at the same time be sure they are agitated; shuffle them occasionally. After the print has been in the hypo for about 30 seconds you can turn the room lights on to inspect the print; but be sure your unexposed paper is safely covered in its package or in a light-tight drawer. Study the highlights of the print. Do they have sufficient detail and texture? And what about the shadow areas and the other dark portions? They should have a sort of luminous quality, even though black. Examine the contrast between the highlight and shadow areas. If it is extreme and harsh you will need a low-numbered (softer) paper, or a low-numbered filter with variable contrast paper; if it is flat with blacks that are muddy you will need a harder-grade paper or a higher-numbered filter. Look, too, for blemishes such as white spots caused by dust or lint on the negative. And study local areas to see if the exposure has been correct for all parts of the print; if not you will have to make some corrections by manipulating the exposure.

# Manipulations

Often a highlight area in an image, such as a white shirt or even a face, comes out almost blank white in the print even though all other areas are correctly exposed for just the right image tone and detail. Examination of the negative may show that there is detail in the highlight area as well. Paper emulsions do not have the range of exposure characteristic of most black-and-white film emulsions. To retain detail in both highlights and shadows we often must resort to a bit of exposure manipulation, called *burning-in* and *dodging*.

## Burning-in

If the first print shows that the exposure is correct for all areas but one or two highlight sections, the answer is to use the burning-in technique. Give the second piece of paper the same exposure as the first and then give the highlight area some additional exposure. How much can be determined by running another test strip for the highlight area alone. If the highlight area that needs burning-in is the sky at the top of the picture or some other area near an edge, you can burn it in by holding a piece of cardboard (or your hand) under the enlarger lens so that it blocks all light from reaching the paper. Then, with the light on, slowly move the cardboard until the sky area at the top of the picture begins to appear on the paper. Keep moving the cardboard until the light reaches the inside edge of the area you want to burn-in, then move back so the shadow returns to the margin. Repeat the procedure if necessary. You must keep

the cardboard moving and give the topmost part of the sky the greatest additional exposure. (See Figure 32.)

To burn-in central areas of the picture, cut a hole in a large sheet of cardboard. The size and shape of this hole can be controlled by inserting one or more fingers into the hole or by cutting smaller holes in a second, small piece of cardboard, which can be placed over the first board. After experimenting to find the exact size and shape of the hole needed as well as the position in which you will need to hold the board, insert paper in the easel and make the over-all exposure. Then, until you can move the hole into the proper position, block out all light with the cardboard. Keep the cardboard moving constantly while you let the highlight area get additional exposure. Be careful not to burn-in the central part of the area excessively while the edges get much less. Only through practice can you develop the necessary skill.

You may on occasion want to burn-in a dark or shadow area as well so that it will have a richness of tone instead of a dark but muddy appearance. Full, rich, black tones and highlights with enough variation in tone to give them sparkle are often the basis for rich, dramatic prints.

## Dodging

Sometimes a shadow or other dark area of the print is too dark, even though highlights and middle tones are fine with a given exposure. We must make the shadow lighter by holding the light back from this area. If the too dark area is at the margin, you can shade or dodge it with your hand or a piece of cardboard. If it is toward the center of the picture, dodging can be accomplished by using a piece of cotton or cardboard on the end of a length of wire at least 12 inches long. Pieces of cardboard can be cut to various sizes and shapes. One size and shape can serve many purposes because the area it shades can be varied by moving it closer or farther away from the paper and by turning it so the shape of the shadow changes. The shadow of the dodger at the end of the wire holds back light from the dark area of the print, but if you keep the dodger and wire moving slightly but constantly no shadow of the wire will show in the print. Moving the dodger up and down slightly during the exposure usually helps hide the evidence of the manipulation in the developed image. (See Figure 33.)

The amount of time needed to burn-in or dodge an area varies widely, but don't be afraid to use a reasonable amount of time. It usually does little good to burn-in a highlight for five seconds when the over-all exposure of the print was 20 seconds; a good rule of thumb is to burn-in for a time equal to the original over-all exposure. Sometimes this will be too much; sometimes not enough. For dodging, try shading the dark area for about one half the over-all exposure. You may save time and paper by running a test strip for the area to be burned-in or dodged.

Manipulation of the exposure must be planned before paper is inserted

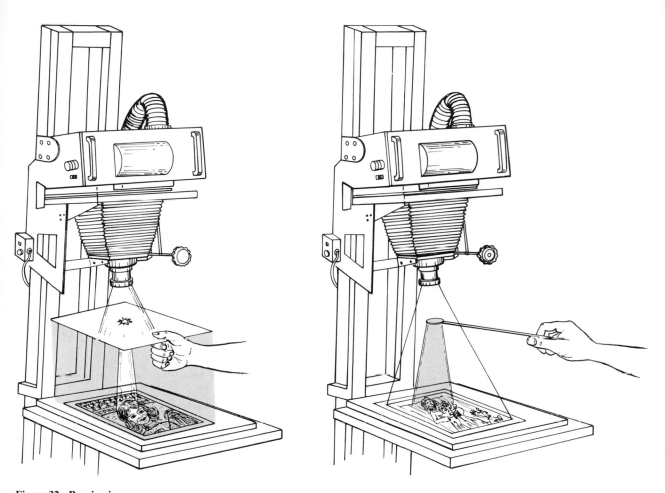

**Figure 32. Burning-in.**

**Figure 33. Dodging (right).**

in the easel, and then must be executed with care. Carelessness will result in a print that reveals your tricks; keep your dodging tool moving during the entire exposure and far enough away from the paper so that no sharp outline will show in the developed print.

# Grain in Prints

Examination of a section of a negative under a microscope reveals that the silver which forms the image is distributed in irregularly shaped black clumps. These clumps of silver may become apparent when an enlarged print is made from the negative. The greater the enlargement the larger the image in the print of the silver clumps. The image of these clumps, if large enough to be visible to the eye, will give that print a rather mealy appearance, sometimes quite unpleasant. This is what photographers mean when they say "This print is grainy."

Graininess in the print results from the grain in the negative. It is a fault (if it is a fault) of the negative, not of the print. If you are seeking the source of graininess in the print, look to the negative; there's the culprit, always. The larger the clumps of silver in the negative image the more the grain in the print.

Most common causes of graininess are overexposure, overdevelopment, excessive agitation, extreme enlargement, and high-speed films. (Grain size generally increases with the speed of the film because increased film speed is partially achieved by increasing the size of the light-sensitive particles in the emulsion.)

To minimize print graininess keep these rules in mind:

1. Use a slow or medium speed film if possible. Using a fine-grain developer with a high-speed film usually means that some of the film speed will be lost in order to gain the fine grain.
2. Fill the negative frame with the scene to be enlarged. Print graininess is approximately proportional to the enlarging magnification, and if you use only a small part of a 35-mm negative to make an 8 by 10 or larger print, graininess is almost inevitable.
3. Give the minimum permissible exposure of the film, just enough to get printable detail in important shadow areas.
4. Develop the film carefully at temperatures no higher than 70°; do not overagitate; do not leave the film in any solutions or the final rinse longer than recommended.

Graininess is most evident in large uniform areas of medium print density (such as flesh tones). Glossy print surfaces accentuate graininess whereas semimatte or matte surfaces de-emphasize it.

# Stabilization Processing

Quick prints are made possible by use of the stabilization process. Trays, wash tanks, and dryers are not needed for this process because developing agents are incorporated within the emulsion coated on the print paper. When such a paper has been exposed in the normal way in a contact printer or an enlarger, it is then passed through a special processor; the finished, nearly dry print emerges in about 10 seconds. In the processor the print first passes through a solution that activates or releases the developing agents incorporated in the emulsion and then it passes through a second solution of a stabilizing chemical that converts the unexposed and undeveloped light-sensitive silver compounds to a colorless substance. This eliminates the normal fixing and washing steps.

The stabilized photographic print is not permanent, for the unexposed light-sensitive particles in the emulsion will eventually begin to react to light. The print can be made permanent, however, by fixing and washing in the conventional way.

# 6

# Composition

To produce an intelligible report the photographer must master the visual grammar and syntax of composition. Composition is a word used frequently in many contexts. Music is composed; so is a poem and a novel; and a printer speaks of composing type. Composition always seems to mean a putting together of various elements so that the sum total makes a recognizable whole. Each element should contribute to the significance of the unified total. The contribution of each element is largely determined by its relationship to other elements, and the logical development of all the interrelationships leads to the message or meaning of the whole. In all cases the objective is communication, the transmission of a message from one person to another, and effective transmission will occur only if the code in which the message is phrased is recognizable and intelligible. An effective communication is one that transmits the composer's meaning with a minimum of distortion and ambiguity. Composition is the art of organizing an effective communication.

Composition in photography, like composition in writing, music, and painting, cannot be reduced to a precise set of hard-and-fast rules. Composition is not something carried about in a kit to be taken out and forced upon each new set of materials. Rather, composition depends upon the content of the message and upon the purpose and viewpoint of the composer, the photographer. For many photographers—the photojournalist, for example—there is more to composition than balance and design. Pretty pictures are not always good news pictures. Composition for the photojournalist has another aim. He must organize the visual elements within the picture to convey his intended meaning.

A major function of composition is to support and clarify content. Content and composition can be discussed as separate parts of the picture; but even so, one still does not exist without the other. Either content or composition may be weak and spiritless or strong and vigorous, but both are present in an image of any kind, and both must be strong if the picture is to be strong. Because composition is inseparable from content, and because content is as infinite in variety as is subject matter, composition too has such infinite variety that no set of precise rules can possibly cover all situations.

Infinite, too, are the purposes and viewpoints of photographers, or the composers in any medium. If it is logic that makes possible the composing of related elements into a unified form or whole, it is purpose that determines what form an idea based on logic will assume. The photographer must have clearly in mind what message it is he wants his photograph to convey; this is his purpose. The form, or the composition, into which he shapes his idea is, to a large extent, controlled by this purpose. What

must be included to convey his meaning? What is important? What is not? Elements important to his purpose must be large, or sharply outlined, or strongly lighted, or placed in eye-catching sections of the picture. Less important elements are smaller, less distinct, less well lighted, and located in less prominent positions.

As purpose varies with each photographer, so does viewpoint. Each of us sees what he wants to see, or what he expects to see; we look not with our eyes alone but with our minds as well. What we see is conditioned by past experiences and personal feelings. Consequently, no two photographers picture the same subject exactly the same way. The composition of each photograph is conditioned by what each photographer sees in the subject from his own unique point of view, a mental stance impossible for anyone else to duplicate.

Thus, it seems futile to indulge in either plain or pontifical commandments decreeing just how much dark mass will balance how much light mass, or whether five-to-eight is (or is not) a divine proportion. Composition cannot be reduced to a collection of such commandments. But neither is composition a mysterious something to be summoned only from an artistic soul, which one is born either with or without. Composition can be instinctive, but it can also be the result of planning and thought. Planning and thought, in turn, can be guided by general principles, if it is thoroughly understood that the principles have no value in and of themselves, but are of value only if they help the photographer form into an intelligible message code what it is he sees that he wants others to see.

A slavish adherence to such principles, general as they may be, can only lead to a tiresome repetition of pictorial clichés. But as guides to message coding they can help beginning photographers to greater satisfaction with their earliest efforts. Later they will find satisfaction and success coming from unconscious application of the principles filtered through their own personalities and purposes—or from conscious violation of the very same principles. Successful writers seldom give conscious attention to the rules of grammar, for long practice has built a reliable feeling for the elements of the language they are using, a feeling that makes it possible for them to violate the rules when necessary with nearly certain knowledge that their purpose will be served thereby. Such expertness generally comes only after a considerable period of experience-gathering, and the photographer may find that a few compositional precepts can speed his rise to that desired level. But it is to be hoped that every beginning photographer recognizes that lack of understanding and imagination can never be replaced by memorizing a set of precepts. No such set of rules, either general or specific, can perform by themselves.

# The Art of Seeing

Seeing takes practice. We live in a world in which light in an infinite variety of intensities is reflected from an infinite variety of forms. Out of the jumble of information our eyes collect from reflected light, our minds must organize unified and meaningful images. Clarity of these images is paramount if we are to function effectively and without incessantly endangering our lives.

Survival is not at stake in the case of a photograph, but communication is. Communication is a photograph's reason for being; it must have something to report: a fact, a story, a mood, an emotion, a relationship, some insight that unveils significance in our surroundings. We want the viewer of our photographs to see and to understand, to be affected by what we saw in reality, and we want this to happen directly and usually without ambiguity.

Study and analysis of visual forms can help the photographer learn to see; then he can, through his photographs, help others see more and better.

We are already aware that the art of seeing involves not just the eyes, but the brain as well, for the brain is needed to organize what the eyes report. The camera has an eye—the lens—but it does not have a brain. Forms the eye and brain see clearly in the three-dimensional space about us may be confusing and ambiguous when transferred, however accurately, to the two-dimensional surface of a photograph.

To avoid ambiguity, there must be planning. Successful planning requires effective seeing in two ways:

1. The photographer must learn to look for order.

By order we mean an arrangement of elements within the image that makes sense for the given subject matter, that seems logical, that conveys meaning, that gives balance to the composition, and perhaps a sense of rhythm. Order is essential for conciseness and clarity and thus must be one of the first objectives in composition, and one of the first things the photographer's eye searches for. Order comes from planning, and the more effort the photographer puts into planning his pictures the easier the planning becomes. The press photographer, of course, will not sacrifice a spot news picture of a riot while he pauses to genuflect before the altar of compositional planning, but even press photographers have time to plan the majority of their pictures. Besides, with practice, planning takes surprisingly little time. (See Figure 34.)

The photographer begins to compose for order when he first perceives a visual relationship, when he realizes *this* relates to *that*. He begins to join separate items to make one, or to look for ways to separate two items that might merge confusingly into one in the photograph. Or, he sees a number of visual elements as a sequence or group, perhaps because he has noted a similarity between things that once seemed dissimilar, perhaps because he has discovered some coherence in apparent confusion or some new idea in the commonplace.

2. The photographer must learn how things look—to his film.

This means that he must pay attention to the basic visual qualities in things, such qualities as form, texture, detail, and mood, and special attention to that most fundamental of all qualities, the one without which the others would not exist, the lighting.

Light, obviously, makes objects visible, but more than that light defines the nature and quality of objects and the atmosphere around them. We cannot accurately assess the meanings we see in objects without considering the source and the nature of the illumination that makes them visible in the first place. It is light that creates the symbols of the photographic vocabulary: space, shapes, lines, textures, patterns, colors, blacks, whites, grays, sharp images, blurred images. (We'll consider light in greater detail in Chapter 9.)

# Three Basic Visual Symbols

The possible list of symbols that light creates for us is so long as to be confusing. Let's, quite arbitrarily, reduce the list to three:

1. Space.
2. Line.
3. Tone.

Using these three pictorial elements and the interrelationships between them in the image, the photographer can select, simplify, and organize a picture that is self-contained (omits nothing that is essential), but leaves room for the play of the viewer's imagination, and gives an illusion of the third dimension.

Sometimes the photographer can physically arrange his subject into a pose that best suits his purpose. At other times he will have no such control, or he may prefer not to interfere. Nevertheless, he still has some control over the three elements or visual symbols that greatly influence the composition of every picture: space, line, and tone. He has such control because with the tools and techniques of photography he can control how these symbols are rendered in the image and because these symbols are at least partially, and often largely, illusions in the image anyway, not reality. Yet they are all real as elements of composition.

## Space

In a photograph space has two important aspects:

1. The flat space marked off by the picture frame itself, *the format*.
2. The illusion of a third dimension, *the perspective*.

The borders of a picture are always the first dominating and controlling elements of the composition the photographer must consider. Everything contained within the borders exists in relationship to those borders; each line is a horizontal, vertical or diagonal line because of its relationship

to the borders; each mass appears to occupy space in relationship to the borders. The borders are always there; you cannot eliminate them. So you must come to terms with them. This means using the borders, if at all possible, to strengthen the image. Learn to see the subject as the film sees it, with borders around it.

The picture frame establishes the two-dimensional spatial field of the picture, and the optical elements within the picture seem to advance or recede from that frame and thus establish the second aspect of space: the illusion of a third dimension. The photograph becomes a world of its own that seems to extend beyond the flat surface of the paper on which it is printed. This third dimension is only an illusion, but a powerful one, and there are definite compositional devices that contribute to this illusion.

## Perspective

All devices used to create the illusion of depth or the third dimension can be lumped under one word—perspective; this is the term for the depiction of three-dimensional space on a flat plane. In visual images, including photographs, the illusion of a third dimension is created in five ways, more than one of which is usually involved in any given picture and often all five will be involved. The five perspective devices are:

1. Linear perspective.
2. Aerial perspective.
3. Contrasts in image sharpness.
4. Vertical location.
5. Overlapping figures.

**Figure 35. Linear perspective. Rapid convergence of the overhead lines establishes a strong feeling of the third dimension. Note how the image of the human figure establishes scale.**

**Figure 36. Aerial perspective.**

*Linear perspective* occurs in the actual world. A familiar example involves the converging lines of a straight stretch of highway and the diminishing size of the telephone poles running parallel with the highway. Converging lines continue to approach each other as the distance increases until finally they meet at the vanishing point on the horizon. So, if lines we know to be parallel appear to converge in a photograph, then we reason that the lines are receding into the distance, and thus we are persuaded to see depth in the picture. (See Figure 35.) The same applies for diminishing size.

*Aerial perspective* is based on changes in tone values as distance increases. This, too, is evident in nature because haze, dust, or smoke in the atmosphere tend to make distant objects appear lighter and less distinct than close ones. Photos of landscapes, particularly those that include distant

mountains, often recreate this difference in tonal values between a relatively dark foreground and a light and hazy background. The impression for the viewer of the photo is much the same as the impression for the viewer of the actual scene: both are seen as having depth—the third dimension. (See Figure 36.)

In other photographic images this effect of aerial perspective may appear when the image includes a natural frame. Some of the foreground elements (the trunk and branch of a tree perhaps) establish a frame for the elements in the background. The framing elements generally tend to be darker in tone than the background images. The result is a combination of effects. Aerial perspective plus the influence of the framing create an illusion of the third dimension and at the same time emphasize the background images because the viewer's eye is naturally guided to these by the combined effect of the lighter tones in the background and by the natural frame.

*Contrasts in image sharpness* is also an effect we can observe when we look at real scenes and objects. The human eye can focus on only one plane at a time, and objects in front and behind the place focused on will appear to be in various degrees of unsharpness. The lens of the camera can record depth in the same manner by contrasts in sharpness. (See Figure 37.)

**Figure 37. Contrast in image sharpness.**

It is also possible with the camera lens to produce images in which all or nearly all objects recorded by the lens will appear sharp and clearly defined. In this case there is virtually no contrast in sharpness, and if an illusion of a third dimension is wanted it must be achieved by one or both of the other devices: linear or aerial perspective. The effect of linear perspective is strikingly enhanced by sharpness extending to the farthest background. An unsharp background is generally better with aerial perspective because it seems more real if a hazy background is also somewhat blurred. (See Figure 36.)

*Vertical location* is related to linear perspective. As an object moves higher on the vertical plane of the picture's surface, it will also appear to recede into the distance. (See Figure 38.) Normally it will also diminish in size.

*Overlapping figures* are planes and masses that are partly covered by other elements. These partly covered figures appear to recede behind the picture plane, and the effect is frequently reinforced by differences in tones and sharpness as well as by differences in size. (See figure 38.)

**Figure 38. Vertical location and overlapping figures.**

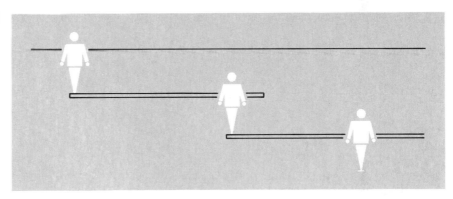

## Space and Scale

Creating the depth illusion through perspective is generally not a difficult problem in photography; in fact, it is often quite difficult to take a picture that does not contain that illusion, at least to some degree. But another problem involving space is not always so easily solved. This is the problem of defining the scope of the space depicted within the picture's borders and the size of objects within the picture. This can be a problem in a large, empty hall if there are no familiar objects within the picture to scale the space enclosed by the hall. Or, to give another example, an impressive, massive mountain in scenery shots may turn up in the print as a disappointing, minor hill.

The solution in both cases is to supply scale within the picture's composition, that is, a familiar element, perhaps the image of a person. Other objects can also serve: trees, automobiles, houses, animals, a chair, a fence.

Figure 39. Scale. Contrast between the adult hand and the baby gives an idea of size.

Images of such objects in the foreground, often to one side or the other where they serve an additional function in framing a center of interest in the background, establish a scale for the viewer's judgment of the depth or third dimension. At other times, a familiar image of relatively familiar size placed within the depth of the picture (not in the foreground) defines the total space as large or the mountain in the background as massive. For close-ups, scale can be supplied by smaller objects; the human hand often provides an effective scale. (See Figure 39.)

Horizons will also affect the rendition of space within a photograph. Extremely low or extremely high horizon lines create strong illusions of picture depth and space. A high horizon line puts the emphasis on depth in the land, while a low horizon will put emphasis on depth or broad expanse of the sky. Horizon lines should not, ordinarily, split the picture space into two equal parts because the picture then tends to become static and uninteresting. Eliminating the horizon from a scenic view tends to emphasize the abstract pattern.

The choice of shooting distance is an important one in composition not only because of the perspective involved but because choice of shooting distance has a major effect on emphasis within the picture frame. As more is included within the frame as the shooting distance increases, emphasis

generally falls to large masses rather than details. Moving closer to the subject will, of course, reverse this effect. Choice of shooting distance depends upon subject and purpose, but the most frequent admonition beginning photographers are likely to hear from their honest critics is this simple one: "Move closer to the subject." Uncounted and uncountable are the times when photographs have depicted more than the photographer saw. This happens because the photographer becomes so preoccupied with the object of his central interest that he fails to notice the useless expanse of foreground or the cluttered background.

Also, photos taken from a close viewpoint gain in emphasis and impact; they can report expressions and details that enhance meaning. (See Figure 40.) Make certain you are seeing all that the viewfinder includes and use the frame of the viewfinder to cut away the parts of the scene that only distract. Move in. Seeing is more intense from the close viewpoint.

The photographer must constantly be searching for the best viewpoint. A step to right or left may eliminate an unpleasant fragment of background,

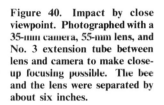

Figure 40. Impact by close viewpoint. Photographed with a 35-mm camera, 55-mm lens, and No. 3 extension tube between lens and camera to make close-up focusing possible. The bee and the lens were separated by about six inches.

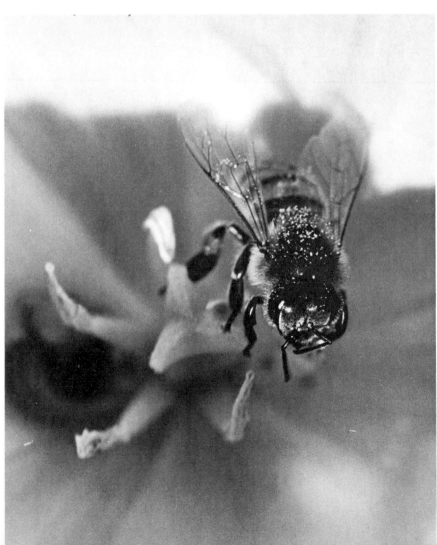

Figure 41. Background problem. At left, the tree seems to be growing from the head of the statue. A move of just one short step to the photographer's right produced the view in the second photo.

such as a tree branch seemingly growing out of Aunt Maud's ear (Figure 41); or a slight bending of the knees may bring perspective lines into position to put emphasis on the main point of interest. The three basic viewpoints in terms of distance from the subject are the close-up, the medium shot, and the long shot. All are useful and all three may be called for with a single subject, only the view through the viewfinder can be the final guide in any particular situation.

Photographers must remember that size, either the mass of individual objects or the extent of space, is not an absolute in pictures; size is always relative. Length, width, shape, and volume each gain their scale through a dynamic interrelationship with all the remaining elements of the image including the borders of the picture. (See Figure 42.)

## Line

Two kinds of lines exist in most images: the actual and the implied. Actual lines are really seen. They are the edges of buildings, fence wires and rails, stair railings, separations between sidewalk and grass, the edges of a path or road, separations between light and shadow. (See Figure 43.)

Real lines define space and forms and separate one form from other forms on our retinas or on photographic film. Actual lines are particularly significant in establishing linear perspective since actual converging lines carry a viewer's eye back into the depth of the picture. (See Figure 35.)

**Figure 42. Scale through inter-relationships. We judge space and size by comparison of various objects in the image.**

Implied lines are only suggested, not real, but they can be controlling factors in a visual composition

They are lines suggested by the motion or position of subjects or the shape of objects. Here are some examples of implied lines:

*Lines of extension.* An extended arm and finger establishes a real line and, at the same time, an extension of that real line beyond the end of the finger—an implied line. (See Figure 44.)

*Lines of movement.* Our experience with real objects often tells us that things we see imaged in a still photograph were actually moving at the time the photo was taken. So we "see" an implied or psychological line along the direction of movement. (See Figure 45.)

*Lines of repetition.* Another kind of implied line—a sort of dotted line in this case—occurs in a repetition of images as in a row of trees. Even the word "Row" indicates we see such things not as separate objects but as a line of objects. (See Figures 34 and 36.)

*Lines of gaze.* Still another kind of implied line occurs along the direction in which people or animals are looking. (See Figure 46.)

Both kinds of lines are important in composition because:

1. They direct the movement of the viewer's eye through the photograph and, in a well composed photo, keep the eye within the borders of the picture.

**Figure 43. (left) Actual lines define space and form.**

**Figure 44. Implied line.**

2. They establish visual emphasis if they guide the eye of the viewer to the center of interest.
3. They indicate movement or action. Diagonal lines in the format are especially indicative of movement. Horizontal lines tend to be static, restful, inactive. Vertical lines often seem alive, vigorous.
4. They indicate stress, strain, or a conflict of opposing forces.
5. They indicate stability or instability. (See following section on Stability.)

But actual or implied lines are not always desirable; they may distract from the center of interest. Strong lines in a background building may be disturbing rather than a contributing element. The photographer must be constantly aware of lines, attempting to use them to knit his composition. He may fail to see them in the viewfinder; the camera lens will not, and in the image the lines take a prominence much more controlling than in the actual scene because the image is boxed in with borders and because image lines take on greater prominence as they parallel or intersect the borders.

Figure 45. Line of movement.

## Tone

The third factor of significance in composition is tone (sometimes called value). A tone is defined in black-and-white photography as a section or *a step* of the gray scale. Thus a tone can be black or white or any one of the gray tones between black and white. We often think of tones as falling into three broad classifications:

1. The dark tones—the blacks and near blacks, which are the shadows and other dark areas of the image.
2. The middle tones—the grays, ranging from dark to light gray.
3. The light tones—the whites and near whites, which include the highlights of the image.

In considering tone we must first of all recognize that any tone is important only as it is related to, or contrasted with, other tones around it. A middle gray may appear as either dark or light in the print depending upon the tones next to it. If the surrounding area is predominantly black, a middle gray appears light; if the surrounding area is primarily white

or nearly so, middle gray appears dark, tending toward black. In addition, white or nearly white areas look all the whiter if surrounding tones tend toward black, and these white areas also appear larger than dark ones of equal size and shape.

Good photographs often contain an extended gray scale—a great number of varying gray tones between black and white—and the tones are well distributed through the picture. (See Figure 31.) However, photography is also capable of strong graphic statements in which the contrast between dark and light tones is predominant. (See Figure 19.) Or, photos may

**Figure 46. Line of gaze.**

**Figure 47. Mood established by a predominant tone.**

be composed predominantly of the middle tones, establishing a quite different atmosphere and mood. (See Figure 47.)

Tones are important in composition because:

1. *Tones evoke emotional responses.* Tones play a particular role in establishing the mood of a photograph. We usually associate light tones, whites and light grays, with sunlight, gaiety, youth, and a sense of well-being. We tend to associate dark tones, shadows and blackness, with night,

death, the unknown, and perhaps a feeling of dread. Pronounced gray areas in a photo may convey a feeling of mystery and of isolation, aloneness.

Closely related middle tones usually are gentle, soothing, peaceful; the mystery they imply seldom seems threatening, while the mystery implied by blackness often seems so. The contrast between tones can also affect the emotional response of the viewer, since light against dark has a generally strong quality often connoting excitement or drama. (See Figure 48.)

However, the emotional response evoked by tones will depend to a great extent on context; other aspects of the photograph, particularly the subject matter, will control the emotional response of the viewer. It is only that tones can be used deliberately to reinforce a mood or emotional response.

2. *Tones define form.* The contrast between tones establishes the form or shape of objects depicted, making round things seem round, angular things seem angular. It is from the difference in tones in the photo that we know where one object ends and another begins. Forms within a photograph can be ambiguous and even annoying if tonal separations fail

**Figure 48. Dramatic effect through contrast of light and dark tones.**

to establish the forms involved, as in a photograph in which a person's dark hair is indistinguishable from a dark background.

3. *Tones aid emphasis.*   Strong contrast in tones can attract initial attention to the photograph and can also direct attention to a particular part of a photograph. White on black will not only give sharper definition of form but will also give greater emphasis than a light gray on a dark gray, for example. The greater the contrast in tones, the sharper the definition and the greater the emphasis.

Tones are highly important parts of a composition, and the photographer must learn to previsualize the finished print as he looks through the viewfinder, translating color, light, and shade into tones of the gray scale. He must learn to recognize large areas that will reproduce as empty spaces in the print, such as a large, empty expanse of snow or sky. These are often empty of detail and empty of interest, contributing only weakness to the composition.

# Center of Interest

Because the best composed picture is one in which elements are readily perceived as a simple, organized whole, the photographer must develop the ability of selecting viewpoints that will achieve this simplicity, subduing the distracting elements that nearly always exist. Good photographs clarify, emphasize, and dramatize the essence of the subject.

With few exceptions the best photographs are simple, straightforward expositions of a single principal subject. One pictured person or object, or group of persons or objects, dominates; other elements are subordinate. Thus the picture gains through this combination of dominance and subordination. Such pictures have only one story to tell and one major center of interest. Too much crammed within the borders of a picture or two or more areas of equal interest often result in a scattering of interest and a loss of unity.

The first step for the photographer is finding the center of interest, that part of the image to which he wants the eye of the viewer to move automatically. Then he studies the image in the viewfinder for ways in which to eliminate or subdue the extraneous and irrelevant and for ways in which the remaining elements can be made to contribute emphasis to the center of interest. He attempts to simplify by moving in close, by searching for camera angles that will provide a neutral background and provide guiding lines leading to the center of interest. He attempts to arrange his exposure ($f$/number and shutter settings) or lighting (if possible) so that contrasts in tones will emphasize the center of interest. (See Figure 49.)

He uses focusing and aperture-setting to sharpen essential points and subdue the nonessential. Contrasts between sharp and unsharp images can help provide emphasis. The contrast between the sharply reproduced features of a face, for example, and an unsharp background will concentrate

Figure 49. Center of interest emphasized by contrast in tones.

attention where the photographer wants it to be, on the face, the only clearly defined part of the picture.

If maneuvering with the viewfinder or camera controls before the shutter is snapped does not give the simplicity we are looking for, we then can crop the image or use other manipulations in making the print.

This suggestion that each photograph should have only one major center of interest is as firm a rule as there is in photographic composition. Two other rules, often stated, are these: Never place the center of interest in the exact center of the physical, two-dimensional space of the picture, but at the same time keep the center of interest away from the margins. The arguments usually are that central placement is apt to be dull and static, while edge placement destroys emphasis, leaving the composition uncomfortably out of balance. In many cases these arguments are valid, but for a significant number of picture subjects they are just as obviously not valid. It seems that the secondary elements, which create the visual environment for the center of interest, have greater importance than arbitrary rules. You will find many successful and pleasing photographs in which the center of interest has been placed at or very near the picture's center. Less often, strong centers of interest appear near picture borders. Careful study of the total composition will reveal why the photographer selected a particular arrangement and how he managed to do it without being dull, without creating confusion rather than unity.

For positioning the center of interest, many beginners have found the *rule of the thirds* useful, although it must, like other so-called rules, be accepted with the understanding that there are many exceptions. This rule divides the picture area into thirds, vertically and horizontally. Compositional strength may come from placing the center of interest at or near one of the four points where the imaginary division lines cross. (See Figure 50.) But any photographer who always applies the rule of the thirds to his compositions will find monotony an inevitable characteristic of his work. This rule, like all others, should not be applied with arbitrary disregard for elements of the composition other than the center of interest.

Figure 50. The rule of thirds. Center of interest placed approximately two thirds up and two thirds from the left. Have other photographs reproduced in this book taken advantage of this rule?

# Psychological Factors

There are three largely psychological factors that seem to play significant roles in visual communication. An understanding of them can help us organize our photographs for more effective communication.

## Proximity

The primary and simplest of these psychological factors is proximity. A familiar example of proximity in the sense in which we are using it here is provided by the page of type you are now reading. Proximity of the letters builds relationships you recognize as words, which in turn form sentences. In the same way, two lines close together in a photograph may

become the two parts of a combined unit; that is, we see the two as belonging together, just as *i* placed next to *t* results in something quite different than either one alone: *it*. Most elements, whether lines, masses, or shapes, may be seen in a photograph as a unit if they are close together in the visual field. (See Figure 51.)

## Rhythm

In addition, similarity or equality among various elements tends to tie those elements into recognizable relationships: similar or equal size, shape, direction, value, and texture. Often this results in a rhythm or pattern within the visual field to strengthen simplicity and emphasis. Rhythm can appear in the alternating or orderly repetition of shapes, lengths, angles, curves, directions, or intervals. In rhythm or pattern there is the risk of monotony that detracts. Often the most effective rhythm is the interrupted one, which implies movement or change. Or two patterns may oppose each other and thus build tension and interest, that is, if the emphasis implied by the opposition contributes to the meaning of the picture. (See Figure 52.)

## Stability

As the elements are brought into relationships through proximity and similarity, stability becomes involved. This is, in part, a need for balance, not a precise and static form of balance that gives the imagination of the viewer no excuse for activity, but a dynamic arrangement that gives satisfaction without monotony. A perfectly symmetrical arrangement, with elements of equal size, shape, and tone at either side of the picture at equal distances from the physical center, gives balance but ordinarily without interest. There is no tension, no excitement, and no implication of movement and change, only a static, unchanging relationship. Yet complete lack of balance, with all form and movement in one half of the picture while the other half lacks visual interest, may be equally disturbing and ineffective. (See Figure 53.)

The mind imagines forces implied by the image masses and lines of direction as imparting pressures this way or that, and these pressures seem to demand equality. The most familiar natural force is gravity. Heavy, dark masses in the photograph tend to be pulled down, with the result that a photograph containing predominantly light tones near the bottom margin and dark masses at the top is disturbing and uncomfortable to look at; just the reverse is what we normally expect, and if this abnormal arrangement is not a deliberate contribution to the photographer's purpose it becomes a distraction. Failure to pay attention to lateral balance in the picture can result in an equal distraction, but large or heavy elements near the physical center of the picture can be balanced by much smaller or lighter elements farther from the center on the opposite side. Balance, of course, is not precisely measured, but is judged by the photographer's eye.

**Figure 51. Aspects of proximity and closure in stability.**

Figure 52. Rhythm. If the rhythm is broken, it may add interest.

Figure 53. Aspects of balance in stability.

Stability also involves the tendency for image lines, both actual and implied, to drive toward some sort of closed, compact shape. When we look at a picture we immediately begin a search for the simplest and most stable forms. Areas within a picture that appear to be closed and separated from their surroundings please and attract the eye because these are areas that are stable. If actual lines in the image do not form these stable areas, psychological factors come into play to fill out the broken lines, thus completing the figure. (See Figure 51.) Each such stable unit either combines with or clashes with others within the picture borders. The normal objective, of course, is a combination that makes a unified whole of the entire picture as two or more musical notes, each by itself an individual tone, merge into a pleasing whole to serve a common purpose.

## Post-exposure Controls

All the foregoing compositional factors are considered, if at all possible, before the shutter is snapped. Later some controls are still available, but they are limited and can rarely produce a satisfying composition from an image that was poorly organized in the camera viewfinder. Development and printing procedures can alter tonal values, and faults in framing the subject in the viewfinder can be corrected, at least to some extent, by cropping when making an enlargement of the negative.

If unwanted elements are to be cropped out of the picture during printing, those elements must be placed at or near the margin of the viewfinder. A plan for cropping often originates before the film is exposed. Cropping, too, can change the dimensions of the visual field presented by the print and thus put greater emphasis on certain subject lines or other elements. It is wise for the beginner to look for cropping possibilities when he projects the negative image onto the enlarging easel, but experience will demonstrate that the most effective use of cropping is generally based on a plan made at the time the subject was composed in the viewfinder of the camera. There are rather severe limitations on how much a photograph can be reworked after the photographer has left the scene where the picture was taken.

## Schooling the Eye

For most persons, schooling the eye and mind to see in terms of photographic images takes practice. The capacity to see—really see—is the underlying essential, and this capacity must be learned or, perhaps more precisely, relearned, since most persons seem to have this capacity as children but gradually lose it as life forces upon them the necessity of seeing all objects in practical terms of functional use.

A beginning photographer generally shoots haphazardly. Because he points his camera at subjects that interest him, some of the time the resulting

pictures are interesting. But if he perseveres he soon must learn that shooting without thought of purpose produces a high percentage of dull and unprofitable pictures. He must aim not at the subject alone, but at expression through interpretation of the subject. Good photographs stem from the mind of the photographer, a mind enriched by observation, experience, and knowledge, a mind that must be cultivated and made to work if it is to produce.

It is generally true that the photographer draws his mental sustenance from the electricity of the scene around him. His pictures should be the result of his imagination, guided by observation, experience, and knowledge, speculating upon the significance of the scene. Margaret Bourke-White, for more than thirty years a leading American photojournalist, told a story in her autobiography illustrating this point. She asked permission to take pictures of Gandhi at his spinning wheel. To do that, Gandhi's secretary told her, she must first learn to spin. The photographer must first comprehend and then he can interpret and explain.

Looking for the reasons a picture is effective or looking for ways to convert a subject into an effective picture can be a struggle at first, but it becomes progressively easier. There may be periods of uncertainty when the photographer is not sure just what it is he is looking for, perhaps because what he was looking for yesterday may not be what he is looking for today. The search should be not for composition as an end in itself, but for meaningful content first and then for the composition that will enhance that meaning.

Here are four steps that should help you expand your ability to see. First of all, look around you for style and composition in nature and in all sorts of man-made objects. For example, look at the shape and texture of pine and aspen groves against the backdrop of Rocky Mountain peaks, or look at the play of light and shadow among the maples of the Appalachians, or look at the lines of the cloverleaf at a freeway interchange. Study architecture, the old as well as the new, the complexities of Victorian structures, and the starched and rhythmic simplicity of the modern city's cliff dwellings. And look at people, individually and in crowds, at work and at play. Have the photographic possibilities, that is, the visual interpretations of any subject, been exhausted? Consider some possibilities: people and their emotions, Halloween, Main Street, reflections, traffic, weather, the teen-age world, a city park, a boy being himself, light and shadow, parades. The list is endless. Sharpen your "seeing" proficiency on them all, at all times, whether you have a camera in hand or not.

Second, study the pictures of others, both photographers and painters. Criticize the pictures. Why do you like or dislike them? Put your answers in writing. The study of pictures produced by others helps develop the ability to see potentially effective visual images in the world around you. Study means concentrated attention, an evaluating contemplation, not a mere casual glance.

Third, think about what your photographs have to say to other people, not just to yourself. The forms and lines, shadows, and textures of the photographs must have something more than a personal significance. Will the pictures say something to a viewer who is not personally involved with the subject? What may have great personal meaning for you and perhaps members of your family may be largely meaningless to others. The good photograph is a shared experience that enriches the viewer as well as the photographer. The viewers of your photos, generally, are not concerned about subtle problems in technique; only other photographers comprehend these and even they may not care.

The fourth step is to develop a special interest in some particular subject matter. Become a person with a mission, a desire to tell, through photographs, about something that interests you. This does not mean a lifetime commitment. You may exhaust your interest in a particular subject in a week, a month, or a year. If so, go on to something else. But at least you have gained new insights about a particular subject.

## Summary

Composition in photography is combining and arranging visual elements to achieve a purpose—communication.

Three major visual elements or symbols we use in composing images are space, line, and tone. Space has two important aspects: (1) the two-dimensional space marked off by the picture's borders and (2) the illusion of a third dimension or perspective. There are two kinds of line in images—actual and implied—which establish direction of eye movement through the picture area, help define space and form, and give a sense of depth and movement. Tones range from black through middle (gray) tones, to white (in black-and-white photography) and evoke emotions, help define form, and aid emphasis.

Three psychological factors are proximity, rhythm, and stability.

All of these elements and factors can be employed to provide unity in the photograph, emphasize the major center of interest, and delineate meaning.

# 7

# The Nature
of Light

Light provides most of our information about the world around us. It is that information carried by light that we record in photographs. To understand the nature of photography we must understand a few fundamentals about the nature of light.

In the seventeenth century, Sir Isaac Newton concluded that light was a stream of corpuscles or some similar tiny particles fired out in all directions by a light source. These particles, coming directly from their source or after being reflected off nonluminous objects, created vision, he theorized, by their impact on the eye. Other scientists, notably a Dutch physicist named Christian Huygens, found the corpuscle theory inadequate to explain some of the activities of light. Huygens demonstrated that reflection and refraction of light could be explained much more simply if light were considered a wave motion. Accumulating evidence gradually established support for the wave theory. Then, in the late nineteenth century, a Scottish physicist, James Clerk Maxwell, succeeded in showing that a combination of electric and magnetic fields would move through space in a wave motion. Light waves, he said, are of a similar nature. Subsequent experiments by others confirmed this.

This proposal, that light was electromagnetic radiation of very short wavelength, was of great importance in developing modern theories on the nature of light. Radiation is the emission of energy, in the form of electromagnetic fields, by substances or bodies of matter and its transfer through space. The sun is the most familiar source of radiant energy, and sunlight is its best-known form.

The electromagnetic wave theory worked perfectly in explaining a great many of the manifestations of light energy, but still did not satisfy in a number of other situations. Then, at the turn of the twentieth century, Max Planck, professor of physics at Berlin University, advanced the quantum theory. Energy, he said, is not emitted in a continuous stream, as the electromagnetic theory suggested, but in tiny spurts or packets. He gave the name of *quanta* (in the singular, *quantum*) to these minute energy doses. This was the quantum theory, which became, with modification, the basis for quantum mechanics and a revolution in a major area of physics.

Four years after Planck announced his quantum theory, Albert Einstein adapted the theory to light, postulating that light, as a form of radiant energy, must also be given off in tiny packets. Einstein called these light packets *photons*. (A photon is, in Planck's terms, a quantum of light energy.) Einstein's theory brought us back to Newton's light corpuscles, but we were not really back where we started because we now had two theories, which were not antithetical but complementary. Light has a dual nature: It is small packets of energy called photons that travel in waves.

The aim here will be to further describe light as it manifests itself to our senses and to our intellect, so that we can explain the nature of light as it is involved in photography. But it is not possible to describe light entirely in laymen's terms; we must inevitably use some scientific terms.

## Light As Waves

The more common phenomena of light can be explained by the wave theory, the same theory that applies to all electromagnetic radiation. All of these waves of radiant energy have been organized into a broad series according to wavelength, ranging from the shortest to the longest. This is called the *spectrum*. The spectrum extends from the very short wavelengths of cosmic rays to the long wavelengths used in radio broadcasting. In between are the gamma rays, X rays, ultraviolet rays, visible light, infrared, and microwaves. We live in a sea of radiation, but our eyes are sensitive to only a small part of it—that part we call the visual spectrum, which we have, for purposes of this discussion, defined simply as light. Ultraviolet and infrared waves are abundantly present in the atmosphere around us, but we do not see them. All photographic films are sensitive to ultraviolet, however, and film can be made that is sensitive to infrared.

The concept of radiant energy traveling through space as packets of energy that act as though they were moving in waves is not one that is easy to picture. But we are familiar with transmission by radio waves in broadcasting, and so the basic idea does not seem completely strange. We take for granted that some sort of disturbance or condition exists that moves in waves from a central broadcasting station and this disturbance is received by and interpreted by radio sets situated many different directions and distances from the transmitting station. We may think of the sun, or any light source, as being a central station sending out waves of some sort that our eyes receive and interpret. Apparently there is no difference in kind between the two sets of waves, although there is a difference in wave dimensions. We don't know what sort of medium it is that carries these waves. What is it that moves to and fro or up and down to form the waves? Once scientists believed there was some sort of invisible, odorless substance named ether that occupied all space, even the vacuum of outer space and the space between the molecules of gas and the molecules of solids. The existence of any such hypothetical substance is now generally doubted. We do know, however, that radiant energy, including light, acts as though it travels in waves, and this is enough for our purposes.

A part of the wave theory is the hypothesis that light, as electromagnetic radiation, moves in transverse waves; that is, the wave vibration is transverse vibration. This means the vibration is at right angles to the direction in which the wave is moving. Water waves provide a familiar example of transverse vibration. If we drop a rock into a quiet pool, waves move away from the point at which the rock entered the water and in all directions. If we were to observe a single molecule of water, we would find

that it moves up and down but does not move in the direction that the wave moves. Water waves, however, are not exactly the same as light waves. Waves in water rise and fall, vibrate, in other words, in only one direction. Light vibrates up and down, but from side to side as well—in fact, vibrates in all directions perpendicular to the wave's direction of travel.

## Wavelength

A major characteristic of light and of all electromagnetic radiation is wavelength—the distance from one wave crest to the next. Near one end of the full spectrum are the gamma rays, emitted by radioactive substances, with wavelengths measuring less than one billionth of an inch. At the other end are the radio waves, undulations measuring as much as six miles in length.

The radiations we see as light fall in the very short wavelength region, measuring such tiny fractions of an inch or even of a millimeter that it is more convenient to express their length in terms of smaller units. Light wavelengths usually are measured either in nanometers or angstrom units. There are one million nanometers (usually abbreviated nm) to a millimeter and ten million angstroms (usually abbreviated A) to a millimeter. Light, or the visible region of the electromagnetic spectrum, ranges from a wavelength of 400 nm to 700 nm. (See Figure 54.)

Normal sunlight or white light behaves as though it consisted of a mixture of all the visible wavelengths. We see colors, which means we are seeing colored light, when only a portion of the visible wavelengths are present. If only some of the shortest wavelengths are present (from 450 to 480 nm) we see blue; the longest wavelengths (from 600 to 700 nm) we interpret as red.

**Figure 54. The radiation spectrum. Light is a small part of the total spectrum.**

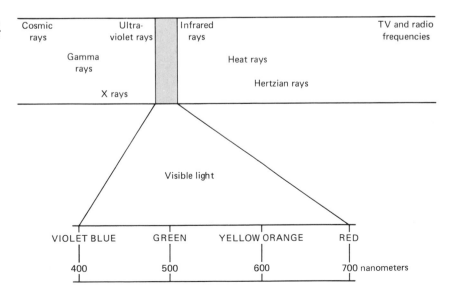

## Frequency

Another measurement of wave motion is called frequency: the number of complete waves that would pass a given point in a second of time.

The velocity of light and of all electromagnetic radiation is the product of wavelength multiplied by frequency. The formula is:

$$\text{Speed of light} = \text{wavelength} \times \text{frequency.}$$

With this formula we learn that the speed of light in a vacuum (space) is 186,000 miles a second, or 980,000,000 miles per hour, or 300,000,000 meters a second. But in scientific notation, 300,000,000 meters a second would be written as $3 \times 10^8$ meters a second. Translated that means 3 $\times$ 10 eight times, or 3 followed by eight zeros.

The speed of light will be nearly the same in air, but in denser transparent mediums, such as glass, its speed is significantly less.

## Rays

We also speak of rays—gamma rays or light rays—as though these various forms of radiant energy proceeded along some sort of thin, straight-line beam. Actually this is another one of those concepts in physics that makes no claim to describe a phenomenon as it actually is, but it is useful in helping us describe the way light behaves. A ray is a narrow beam of light, so narrow that it is essentially zero in cross-sectional area.

When light spreads out, like water waves in the pool where we dropped the rock, it travels through the air with the same velocity in all directions. If at any given instant we suspended the movement of the light, if that were possible, we would find the wave had reached the same distance from the source in whatever direction we took a measurement. This distance could be represented as a sphere surrounding the point light source. The sphere would be the wave front and any straight line drawn from the source to the wave front would be perpendicular to that wave front. This line would represent the direction in which the wave was traveling at that point and would be, theoretically, a light ray. This ray will continue to travel in a straight line as long as the light is traveling in a uniform medium, such as air under ordinary conditions. With the concept of light rays we can provide a coherent description of much of light's behavior.

Optics is a branch of science concerned with the behavior of light. Up to this point we have been primarily concerned with physical optics, the composition of light. Now we turn to the geometry of the paths that light rays follow: geometrical optics. Here, in summary, are four of the basic characteristics of light's behavior that we use in seeing and in producing photographic images:

## Laws of Geometrical Optics

1. Light rays travel in straight lines.
2. Light rays can be reflected.

3. Light rays can be absorbed, and this absorption can be selective; that is, part (selected wavelengths) of the light can be absorbed and not other parts. (This is the basis of many light filters, which we will discuss in Chapter 11.)
4. Light rays can be bent or refracted.

## Rectilinear Propagation

Light propagates (travels) rectilinearly (in straight lines). This is one of the most fundamental principles or laws of geometrical optics. Light travels in straight lines as long as it is moving through a homogeneous medium such as air. The straight beam of a flashlight and the straight lines of shadows cast by buildings indicate this.

Another version of this law of rectilinear propagation is that light always takes the path that requires the least amount of time, and as everyone knows the shortest distance between two points is a straight line. Light rays travel in all unobstructed directions in an infinite number of straight lines from any single point of origin or from any point of reflection.

## Reflection

Among the most familiar of light phenomena is reflection. Any object that is nonluminous, that does not of itself emit light, can be seen only by reflected light that has originated at a luminous source. Most of the light we see is reflected light, which varies with the surface that reflects it, so after we have learned these variations we can mentally organize our visual world. Photographs can record and recreate these patterns of reflected light so that we see much the same thing in the photographs as we observed in reality.

There are only two major classes of reflected light. They are:

1. Diffuse reflection.
2. Specular reflection.

Light is reflected from the white surface of the page of this book, and it would also be reflected from a mirror you might hold alongside this page. But the results you get from the two reflecting surfaces are radically different because of a difference in the smoothness of the two surfaces. The reflection from the paper is diffuse because the tiny irregularities in the surface are large compared with the wavelength of the light. This results in the light being reflected somewhat as a handful of table tennis balls would bounce off a rock pile. It would be impossible to predict just which direction each ball would take, but we know they would go in a lot of different directions. Diffuse reflection of light happens off surfaces that are, for the light, as rough as a rock pile but the light bounces off not just in "a lot of different directions" but in all directions. You can see the object from any position. (See Figure 55.)

As you look at the mirror, however, you see an image of yourself or

**Figure 55. Diffuse reflection.**

of other objects in the room, and as you move your head, what you see in the mirror changes. This is specular reflection. A ray of light bounced off the surface of a mirror, or any similar smooth or highly polished surface, goes in only one direction because the irregularities in the surface are very small.

Light reflected from a highly polished surface, such as a mirror, obeys a simple but important law: The reflected ray of light bounces off at an angle from the surface equal to the angle at which it hit the surface; the angle of reflection equals the angle of incidence. (See Figure 56.) Also, the reflected ray always lies in the same plane as the incident ray; a horizontal incident ray results in a horizontal reflected ray.

Many surfaces, of course, lie between the polished and the rough, with the result that light reflected from them is both specular and diffuse.

## Absorption

We are familiar with the fact that some objects reflect most of the light while others reflect very little. If light is not reflected then it must be absorbed by the surface it hit. The printed words on this page stand

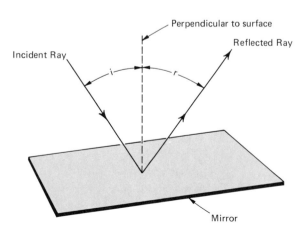

**Figure 56. Specular reflection. The angle of incidence (i) is equal to the angle of reflection (r).**

out because of the contrast between the black ink, which absorbs most of the light, and the white page, which reflects most of the light.

Also we know that many objects or surfaces absorb light selectively; that is, they absorb some of the light's wavelengths but not others. A red apple appears red because it absorbs a large part of the light's short and medium wavelengths, particularly blue and green, but the apple reflects most of the long wavelengths, the reds. As another example, a piece of glass may look blue because it absorbs most of the long wavelengths but not the short wavelengths, which are the ones that cause us to see what we call blue. The difference in the molecular structure of substances causes a difference in light absorption.

## Refraction

When light strikes the surface of opaque objects, some is absorbed and some is reflected. But what happens when light strikes a transparent object such as glass? A little light is absorbed and a somewhat larger amount is reflected, but some travels on through the transparent medium to emerge on the other side. These penetrating rays, however, have quite probably undergone a change; they have been bent. We say the light has been refracted. Refraction occurs because the velocity of light varies inversely with the density of the medium it is passing through. The denser the medium, the slower light's speed. Its speed is greatest in a vacuum, only slightly less in air, but significantly less in glass or water. Light's speed is reduced about one third in glass, although this varies with different kinds of glass, and about one fourth in water.

When a light beam traveling through air strikes the surface of a sheet of glass it is always slowed down. Its path of travel may or may not be changed, depending on the angle at which it strikes the surface of the glass. If it hits perpendicularly to the surface, it slows down in the denser medium of the glass but does not change direction. But if the beam strikes at an oblique angle, one side of the beam hits first and will be slowed down while the other side continues, briefly, at full speed. Inevitably the beam is turned or bent and its direction of travel has been changed. As the beam emerges at an oblique angle from the opposite surface of the glass, it bends again, in the reverse of the first change but for the same reason. One part of the beam emerges first and resumes air speed while the other side is still dawdling along at about 124,000 miles a second because it is still in the glass. The refracted beam, after it has emerged from a piece of glass with parallel sides, is offset but parallel to the original beam. It is much like the case of the caterpillar tractor whose driver wants to turn. He brakes the tracks on the left side and the tractor immediately swerves to that side; when he brakes the right side, the tractor swerves right. (See Figure 57.)

The degree of refraction depends upon two factors: the angle at which the light strikes the glass and the difference in the speed of light in the

Figure 57. Refraction of light.

two mediums. The greater the angle, the greater the change in direction; the greater the difference in speed, the greater the change.

The speed of light in a vacuum (186,000 miles a second) divided by the speed of light in a transparent substance such as glass (in some glass about 124,000 miles a second) gives the refractive index of the substance. Using the two figures just given, we find that the refractive index of the glass would be 1.5 (124,000 divided into 186,000). The refractive index of water is about 1.3. The refractive index is never less than 1 and rarely more than 2. The higher the index number, the greater the light-bending power of the substance.

There is a special case of refraction that is of interest and of value. This occurs when a ray of light tries to move from a dense medium to one that is less dense, as from glass to air. As the angle of incidence increases a point is finally reached where the ray cannot escape from the glass but will be turned back into the glass. This phenomenon is called *total internal reflection.* (Figure 58.) This principle is used in constructing

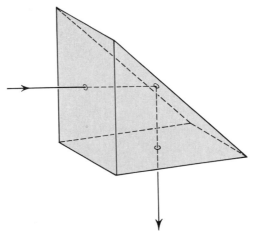

Figure 58. Total internal reflection.

the prisms for the viewing and focusing systems of single-lens reflex cameras.

Is refraction an exception, then, to the law of rectilinear propagation? Not really. You will recall that light as a traveler stubbornly refuses to waste time; it always takes the quickest route. Ordinarily that means a straight line, but when light moves from one transparent medium into another, as from air into glass, a straight line is often not the shortest time route. Light spends as little time as possible in the dense medium where its speed has been curtailed. It is like the automobile driver who has been forced off the freeway onto a detour; he gets back on the freeway as soon as he can. The path of travel may not be straight, but it saves time.

## Dispersion

If we send a beam of light through a transparent medium that does not have parallel sides, a somewhat different situation prevails. This difference can be observed by using a prism, a triangular piece of glass. The light, if it strikes the first surface at some angle other than the perpendicular, is refracted as before and travels on, at somewhat reduced speed, through the prism. When the light reaches the opposite surface, which is inclined at an angle to the first, it is refracted again, not in the opposite direction to the first change but in the same direction. The two refractions do not cancel each other and return the light beam to an offset but parallel path; their effect is instead cumulative so that the change in direction is accentuated. The brakes of the caterpillar have been applied on the same side twice in succession.

But the prism causes something else to happen, too. A transparent material, such as glass, has a different index of refraction for each wavelength of light. The index increases as the wavelength decreases. Thus, a glass prism has a higher index for blue light than for red. For example,

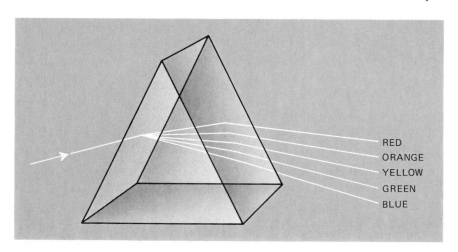

RED
ORANGE
YELLOW
GREEN
BLUE

**Figure 59. Prismatic refraction and dispersion. (Also see the color illustration of prismatic refraction in Chapter 18.)**

the variation of index of refraction with wavelength for a dense flint glass (silicate flint glass) follows approximately this pattern:

Blue (500 nm): 1.63—yellow (600 nm): 1.62—red (700 nm): 1.61.

This means that blue light is bent more in going through a prism than is red. The other colors (wavelengths) fall in between. So when we send a beam of white light, containing all the visible wavelengths, through a prism it emerges spread out into a fan-shaped beam that, if intercepted by a screen or white sheet of paper, will show the major colors of the visible spectrum—a rainbow. This phenomenon is called dispersion. (See Figure 59.)

## Diffraction

Light can be deflected from its straight-line course by still another circumstance. This involves a basic characteristic in the behavior pattern of waves. If a wave front hits an opening in a barrier, the small part of the wave that slips through the opening acts as if the hole were a starting

Advancing wave front

Figure 60. Diffraction. A new wave front spreads out beyond an opening in a barrier.

point of a new circular wave front. (See Figure 60.) This new wave spreads out beyond the opening, especially if the size of the opening is near the wave's length (distance between the crests). What this means with light is that it seems to spread into what should be shadow area after the wave of light has passed through a small opening. This effect is called diffraction.

Thus, the smaller the aperture used in camera lens or enlarger lens the greater the diffraction effect, or the greater the tendency for the light to spread out beyond the aperture and thus reduce the sharpness of the image. Actually, even the smallest aperture setting on most lenses is still so much larger than the wavelengths of light that the diffraction effect

is minor. Nevertheless, it is well to remember that stopping the diaphragm down as far as it will go cannot increase the sharpness of an image that is already sharply focused; it will, in fact, decrease that sharpness because of diffraction, although the effect may not be enough to be noticed. (Sharpness in depth is increased, of course, as aperture size decreases; see depth of field in Chapter 8.)

## Polarization

A final phenomenon we should note involves a change in the vibration of light waves. Ordinary light waves vibrate in all directions that are at right angles to the direction of travel. If all of this vibration is eliminated except vibration in one direction or in one plane, that light ray will still be there, only weaker. Such a light ray is said to be polarized.

Certain crystals will polarize light because they are transparent to electromagnetic radiation only if the waves are vibrating in one specific plane. We might think of an ordinary light ray as a wooden circular rod, the circular shape indicating the multidirectional vibration. The polarizing crystal is a sort of double-bladed saw. As the light strikes the crystal it is sliced (actually absorbed) down both sides. The only part that passes through is a thin slice through the center, so it comes out of our crystal saw no longer as a rod but as a flat board. The board will be standing on edge, lying flat, or in any other position in between, depending upon the orientation of the crystal that did the sawing. This is a description of plane-polarized light. Light can also be circularly polarized; in this case the plane of polarization is not flat, but twisted like a spiral staircase.

As you look about you some of the light reflected to your eyes from various objects is actually polarized. But the eye is unable to distinguish any difference between ordinary light and polarized light. The reflected light from most surfaces is polarized to some degree, from some surfaces more than from others. This is why so-called polaroid glasses keep the glare of a bright day from blinding us. The glasses admit all light vibrating in one direction and that includes all normal (unpolarized) light because it is vibrating in all directions, one of which must match the orientation of the screen in the glasses. But some reflected and polarized light will not match the screen of the glasses and cannot pass through. A polarizing filter over the camera lens can also eliminate unwanted reflections. (See Chapter 11 on filters.)

# 8

# The Lens

Because light travels in straight lines we can take pictures with the pinhole camera, which can be any light-tight box—even a shoe box will do—with a tiny, sharp-edged pinhole in one end. With a film in the box so that its light-sensitive surface faces the pinhole, we place the box on a firm support so that the pinhole is aimed at a stationary subject. Then if the pinhole is uncovered for a minute or perhaps several minutes and if the box and subject remain completely stationary we will have a picture.

This works because some of the light rays reflected from the subject enter the pinhole and, traveling in straight lines, continue on to the film. Theoretically, one ray of light is admitted through the pinhole from each point on the subject. These admitted rays cross one another as they pass through the pinhole and this means the right side of the subject will appear on the left of the film and the top of the subject on the bottom of the film.

The negative image that appears after the film is developed will not be very sharp, but it will be quite recognizable as an image of the scene at which the pinhole was aimed. It will not be sharp because the pinhole actually lets in more than one ray of light from each point on the subject and these rays do not strike at exactly the same point on the film. But if you decrease the size of the pinhole to reduce this image blur you will need to increase the already long exposure time. In addition, a very tiny pinhole tends to scatter the light rays by diffraction and thus image blur actually increases.

The pinhole camera is fun to play with, but it is not very practical. We need a brighter image (so exposure times can be reduced to fractions of a second) and a sharper image. Both can be accomplished by refracting the light so that we can collect great bundles of light rays from a single point and redirect them all to meet again at another point—on the film. This is precisely the function of the camera lens.

A simple glass lens, circular in form and with its two surfaces curved, acts like a great many prisms arranged in a circle with their bases toward the center. All rays of light passing through the lens are bent except those that pass directly through the center; the rays striking the lens at points farthest from the center are bent the most.

Thus we can make the light-admitting hole in the front of the camera quite large and then fit into this hole a lens that will collect a great number of light rays from any one point on the subject and by refraction cause those rays to converge at a meeting place on the film. The results: short exposures and sharp images. (See Figure 61.)

The images will be sharp if the film is positioned at the exact point where those converging light rays meet. If the film is in front of that

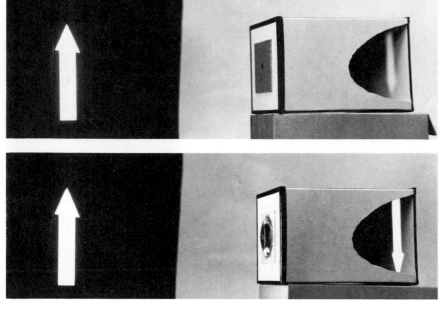

Figure 61. Pinhole compared with lens. Top photo shows the image of an illuminated arrow as photographed through a pinhole. To admit sufficient light to make the image visible at the back of the camera, the pinhole was made larger than normal; consequently, the image is considerably diffused. For the bottom photo, the pinhole was replaced by a lens; the image is brighter and sharper.

point, or behind it, the image will be blurred. So the lens solves the two problems with the pinhole, but adds a problem of its own—that is, the problem of focus. As we shorten the distance between lens and subject, we must extend the distance between lens and film; and as lens-subject distance increases, lens-film distance must decrease. This, of course, is the adjustment we make when we focus a camera: we move the lens out away from the film for close subjects and move it in toward the film for distant subjects.

We need, now, to master a few fundamental concepts if we are to get the full potential out of the photographic medium. These concepts are: relative aperture, focal length, angle of view, perspective, and depth of field.

## Aperture and Focal Length

Two characteristics of the photographic lens are fundamental. They are relative aperture and focal length. Both were discussed in Chapter 2 in connection with exposure. Aperture is important because it is fundamental in establishing exposure. We refer to "relative" aperture because we always consider the size of the aperture *relative* to the focal length. The size of the aperture is indicated by its $f$/number, which is simply a comparison of the diameter of the opening with the focal length, or a ratio. Thus, $f$/4 means the aperture diameter is ¼ of the focal length. Besides being

a controlling factor in exposure, the aperture is also a controlling factor in depth of field, as we will see a bit further on.

Focal length is important because it determines the size of the image projected on the film for any subject at a given distance from the camera and it also determines the area of the scene in front of the camera that will actually be projected on the film.

Focal length we defined in Chapter 2 as the distance from the lens to the image (or film) plane when the lens is focused at infinity. Focal length is not measured from either the front or rear surface of the lens or from the physical center of the lens. It is measured from what is called the rear nodal point. This is the point from which emerging light rays seem to come as they converge toward focus. It is a point usually within the lens and often close to a point midway between the front and back surfaces. But with some lenses, as we shall see in the discussion of the telephoto and retrofocus lenses, this rear nodal point may be either in front of or behind the actual lens. However, it is extremely unlikely that you will ever need to measure the focal length of a lens, for this characteristic is almost always marked on the front of the lens mount in millimeters, centimeters, or inches.

Of course, with all but fixed-focus cameras, we move the lens back and forth to focus on distant or near subjects. This lens movement is slight for subjects 50 to 100 feet away, but noticeably greater for closer subjects. Accuracy is especially important in focusing for subjects at close range, and as another practical point, we might note here that with a lens of long focal length there are greater shifts in lens-to-film distance in focusing than with a lens of short focal length.

However, the fact that lens-to-film distance changes as lens-to-subject distance changes does not alter focal length. It remains the same for any given lens because it is based on entering light rays that are parallel, and these occur only when the subject is at infinity or so distant (200 feet or more) that for practical purposes the rays may be regarded as entering the lens on parallel paths.

Although a given lens does not alter its focal length (with the exception of the so-called "zoom" lenses), a single camera can be used with a variety of lenses, each with a different focal length. Photographic lenses are frequently identified in relative terms as short, normal, or long in focal length. But these designations are not absolute. A lens may be short focal length for a large negative but the same lens would be long focal length for a small negative.

A lens is generally regarded as normal if its focal length is approximately equal to the diagonal of the negative. Judging by the focal length of the lenses that are standard equipment on 35-mm cameras marketed today, a normal or standard lens for the 35-mm negative, with a diagonal of a little less than 45 mm, may be any focal length from 40 to 58 mm. Both 45- and 50-mm lengths are common on 35-mm cameras with range

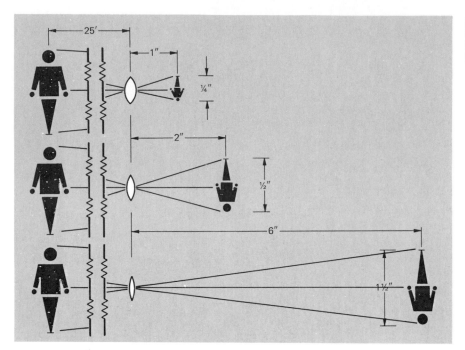

finders, whereas 50-, 55-, and 58-mm are common on single-lens reflex 35s. So what is normal with these cameras is hardly susceptible to precise definition; and the same is true, to a somewhat lesser extent, of all other types of cameras.

A lens with a focal length significantly shorter than the negative diagonal is regarded as a short focal-length lens. *Example:* Any lens with a focal length of 35 mm or less is a short focal length with a 35-mm camera.

A lens with a focal length significantly longer than the negative diagonal is regarded as a long focal-length lens. *Example:* Any lens with a focal length of 90 mm or more is a long focal length with a 35-mm camera.

The longer the focal length, the greater the size of the image on the film when the subject remains at a given distance. In fact, image size and focal length are directly proportional; doubling the focal length results in doubling the size of the image. (See Figure 62.)

Because image size increases with focal length, it logically follows that the longer the focal length of the lens the less of the subject the lens will include on the negative, that is, if the negative size remains constant. Or, to state it another way, the greater the lens focal length, the narrower its angle of view (sometimes called "field of view").

With a single camera, then, but with three or more lenses for that camera, the photographer has considerable flexibility in his photographic point of

# Angle of View

view. The short focal-length, or *wide-angle*, lens encompasses more of the scene at any given distance. Angle of view expands as focal length decreases: the 21-mm lens on the 35-mm camera will give an angle of view of approximately 90°, double the angle of view of the 50-mm lens. Thus the wide-angle lens can be used relatively close to a central subject without eliminating the surrounding environment from the negative. Such a lens also seems to exaggerate the spatial separation between objects within its field of view, but as we shall see in the following section on perspective, this is a function of the distance between camera and subject.

The long focal-length lens, on the other hand, limits the field of view and, in effect, reaches out to bring objects closer so that the photographer can take the picture from a relatively distant position but keep the image large on the negative and limit the recorded image to just that part of the scene where his interest lies.

Thus we see why newspaper and magazine photographers and other professional photographers prefer a camera with interchangeable lenses. The photojournalist with, for example, a single 35-mm camera and several lenses can function effectively in close quarters with a wide-angle lens. On the other hand, the same camera with a long lens serves him well at sports events. Although he may have to remain in a specific assigned position, he can still pull in large-sized images with 100- to 1,000-mm lenses. The long lens provides closeup views without the necessity of the camera being close.

Interchangeable lenses are most commonly used with the 35-mm camera. In 1940 only a half-dozen 35-mm cameras featured interchangeable lenses, ranging in focal length from 38 to 500 mm. Twenty-five years later more than fifty such cameras offered interchangeable lenses, ranging from 18 to 2,000 mm. Abnormal focal lengths are especially suited to these small cameras. With a large camera that uses film measuring four by five inches, the normal lens is approximately six inches in focal length. To double that focal length would require a twelve-inch lens. With the 35-mm camera (normal lens 45 to 55 mm), a four-inch lens doubles the normal focal length. The image magnification factor is the same in both cases (twice normal), but it is achieved with the 35-mm camera at much less expense and bulk.

Wide-angle lenses for the 35-mm camera are generally considered to begin with the 35-mm lens. However, may photojournalists make the 35-mm their standard lens, keeping it on the camera most of the time. Other frequently used short focal-length lenses with the 35-mm camera are the 28-mm lens (76° angle of view) and the 21-mm lens (90°). Long focal-length lenses for the 35-mm camera include 90-mm (27°), 105-mm (23°), 135-mm (18°), 200-mm (12°), 400-mm (6°).

Short and long lenses pose special problems for the photographer. The field of view of the short focal-length lens includes so much that we may get more of the scene on the negative than we really want unless we move

in close with the camera. The long lens magnifies image blur caused by camera movement; the camera must be firmly held at the moment of exposure and the shutter speed should be 1/200 of a second or faster, or the camera should be anchored on a tripod.

A 35-mm single-lens reflex camera is the best tool for learning to use lenses of varying focal lengths because you can actually see what the lens is putting in your picture frame. With a single-lens reflex camera you can study the picture in the finder, watch what is happening in the corners, observe the lines in your subject, particularly those straight lines near the edge of the frame, and observe the relative sizes of images within the picture's depth. You can study the subject through the lens, moving closer, then still closer, moving to one side or the other, moving up or down. Often the right view suddenly appears in the view finder, a startlingly new view of the subject that will add both impact and meaning to the picture. Searching for this viewpoint is half the fun of photography with interchangeable lenses.

## Perspective

Photographs reproduce three dimensions in only two dimensions. But if two lines we know to be parallel converge in a picture, we "read" the third dimension, depth or increasing distance. Similarly, if two objects we know to be the same size are not the same size in a picture we assume the smaller of the two is farther away. Both are examples of linear perspective discussed in Chapter 6. The appearance of this kind of perspective in a photograph is controlled solely by the distance between the camera and the objects pictured.

An object 20 feet from the camera will appear in the photograph to be one-half the size of an identical object only 10 feet from the camera. The perspective effect is relatively great. If the distances are 30 to 20 feet, however, the more distant object will be three-fourths the size of the closer one. The perspective effect is noticeably less, although the two objects are the same distance apart in the two situations. (See Figure 63.)

This effect remains constant even if we change lenses but keep the distance between camera and objects unchanged. If we double or halve the focal length we double or halve the size of both images. Since both increase or decrease the same amount in size, then the difference between their sizes is unchanged; therefore, perspective, which depends on that difference, remains unchanged.

*Thus, a basic concept: pictures taken with short, normal, and long lenses from the same camera position exhibit precisely the same perspective in that portion of the scene that is common to all the different angles of view.*

The shorter the focal length the wider the angle of view, and thus the more will be included of any given scene. That means, of course, that different focal lengths will produce noticeably different pictures from the same camera position, because of the different angles of view, with the

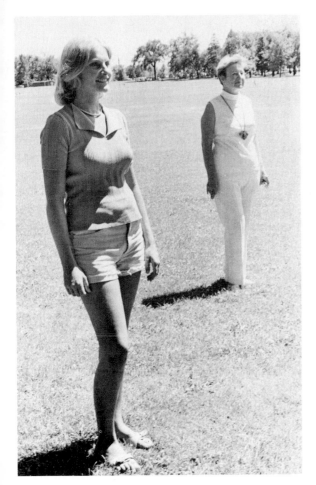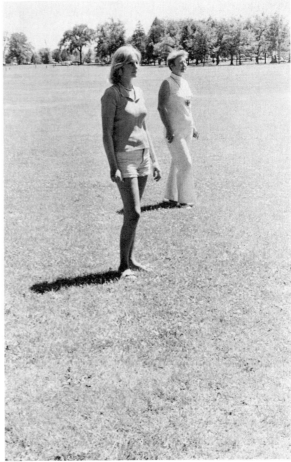

Figure 63. Perspective. The two women are the same height. The difference in the image sizes and the apparent distance between them is perspective and that difference is achieved through distance between camera and subjects. The same camera and lens were used to take both photographs.

short focal length lens including a great deal more area. But in reality, we usually change camera position when we change focal length or we select a lens to fit the camera-subject distance. When we use a short focal length lens we usually move in close to the subject, because the wide angle of view makes it possible to include all the subject we are interested in from a close viewpoint. As a result the perspective in the photograph appears to be distorted. More distant objects decrease rapidly in image size because that short distance between camera and nearest object is quickly doubled or tripled by the distances to objects farther away. The long lens, on the other hand, is used when the nearest object to be pictured is many feet from the camera, and more distant objects then decrease slowly in image size.

The perspective recorded by a lens with other than the normal focal length is never actually distorted, but it appears strange because the view-

**Taken with a 24-mm lens.**                    **Taken with a 55-mm lens.**

point is strange. In the photograph taken with the short focal-length lens we see the perspective of an abnormally close viewpoint but we view the photograph itself from a normal distance. The distance between eye and photo is wrong; the perspective in the photo is correct.

In the photo taken with a long lens we see an image that seems to have been recorded from a close viewpoint, but it actually was taken from a distant viewpoint and the perspective of the picture must of necessity be that of a distant view. Enlarging a small section of a negative made with a normal or short lens will duplicate the view and perspective of the picture taken from the same position with a long lens. Such an experiment will clearly demonstrate to you that perspective is controlled solely by camera viewpoint, or the distance from the camera to the subject, and not by lens focal length.

This experiment will also demonstrate how we can use the long lens for a particular purpose: to pull subjects widely separated in the actual scene into closer relationship in the photographic image. Suppose we want to take a picture of a farm scene. We find picturesque shocks of grain in the foreground and the farmhouse in the background. We are using a 35-mm camera with a 50-mm lens. But when we stand at 10 feet from the grain shocks the image of the house is too small. The answer? Let's make two changes. We will move back with our camera to 20 feet from the grain shocks and change to a 100-mm lens. The image size of the grain shocks remains the same, because doubling the focal length of the lens has been exactly balanced by doubling the camera-to-subject distance. But what of the farmhouse? Its image is nearly doubled in size because the distance from the camera to the house has been increased only a fraction, whereas lens focal length has been doubled. If we can change both lens focal length and camera position we will have vastly increased control over the picture composition.

**Figure 64. Perspective control. Changing both camera position and lens focal length provides control of the relationships between the objects pictured. For these photographs, the camera-to-subject distance was increased with each change to a longer focal-length lens.**

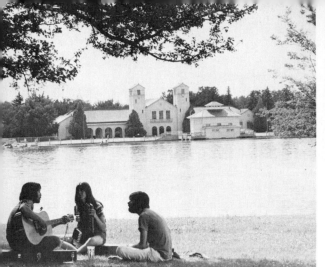

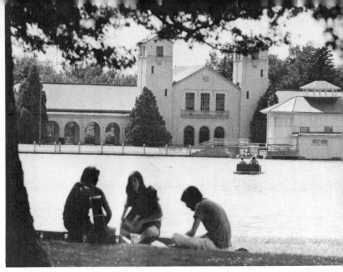

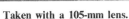

Taken with a 105-mm lens.                    Taken with a 200-mm lens.

# Depth of Field

Anyone who has examined photographs at all critically will have noticed that images of objects both near and far from the camera appear to be in focus in many pictures, although a lens can be focused on only one plane at a time. This optical phenomenon is called depth of field.

Depth of field is, in fact, a result of the limitations of the human eye and not the result of any optical magic produced by the photographic lens. When a lens is focused to give a sharp image of a particular object, other objects closer and farther away will not be equally sharp. But the decline in sharpness is gradual, so that the eye viewing the photograph does not detect any blur. This zone of apparent sharpness, the distance from the nearest object to the farthest object that both appear to be in focus, is depth of field.

A rule of thumb has practical value. The depth of field will normally be divided approximately one third in front of the point focused upon and two thirds behind it. This one third/two thirds rule is, however, only an approximation. As the lens is focused closer to the camera, the depth of field narrows and is more evenly divided, until finally it is equally divided on either side of the point of focus. This occurs when the lens is focused at a distance equal to twice the lens focal length, giving an image the same size as the actual object. At this point, too, depth of field is extremely shallow.

Obviously, depth of field depends, for one thing, upon our own critical standard. How much blur are we prepared to accept? However, there will be some objects that are actually out of focus in the picture that will look sharp to us no matter how critical we are. A lens reproduces an image of a point as a circle, called a *circle of confusion*. But the unaided eye cannot resolve extremely fine detail, so all circles smaller than 1/100 of an inch in diameter look like points, and it is these points that make up the sharp image.

*Depth of Field*  **123**

## Controlling Depth of Field

Enlarging, of course, also affects depth of field, because enlarging the image also enlarges the circles of confusion or the inherent, always present, blur in any image. If the negative image is to be enlarged, normal practice with most professional photographers and universal with 35-mm negatives, the circles of confusion in the negative must be about 1/500 of an inch in diameter or less, so that when they are enlarged they will not exceed 1/100 of an inch in the print.

The size of the circles of confusion (the sharpness or critical rendition of object points) in the negative image is controlled by the angle between light rays approaching the film—that is, the angle between rays originating at a given subject point. The smaller this angle, the smaller the circles of confusion—or the sharper the image. (See Figure 65.)

The angle of the light rays is controlled by two factors: the size of the lens aperture used for making the exposure and the distance between lens and object. As the diameter of the lens aperture is reduced, the angle between the converging light rays is reduced, thus increasing depth of field. Likewise, as distance between lens and subject increases, the angle between the light rays is reduced, and depth of field again increases—until the far limit of depth of field reaches infinity, beyond which, of course, it cannot go.

Lens focal length is sometimes listed as another factor controlling depth of field. But actually this is simply another way of saying that lens aperture

Far object

Point of focus

Near object

Small aperture

Film

Figure 65. Aperture and depth of field. As aperture is decreased in size, the cones of light are narrowed and circles of confusion at the film become smaller, resulting in greater depth of field.

controls depth of field. It is true that a lens with a focal length of two inches, set at $f/4$, gives greater depth of field than a lens with a focal length of four inches, also set a $f/4$. But the difference in the depths of field is accounted for by the actual, physically measurable diameter of the opening in the lens diaphragm. In the example of the two-inch lens, that opening measures half an inch (one quarter of two); with the four-inch lens the opening is twice that diameter, one full inch (one quarter of four). $F/4$ on the short focal-length lens gives the smallest base for the cone of light converging from the lens to the film, and thus the smallest angle between the converging rays.

However, we must remember the differences in the sizes of the images projected by the two lenses. If we are taking a portrait, for example, the size of the image of the subject's head will be twice as big in the negative taken with the four-inch lens as the image in the negative taken with the two-inch lens, assuming that lens-to-subject distance remains constant. If we move closer to the subject with the short focal-length lens so that we have images of equal size, then depth of field at any given $f$/stop will be the same with the two lenses. Or if in printing you enlarge one negative image to equal that of the other, depth of field in the prints will be the same.

The short focal-length lens offers an advantage in increased depth of field at any given $f$/stop if we are willing to accept the decreased image size. But if the image size is the same, the depth of field will be the same.

Most photographers seldom, if ever, find it necessary to determine the depth of field down to the final inch or even foot. But it is sometimes helpful to have an approximate idea of what the depth of field will be

**Figure 66. Controlling depth of field.** In photo at left, the lens was focused on the cannon. For center photo, the lens was focused on the background buildings. For photo at right, the lens was focused on a point about one third of the way from cannon to buildings and the diaphragm was set at smallest aperture.

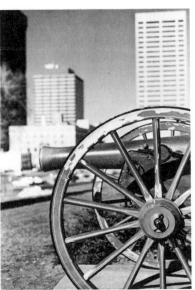

at any given *f*/stop on the lens in use. The depth-of-field scale that manufacturers often mount on lenses will give the approximate depth of field for any given *f*/stop after the lens has been focused.

This scale can also help you find and use the hyperfocal distance for any given *f*/stop. *Hyperfocal distance* is the distance from the camera to the nearest point in acceptable focus when the lens is focused at infinity. To learn what this distance will be for a given *f*/stop, set the lens for infinity and then look for the *f*/stop you plan to use on the depth-of-field scale. On the focusing scale opposite this *f*/stop marking on the depth of field scale will be the hyperfocal distance for that *f*/stop in feet and/or meters.

Now, if you refocus the lens at that hyperfocal distance the depth of field in your picture will extend from one half the hyperfocal distance to infinity. And this is the maximum depth of field possible with any given *f*/number and lens.

Simple lenses are classified according to the way in which they bend the rays of light entering them. Some refract light so that the rays leaving the lens are bent inward and toward one another and so eventually meet. These are *converging* or *positive lenses,* in that they converge a beam of parallel rays of light to a point of focus behind the lens. Such lenses are thicker at the center than at the edges. They have at least one convex surface, that is, a surface that curves outward, and often both sides are convex.

The only other general type of simple lens is one that bends rays outward and away from one another. These are *diverging* or *negative lenses,* and rays of light coming from them seem to have come from a point of focus in front of the lens. Such lenses are thicker at the edges than at the center and have at least one concave surface.

## Types of Lenses

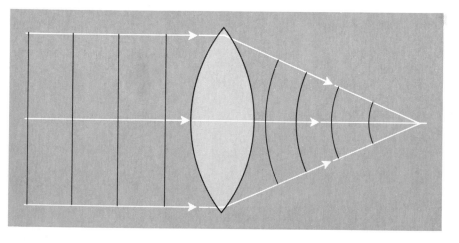

Figure 67. Converging or positive lens.

**Figure 68. Diverging or negative lens.**

Lenses may be made of a number of substances but are usually made of special kinds of glass. Optical glasses are composed essentially of a pure variety of sand, especially selected for freedom from iron. Mixed with this sand is any one or more of a wide variety of metallic oxides, selected to give the glass particular properties, such as a high refractive index and/or a low dispersal effect. Oxides of lanthanum, cerium, thorium, and lithium, as well as other elements, have been used to make the newest kinds of optical glass. Some of these elements are rare earth elements, so the new glasses have been called rare earth glasses.

## Aberrations

No lens is perfect in focusing light rays and simple lenses are a long way from being perfect because of inherent optical defects called aberrations. Some of the aberrations are as follows:

*Spherical aberration.* Because the lens surfaces are spherical, rays that move through the thinner outer portions of the lens do not come to a focus at the same point as rays that move through the thicker center of the lens.

*Coma.* Because of the shape of a simple lens, rays of light traveling

obliquely through it will produce pear-shaped blurs rather than sharp points at or near picture borders.

*Astigmatism.* Because of unequal refraction in a simple lens, vertical and horizontal lines cannot be sharply defined at the same focus.

*Chromatic aberration.* Because glass disperses light into its component wavelengths, the different wavelengths are not brought to a common focus by a simple lens.

*Curvature of field.* Because points on the subject at the side of the picture area are farther away from the lens than points directly ahead (along the lens axis), the simple lens tends to form the sharpest overall image on a curved plane, not on a flat surface.

*Distortion.* Because those parts of the image at the picture corners (off axis) are not in the same scale as the part at the center (on axis), lines in the image tend to curve outward (like a barrel) or inward (like a pincushion).

The manufacturers of the compound lenses used in photography have reduced the effects of these aberrations to the point where they rarely cause us any problems. They do this by combining a number of simple lenses, both positive and negative types, into a single compound lens, by using a variety of types of optical glass, by positioning the diaphragm aperture carefully between the lens elements, and sometimes by balancing one aberration against another. Thus we get remarkably sharp images despite the fact that the effects of the aberrations on the images cannot be eliminated entirely. The task of reducing the effect of the aberrations becomes progressively more difficult as the diameter of the lens is increased to let in more light. This is the principal reason high-speed lenses are relatively expensive.

Color correction is a correction for chromatic aberration, so a "color-corrected" lens is not, as sometimes assumed, a lens specifically intended for taking color pictures. A color-corrected lens brings all rays, regardless of wavelength, to focus at very nearly the same point, and this is as important for sharp images in black-and-white photography as in color.

## Compound Lenses

So the lens manufacturer selects a number of simple lenses (or elements, as they are called), combining four, six, or even as many as twelve into a compound lens. In arranging these elements to reduce the effects of aberrations, he cements some of the elements together with transparent cement; others he mounts separately with air space between them. (See Figure 69.) Lens design is based on complex mathematical calculations, which have been greatly speeded by computers. Lens designing has also been greatly aided and improved by development of the new kinds of optical glass. By selecting from among the approximately one hundred different kinds of glass available, the lens designer develops a combination of lens elements of various shapes to meet specific requirements.

Figure 69. Compound lens. The
arrangement of six elements,
some positive and some negative,
in a modern, high-speed lens.

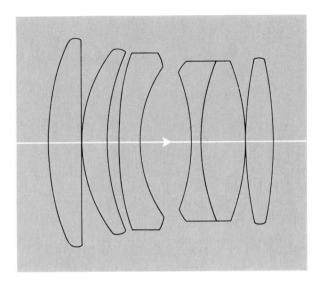

## Lens Flare

Adding elements reduces aberrations but also increases the reflection
of light back and forth between the surfaces of the lens elements. This
internal reflection is known as flare and is particularly noticeable for any
object that is much brighter than its surroundings, such as the sun or a
lamp. Flare increases with the number of cemented (glass-air) surfaces.
It can be eliminated by cementing two elements together, but this means
the concave curve of one element must exactly match the convex curve
of the next, and thus severely limiting the freedom of the lens designer.

The answer to this problem was *lens coating.* The surfaces of some
elements in a compound lens (not necessarily all surfaces) are coated with
a metallic fluoride, often magnesium fluoride. This is why the front surface
of your camera's lens may have a slight bluish or purplish tinge. The
coating layer is extremely thin, about equal to one quarter of the wavelength
of light. Eliminating reflection depends upon a phenomenon of physical
optics known as interference. The reflection from the top of the coating
and the reflection from the glass beneath the coating interfere with each
other, and in effect, cancel each other so there is no light reflected at all.

Coating offers another advantage besides reducing flare. Very little
light is lost by reflection in a coated lens, and the energy saved increases
the transmitted or image-forming light. A glass surface coated with a correct
layer or layers of fluorides may transmit up to 99 per cent of the incident
light. Thus a compound lens with eight glass-air surfaces, all coated, trans-
mits more than 90 per cent of the light, whereas a similar but uncoated
lens may transmit only 70 per cent. Lens designers are then free to use
more air-space separations between lens elements and thus achieve an
improved total lens design.

A refinement of lens coating has been multi-coating—several layers (four or more) of metallic fluorides on a single lens surface. Multi-coating, properly applied, can reduce reflections and increase transmission even further.

## Telephoto and Retrofocus Lenses

Photographers frequently refer to any lens with a longer than normal focal length, or one that gives some image magnification, as a telephoto lens. No great harm results from calling them this, although it is often incorrect. In the true telephoto lens the physical placement of the lens is closer to the film plane than the focal length indicates. For example, one 200-mm lens is only 138½ mm long, or just 3½ mm longer than a common 135-mm lens, which is a long focal-length lens for a 35-mm camera but not a true telephoto lens.

Image magnification is determined by lens-to-image distance as compared with lens-to-subject distance, or, in other words, by the ratio between those two distances. The size of the image grows as this ratio moves toward 1:1. If we move the camera closer to the subject, lens-to-subject distance is decreased and, in focusing the lens on the closer subject, lens-to-image distance will be increased. This increases magnification: the image is bigger. But if we cannot get closer to the subject we can accomplish magnification of the image by maintaining the same lens-to-subject distance and increasing lens-to-image distance. The long focal-length lens accomplishes this, simply by extending the distance between lens and film. This, for example, is the case with the 90-mm, 105-mm, and most 135-mm lenses for 35-mm cameras. Magnification here is a relative term. The image size is still much smaller than the object, but it is larger than that given by the normal camera lens.

The true telephoto lenses are of a special optical construction that gives image magnification without increasing the actual distance between lens and image. This is achieved with two groups of lenses; the front group is a converging or positive lens system, and the rear group is a diverging or negative unit. Each of these groups will include more than one element to give sharp images, relatively free of aberrations. Light rays are converged by the front unit, but the rear unit partially cancels this convergence. As a result the cone of light reaching the film appears to converge from a point somewhere out in front of the complete lens. In other words, the rear nodal point or optical center of the lens is not inside the lens at all but is somewhere out in front of it. (See Figure 70.)

Image magnification can also be achieved with mirrors that reflect the light forward and back within the lens tube. This "folding" of the light path in effect increases its distance of travel from lens to image and thus magnifies. This is the basic principle used in mirror telescopes for astronomy. But only a few mirror lenses have been made for hand-held

cameras, and once one of these lenses is attached to a small camera, a tripod becomes virtually essential. In fact, a tripod is advisable with all telephoto lenses wherever feasible because of the difficulty of holding camera and lens still enough to eliminate image blur caused by camera movement while the shutter is open. Also for this reason we recommend use of high shutter speeds whenever possible with long focal-length lenses.

The long focus or telephoto lenses are especially useful for:

1. Shooting informal portraits without shoving a lens in the subject's face.
2. Getting "close" to shy or dangerous subjects (wild animals).
3. Compressing space, a flattening of perspective, thus establishing a strong visual relationship between two or more objects.
4. Isolating details in a scene when one is forced to remain in a fixed shooting position.
5. Shooting candid photos, such as street scenes, without being observed or disturbing subjects.

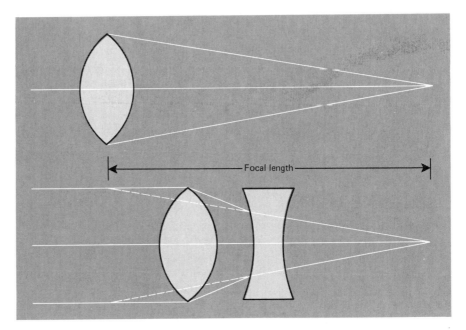

Figure 70. Long lens and telephoto lens compared. The focal lengths of the two lenses are identical, but because of the negative element, the telephoto lens (bottom) is shorter in actual physical length.

Just the reverse of the telephoto lens, in effect, is the retrofocus lens. It is farther away from the film plane than the focal length would indicate. This is achieved with an optical construction that is the reverse of the telephoto lens; the diverging or negative group of lens elements is the front unit and the converging or positive group is the rear unit. The optical center of the lens is somewhere in space behind the rear group. (See Figure 71.)

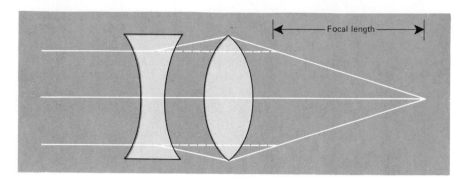

Figure 71. Retrofocus lens. In this lens, which is the reverse of the telephoto lens (note the order of the negative and positive elements), the focal length is less than the physical length.

The retrofocus design has been of value with the single-lens reflex camera because it gives additional space between lens and film without increasing the focal length. This permits the mirror to operate unimpeded by the lens.

## Zoom Lenses

Zoom (variable focal-length) lenses, which are relatively common on movie and television cameras, make it possible for the cinematographer to shift quickly from a distant and wide-angle view of the subject to a close-up shot without moving the camera or removing one lens and inserting another. All shots can be taken with a single lens. The zoom principle was not applied to still cameras in any significant way until about 1958. Since that time there has been a fairly rapid proliferation of zoom lenses for 35-mm still cameras of the single-lens reflex type.

A zoom lens provides a continuously variable focal length over a limited range; that is, it provides an infinite number of focal lengths between two extremes. The extremes may range from a moderately short focal length to a moderately long one, or from an approximately normal to a medium long one. Or both extremes may lie within the long focal-length region.

A zoom lens also keeps the $f$/number constant no matter what the focal length setting and maintains reasonably sharp focus throughout the zoom range. Accurate focus is generally most effectively maintained if the lens is first focused while it is set at its longest focal length. Even so, there will be some loss in image sharpness with zoom lenses and each photographer must judge for himself whether this is crucial to his work. The problem of maintaining focus poses the major difficulty in designing zoom lenses. Focal length can be changed quite simply by changing the distance between components or groups of simple lenses within the total complex lens. But such a change shifts the image plane, the plane at which the film must be positioned if the image is to be in focus. So the zoom-lens design usually provides a way to shift two groups of lens elements simultaneously. One group shifts to change the focal length and the second group shifts to keep the image in focus. (See Figure 72.)

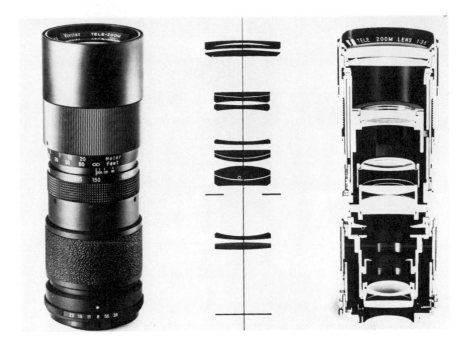

Figure 72. A zoom lens. This is an 85-mm to 205-mm, *f*/3.8 zoom lens. The two interior groups of elements are the ones that move back and forth to change the focal length and keep the image in focus.

# Auxiliary Lenses

Attachments are available that increase or decrease the focal length of the fixed lens in some cameras. Auxiliary telephoto attachments feature the normal telescopic construction with the front converging or positive group of lens elements and the rear diverging or negative group. The reverse is true of the wide-angle auxiliary, which has a diverging or negative group in front and a converging or positive group in the rear. These auxiliary lenses are simply placed in front of the camera's normal lens. Such attachments are useful within a limited range of focal-length shifts. However, it should be noted that there are other limitations in many of these auxiliary lenses. Vignetting (image fading at the negative corners) can occur with some of the telephoto attachments, and the wide-angle auxiliaries sometimes give out-of-focus images at the negative edges. With auxiliary attachments in place, exposures must often be made with apertures no greater than 5.6, and edge-to-edge sharpness for big enlargements requires settings of *f*/11 or *f*/16.

The tele-extender or teleconverter is another kind of supplementary lens. It fits between the camera body and the regular lens, and because the tele-extender is a negative component it increases the effective focal length of the lens. A 2 > tele-extender doubles the focal length of the lens it is attached to; a 3 > extender triples the focal length. They are made for use with 35-mm single-lens reflex cameras that provide for lens interchangeability. A regular 135-mm lens used with a 2 > converter acquires an effective focal length of 135 × 2 or 270 mm. If the regular

Figure 73. Photo taken with close-up attachment. The auxiliary lens added to the front of the regular lens made it possible to focus on a subject only five inches in front of the accessory lens.

lens has a maximum relative aperture of $f/5.6$, with the 2 > extender that maximum aperture becomes $f/11.2$ (5.6 × 2).

Such extenders work best with long-focal length lenses (135 mm or longer). They generally do not produce pictures equal in quality to those taken with a regular lens of equal focal length. But the better extenders work remarkably well, even so, and they can be considerably less expensive than a 400- or 500-mm telephoto lens.

Figure 74. Lens focal length effect on composition. Photo at left was taken with a 35-mm lens on a 35-mm camera. Photo at right with same camera but a 105-mm lens from the same camera position, creating a quite different interpretation of the scene.

Figure 75. One camera position; two views. The top photo was taken with a 105-mm lens (35-mm camera) and bottom photo with a 35-mm lens.

Photographic lenses should be treated with respect and care. Optical glass is softer than ordinary glass and thus more easily scratched or otherwise damaged.

Lenses should be kept clean but not with the same casualness most persons use in cleaning their eyeglasses. Dust on the surface of the lens should be blown off or brushed off with a soft camel's-hair brush. Fingerprints or other smears should be removed by breathing on the lens and then gently wiping the surface with lens-cleaning tissue.

So-called lens-cleaning fluids are not recommended except for occasional use. If used frequently the solvents in such fluids may etch the metal content of the optical glass, or the fluid may seep between the glass elements of the lens and dissolve the cement holding them together. Do not use the specially treated cleaning cloths or cleaning papers designed for use with eyeglasses. If any solvent (plain water or pure grain alcohol) is used to remove stubborn smears on the glass, use only very little. Moisten a wad of lens tissue with the fluid, gently swab away the smear, then immediately dry the lens with another clean tissue. Lenses should never be taken apart for cleaning or any other purpose except by a trained technician.

# Cleaning Lenses

# Questions for Review

1. Focal length of a lens is the distance from the lens to the image or film when the lens is focused at _____.  infinity
2. When a lens is focused on a subject at 10 feet, the focal length of the lens is _____.  unchanged
3. Size of the image is directly related to focal length. If focal length is doubled, image size will be _____.  doubled
4. A normal focal length is one that is approximately equal to the _____ of the negative.  diagonal
5. A short focal length lens is also often called a _____ lens.  wide-angle
6. Linear perspective in a photograph is controlled by _____.  distance
7. Two important factors controlling depth of field are the distance focused upon and _____.  aperture size
8. Greatest depth of field can be achieved with a _____ (small or large) aperture.  small
9. Two principal types of simple lenses are:
   (1) The converging or _____ lens.  positive
   (2) The diverging or _____ lens.  negative
10. Compound lenses for photography are made by combining a number of simple lenses into one mount. This is necessary to correct for _____.  aberrations
11. Coating is done to reduce _____.  flare or reflections

# 9

# Light As
# a Language

Yousuf Karsh, internationally famous for his revealing photographic portraits, said, "Light is my language." So it is (or should be) for all photographers. But light is so pervasive and so variable that describing all of its dimensions as a language—a medium of communication—is impossible. We can only categorize some aspects of light's effects as a guide to using light in photography.

We must begin with some definitions of terms:

*Contrast.* A visual difference between adjacent parts, and in photography, specifically, the difference in visual brightness between one part and another of either subject or image.

*Subject Contrast.* The range of visual brightnesses in the subject, a result of different light intensities reflected from subject parts, and this is the result of two variables:

*Lighting Ratio.* The difference in the illumination that strikes various parts of the subject.

*Reflectance Ratio.* The difference in the capacity of various surfaces to reflect light.

*Image Contrast.* The difference in visual brightness between parts of the image, created by the range of tones from black to white recorded on the film or paper in silver deposits; this is, then, the density scale of the negative or the reflectance scale of the print.

## Light and
## Shade

Most people who are not photographers or artists in another visual medium seldom read the language of light, not because they are incapable of doing so but because they are not interested in doing so. We usually look to identify people and things around us. To do this we select "useful" information from visual impressions, check that information against the brain's stored knowledge, and we decide: "There goes John, he must be on the way to work." We are, at best, only marginally conscious of the shoes John is wearing, of the way the light shines off his blond hair, of many other aspects of the scene. This is because much of the time we see not literally but intellectually; we see not the literal reality but our own edited version of reality. This has been called selective perception: we select that which we want to see.

Sometimes a particularly dramatic performance of light, such as a sunset, will force itself upon our consciousness and we exclaim at the discovery. Photographers should be adept at making these discoveries, not all of them necessarily dramatic. We must read the light not just to determine exposures but also to determine meanings. Our clues to do this come from the way light is radiated by its sources and modulated (absorbed, reflected, and transmitted) by objects that it strikes.

The language of light has only three basic parts:

*Light sources.* The sun, a candle flame, a lamp are examples of light sources. Sometimes reflections have the effect of being light sources, such as the moon at night or a glaring reflection off an auto's windshield.

*Light as color.* The molecular (chemical) structure of many objects is such that it absorbs some of light's wavelengths and reflects others. That part of the visible spectrum the object reflects we see as color. From the color we make judgments about the nature of the object. In fact, we do not say the reflected light is red; we say the apple is red.

*Light as brightness.* We may also say that the apple is round. We see that it has not only modulated the light to produce the sensation of color, but it has also modulated the light to create variations in brightness. Some areas of the object are brightly lighted while others are in shadow. This variation in brightness we attribute to form.

Vision depends upon visual differences, which can be differences in color or differences in brightness. Without brightness differences, we could still distinguish many things by color, but other things would be hidden from us or only vaguely and often erroneously perceived, and our visual world would tend to have a flat, two-dimensional quality. A sphere, a cube, or any form gives its own characteristic modulation of light; each basic form has a basic light and shade pattern. Black and white photography is the ultimate example of rendering form and space in terms of light and shade: *chiaroscuro.*

We assume that a language has a basic syntax, that is standard, generally accepted arrangements of the elements (words) of the language. These arrangements establish different word relationships with which a skillful user of the language can convey different meanings. Major elements that can be arranged to form the syntax of light as a language include:

1. The lighting and reflectance ratios (differences between light and shade).
2. The direction from which the light rays come (from behind the object, from the front, or from the side).
3. The angle at which the light rays strike (from above, from the same level as the object, or from below).

These are factors that establish the length, the shape, and the brightness value (gray, dark gray, black) of shadows, and shadows give us vital information about forms and space.

Light and shade outdoors can vary from the high contrast situation in which shadows are nearly black, to extreme low contrast when shadows are nonexistent or nearly so. Highest ratio would be sunlight alone with no illumination in the shadows—the situation on the moon where there is no atmosphere to provide skylight. (See Figure 76.) On earth such a situation does not exist, except where we might create it indoors with artificial lighting. Outdoors there is always some light, reflected from the sky, falling into the shadows.

Figure 76. One-source lighting. This photograph of the first man on the moon, July 20, 1969, shows the effect of intense, one-source lighting, except for reflection off the space ship that filled in the shadowed side of the astronaut's image. Other shadows tend to be deep black, intense, without detail, because there is no sky (atmosphere) on the moon to reflect light into the shadows. The "sky" is black in pictures taken on the moon because there really is no sky, our name for what we see in the form of reflected light from the atmosphere around the earth.

On earth we are likely to find lighting ratios falling within these broad classifications: high, medium high, medium low, and low.

### High Lighting Ratio

This high ratio exists naturally on earth at high mountain altitude on a sunny day with cloudless sky. The lighting ratio may be 20:1, 20 times more light falling on areas exposed to the direct rays of the sun than is falling on shadow areas, which receive only light reflected from the sky or from surfaces near the shadows. Similar lighting ratios can exist in a city scene with tall buildings in direct sunlight but the street level in deep shadow, or indoors when a single strong directional light acts like the sun outdoors.

Images tend to be extreme in contrast. Lines and forms are sharply outlined by the light but detail may be lost in the shadows. Lighted objects get bold and graphic emphasis where they stand out strongly against these deep shadows. The lighting is incisive, bold, graphic, vigorous, uncompromising, inelastic.

## Medium High Lighting Ratio

Lower lighting ratios are more common, because at lower altitudes more of the sun's rays are filtered out by the air and by the pollutants in it, and because cloudless days are unusual. A few white clouds give increased reflected light in the shadows. On an average day 10 to 20 per cent of the illumination is reflected light from sky, clouds, and other reflecting surfaces (such as buildings). The lighting ratio may range from a high of 8:1 down to 5:1.

Subject contrasts under these conditions tend to be average but the main light (the sun) is still dominant, so shadows are distinct. The volume of forms is pronounced because of the shadows. In fact, forms tend to be more distinct under this kind of lighting than under high ratio lighting. The sharp, black edges of detailless shadows under high ratio lighting tend to destroy the illusion of volume.

The lighting ratio is often medium high when the sun is low in the morning or late afternoon, but this can vary greatly with the proportion of the sky that is covered by clouds that reflect light into the shadows. With clouds, shadows cast by the sun at the horizon can take on a soft, luminous quality. With few or no clouds the sunlight sharply outlines forms dramatically against deep shadows (with the proper camera point of view) and this tends to be a high-lighting-ratio situation. Shadows are distinct, elongated, and can be a major part of the composition.

## Medium Low Lighting Ratio

Frequently a partial cloud cover or haze, smoke or smog filters much of the direct sunlight. The lighting ratio drops still further to about 4:1 or even 3:2. Subject contrasts are low, somewhat flat. Shadows are present but they are indistinct, their edges often difficult to see. Colors tend to be muted. The light does not pick out part of the scene but rather tends to give equal emphasis to all parts. The lighting is soft, plastic, and thus gentle with facial features because the features are not sharply defined.

## Low Lighting Ratio

On an overcast or foggy day subject contrast is low, created almost entirely by the reflectance ratio alone. There is, in effect, no lighting ratio since all areas receive the same illumination. Lack of shadows creates a feeling of flatness, not only in contrast but a dimensional flatness as well, since the lighting provides few clues to the third dimension. Lines and forms tend to be vague, unemphasized, and there may be a feeling of isolation, even mystery, to a scene caught in a fog. The lighting comes from all directions; the scene is floating in a soft sea of gray light. Forms tend to disappear into this amorphous sea. It can be depressing, but it can also be protective, and sometimes exciting. Whatever your feeling you must capture the light to express that feeling in the photographic image. (See Figure 77.)

**Figure 77. Low lighting ratio.**

When we combine lighting ratio with reflectance ratio we get wide, often extreme, degrees of subject contrast. The following table gives some approximate figures for subject contrast ranging from the brightest highlight to the deepest shadow:

|  | *Subject Contrast* |
|---|---|
| Average scene, average lighting. | 160:1 |
| Subject with high reflectance ratio under brilliant sunlight. (Example: Beach scene under full sun, cloudless sky.) | 1000:1 |
| Subject with low reflectance ratio on overcast day. (Example: Gray seascape under cloudy sky.) | 10:1 |

The average black-and-white film can produce an image contrast of about 200 to 1, so it can handle the average subject without difficulty.

Printing papers can handle a much shorter contrast range than film:

|  | *Average Image Contrast* |
|---|---|
| Glossy surface papers | about 70:1 |
| Semimatte papers | about 36:1 |
| Matte papers | about 20:1 |

This compression of subject contrast to the limits of the positive image contrast in the black-and-white print is of practical importance to the photographer. It means he must, in some cases, accept compression of the tonal scale. Or he must reduce the subject contrast by using flash or reflectors to add light to shadow areas.

Figure 78. Side lighting. Emphasis is given shape and volume and the relatively large light source gives shadow lines that deepen gradually, not abruptly.

# Direct Lighting

A street scene that may look flat and unattractively gray at one time may have dramatic highlights and shadows at another time. A wall that looks smooth at noon may look rough at 4 P.M. Water that looks still and flat when a passing cloud obscures the sun may sparkle with ripples a few moments later. The difference is mostly a matter of lighting direction. Diffused lighting of an overcast day is nondirectional—that is, it has no identifiable source from which it seems to come. But for most picture-taking situations, there is a dominant source of light sending its rays directly to the subject. Although the source is usually not included in the picture, we seldom have great difficulty in guessing its position. From the shadows we know the direction of the light.

## Front Lighting

With the light source at or near or behind the camera, the light is frontal on the subject, so shadows fall away to the rear of the subject and thus are largely hidden from the camera position. Front lighting tends to reduce the illusion in the picture of a third dimension, destroying the illusion of volume in forms, because the shadows are not visible or only partly so.

## Side Lighting

Shadows are our clues to form. Round things look round, solid things look solid, angular things look angular because of the shadows they cast. A light source to the side of the subject (relative to camera position) will make those shadows visible, so side lighting emphasizes shape and volume. (See Figure 78.)

Shadow edges can be knife-edge sharp or they can be soft gradual changes, gently curved graduations, from light to shade. The gradual change gives a more pronounced feeling of volume. The difference is largely established by the size of the light source and to some extent by the distance between source and object. A small light source gives the sharp shadow edges that change abruptly from light to deep shade, and the closer the source is to the object the sharper the shadow edge.

Side light coupled with high lighting ratio creates strong contrasts. Some areas are brightly lighted, others less so, and some areas not at all (or not enough to record on the film). Extreme side lighting occurs when the source is lowered to the same horizontal plane as the object, as in the case of light from the setting sun. The lighting then sculptures forms with one side brightly outlined and the other side in deep shade, with an elongated shadow across the ground.

## Back Lighting

Light spreading out from behind and around the subject is characteristic of back lighting. Like side light, back light will pick out and accent parts of the scene, isolating lighted parts against shadow. And shadows can

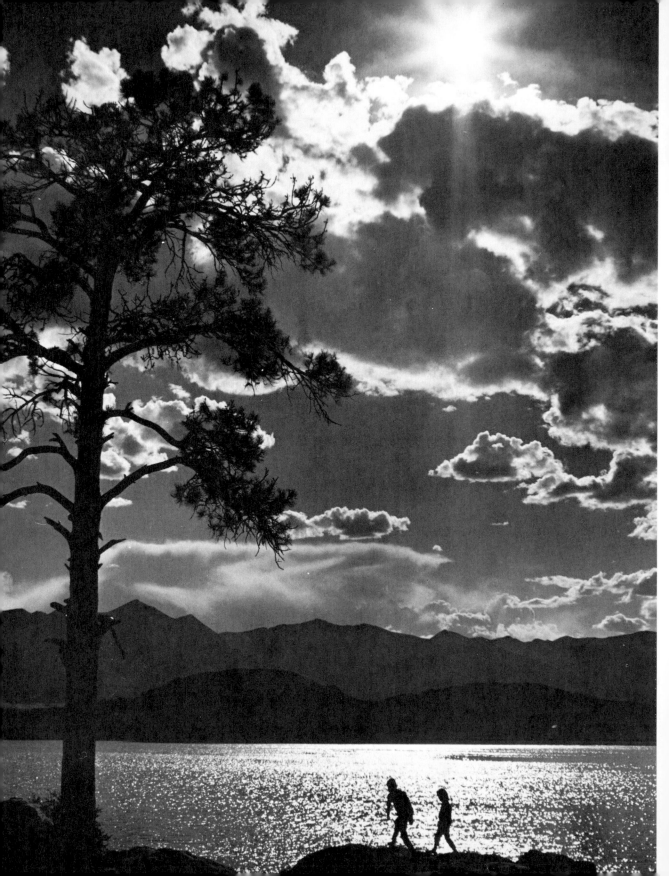

Figure 79. Back lighting. Silhouette effect with source of light included in the picture; taken with a red filter over the camera lens.

become a major part of the composition since they are falling toward the observer. Layers of light and shadow can create patterns. Extreme cases of back lighting create silhouettes. (See Figure 79.)

The light source may appear in pictures taken with back lighting, giving another visual dimension to the picture and helping to unify the composition. (You may find light sources causing flare and reflections in the lens that will be recorded on the film; this often takes the form of roughly circular images of the aperture.)

## Texture

Side lighting and its variation, back lighting, can emphasize texture. The closer the direction of the light's rays is parallel to the surface of the object, the stronger the visual effect of texture. The light skims across the surface casting shadows, visible from the camera position, of every vertical projection from that surface. Even small projections are exaggerated by this kind of lighting and thus the visual texture is pronounced.

Visible texture is a rhythm of light and shade across a surface and it strongly suggests another sensual reaction, the sense of touch. We tend to experience visual texture not only with sight but with the sense of touch as well. We see not just light and shade but we feel softness, coldness, roughness.

## Other Variations

Top lighting, with shadows falling downward from horizontal projections on the subject, is often an unsatisfactory form of lighting because the shadows frequently hide meaningful detail. This happens in the summer with a subject's face under the noontime sun: deep shadows from the eyebrows hide the eyes, or even more of the face may be masked by a shadow from a hat brim. Top lighting can, however, bring out textures.

The opposite, low lighting, throws shadows upward from horizontal projections, and this gives a hobgoblin effect, useful for photographs at Halloween time but not very useful otherwise.

# Available Light

By available light, photographers usually mean illumination that exists at the scene, but this is generally understood not to include daylight outdoors, but rather whatever lighting exists outdoors at night or indoors, day or night. Available light sources can be the light from a match, a 60-watt incandescent bulb, the headlights of a car, a bank of fluorescent lights, the floodlights of a stadium, indoor light from windows or doors. It does not include the flash or floodlights a photographer brings with him.

Available light photography is not new. Erich Salomon used this technique in the 1920s and he used it then for the same basic reasons that we use it today. It is used for:

*Realism.* If we photograph a scene in natural light we are likely to

find that the image reproduces the natural, authentic quality of the scene. We are more likely to capture the essence of the time and place.

*Variety.* Using the available light can give photographs a variety of emotional and visual effects, since the light itself has infinite variety, from the antiseptic brilliance of a modern cafeteria to the dim mystery of a night club. The available light can be gay, somber, gentle, harsh, revealing, concealing, and many other things.

*Freedom.* By using available light the photographer adds freedom both for himself and for his subject. He is freer to respond to what happens around him than when he is setting up and aiming lights, and his subjects are freer because his presence is less disturbing.

The disadvantage of available light photography is a simple but often formidable one: poor image quality. It increases the difficulty of avoiding graininess, harsh image contrasts, lack of detail in highlights or shadows or both, and blurred images.

Often these problems can be overcome by proper exposure and development. For available light situations one usually turns to the high speed films and that means increased likelihood of graininess in the print. Proper exposure and development can hold the grain in the negative to reasonable levels. Three major causes of grain are overexposure of the film, over-development, and overenlargement. Give just enough exposure to record what you need. Usually this means exposing for the highlights—not the brightest areas but those lighted areas where you want detail. The shadows must be left to go black. This will come closest, usually, to a realistic reproduction of the scene's feeling or mood. Hold development time down as much as possible. Forced development (extended time in the developer) is a last resort. Many available light situations have inherent high contrast; increasing development time compounds this contrast. (See Chapter 4.) It is better to give a little more exposure (use a somewhat lower exposure index for the film) and keep development time near normal if possible. Fill the negative frame with the essential subject to avoid the need for excessive enlargement. Use slower shutter speeds, bracing the camera to hold it steady to avoid blurred images.

Exposure meters may spell the difference between success and failure in available light shooting. The human eye is a poor instrument for measuring light levels because it compensates automatically for a wide range of illumination levels to keep our perception fairly constant. Thus we tend to see illumination differences, as between indoors and outdoors, for example, as being much less than they actually are. However, your eyes, notoriously bad for measuring the amount of light, can detect incredibly small differences in reflected light, even between one shadow and another that is only slightly darker, or between a white surface and an off-white surface.

So photograph in available light with care and do not use the available light technique merely as a *tour de force* to show what can be done. Use

**Figure 80. Light and mood. Light is a dominating factor in creating the mood and atmosphere of a scene. Difference in the direction of the light makes the difference in these two photos.**

it to help tell the story, to retain the mood and atmosphere of the original scene, to emphasize the visual drama of the lighting itself, and to be as unobtrusive as possible.

## Summary

Light not only illuminates the subject, it also creates, or at least helps to create, the visual symbolism in the image from which we extract meaning. Light has a dualistic nature. It is light and it is no-light; or, in terms of the subject and image contrasts, it is brightness and it is lack of brightness. This dualistic nature of light makes it possible for light to destroy the very things it can create.

Light makes things visible. Light can also make things invisible, not only under no-light conditions (in shadow) but even in situations of bright lighting. Non-directional light, diffused or balanced lighting, that illuminates background and foreground equally and that illuminates all parts of an object equally, can make that object disappear.

Light can make things real, but it can also make things unreal.

Light explains and defines forms, but it can also distort and disguise them, making them seem what they are not.

Light can establish the illusion of space or volume, but it can also eliminate or de-emphasize both.

Light can isolate an object for strong emphasis, but it can also hide it.

Light creates visual textures, but it also eliminates them.

Patterns and rhythms are created or eliminated according to the quality, direction, and intensity of the light. Atmosphere, mood, and the emotional tug of a scene change with the light.

All things in photography depend upon light; study it closely.

# 10

# Lighting with Flood and Flash

Indoor lighting demands familiarity with only a few simple lighting tools:

1. The spotlight, which gives a hard and relatively narrow beam.
2. The floodlight, which gives a broad, relatively soft and general beam.
3. Flash, of various kinds and dimensions.
4. Reflectors, which can be white or aluminized boards specifically designed for photographic use, or white paper, cardboard, cloth, a light-colored wall or ceiling, or a lightweight board covered with aluminum foil.

Varying the effects of the lighting on the subject is primarily a matter of varying the placement of the light:

1. Raising or lowering the light source will change the angle at which the light strikes the subject, thus changing the position of the shadows.
2. Moving the light source laterally around the subject will change the lighting from front lighting to side lighting to back lighting.
3. Moving the light source closer to or farther away from the subject will change the intensity of the light on the subject.

Each light source can fulfill any one of five functions:

1. *The key light.* This is the principal source of illumination, dominating all others that may be involved. It casts the principal, and usually the only, shadows; it is this light that holds the picture together. (See Figure 84.)

2. *The fill light.* This illuminates the shadows cast by the key light. The intention is not to eliminate the shadows but merely to throw enough light into them so that detail in the shadows can be recorded on the film. But the fill light must cast no shadows of its own, so it must be of less intensity or farther away than the key light. Often a reflecting surface can serve admirably as a fill light. (See Figure 85.)

3. *The accent light.* This adds highlights to the subject's hair, cheek, or forehead and extra sparkle and brilliance to the finished print. (See Figures 84, 85, 86, and 87.)

4. *The background light.* This creates tonal contrast between background and subject and is aimed at the background, usually from a position behind or to one side of the subject. (See Figure 86.)

5. *The bounce light.* In this case the lamp is used as an indirect source of illumination, with its rays bounced off any convenient reflecting surface: the ceiling or walls of a room, or a reflector board. Effective bounce light demands a light-colored surface; dark walls and ceilings absorb too much light. The light, of course, is colored by the hue of the reflecting surface, a factor of importance in color photography. (See Figure 83.)

We place the key light at about a 45-degree angle to the front and

about three or four feet above the subject. Exact positioning should be determined by the appearance of the subject under the light. Approximately two-thirds of the subject is in the direct rays of the key light, the rest in shadow. We must lighten the shadow area so that the film can record some detail there. To do this we add the fill light, placed near the camera but on the opposite side of the camera from the key light. Next we plan, if necessary, for lighting the background. There are no rigid rules for this. The background may be lighter or darker in tone than the subject. The purpose is to achieve a separation between subject and background in the print.

These three lights may be enough, or we can add to the illusion of volume or roundness in the subject by back lighting. In this case the direct rays of the light placed behind the subject and aimed toward the camera must be blocked from reaching the lens. The backlight gives a more pronounced feeling that the subject is occupying space of its own, separate from the background.

Or, another sort of accent light may be used, a spotlight aimed down at the subject from the side opposite the key light to add the sparkle of highlights.

All sorts of variations are possible from this standard lighting arrangement, including such extremes as profile lighting (a strong light placed to illuminate half of the subject's face, leaving the other side in a shadow that can be filled in or left dark). Or silhouette lighting, which is generally best achieved by using a strong backlight diffused through a screen such as an uncreased white sheet.

If an important aspect of the subject involves texture, then strong side lighting is required. Light must strike the surface at such an acute angle, literally skimming the surface, that even tiny projections will be brilliantly lighted on one side and will cast strong shadows on the other. How strong the light and how acute the angle will depend upon the effect desired with each textured surface.

Figure 81. The least desirable lighting: one flash attached to or close to the camera. The results are flat and lack modeling. This and the series of pictures following were made on Panatomic-X film exposed at an index of 100 and developed in Selectol Soft to illustrate the five functions fulfilled by flood and flash.

The mixture of the various wavelengths of light is not consistent from one light source to another, even for those sources that emit what we commonly call white light. You may recall having seen color photographs which seemed to have an unnatural color cast. More often than not this is caused by the color quality of the light that illuminated the subject when the picture was taken. Color quality here means the relative quantities of the various wavelengths in the light. Color quality of light is of particular importance in color photography, but we need to introduce this concept here because the various sources of light we use in photography, for black-and-white as well as color, do vary in quality, or—to use the term more common in the photographer's vocabulary—in *color temperature*.

# Color Temperature

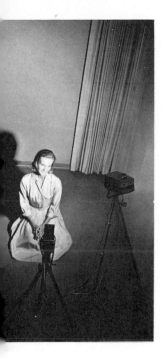

Figure 82. Flash off camera. With one light best results come from holding the light at an arm's length to the side and above the camera, depending on the attitude of the subject. This avoids the flat look, puts in some shadows, and adds a bit of modeling.

Color temperature, in the simplest possible terms, is a measure of the color of light. More accurately, it is a measure of the distribution of the complete spectrum's various wavelengths in the light from a given source.

The color of light can be measured in terms of temperature because the color varies with the temperature of the source. The filament of an incandescent lamp emits light because it is hot, and the hotter it is, the whiter the light. We recognize this in the common expression "white hot," which indicates a higher temperature than "red hot." Light from low-temperature sources is yellowish; it has a high proportion of yellow, orange, and red wavelengths. Light from high-temperature sources is richer in the shorter wavelengths, particularly blue.

Color temperature is measured on a scale that begins at absolute zero (−273° C) and is expressed in degrees Kelvin (K), after British physicist, Lord Kelvin. Thus 0° C is 273° K and 100° C is 373° K.

Here are a few light sources with their approximate color temperatures:

| Light Source | Color Temperature (° K) |
|---|---|
| Candle | 2000 |
| 100-watt incandescent lamp | 2850 |
| Photoflood lamp | 3400 |
| Clear flash bulb | 3800 |
| Blue flash bulb | 6000 |
| Electronic flash | 6000 |
| Daylight | 6000 |

## Flood Lamps

The best way to learn to control photographic lighting is to begin with flood lamps. They give a continuous flow of light while the photographer moves them about to observe the effect of the lighting on the subject. Experience thus gained can be a help in using flash.

Flood lamps are nothing more than ordinary incandescent lamps putting out a more than ordinary amount of light because their filaments burn at an unusually high rate. This is why flood lamps have only a fraction of the life of ordinary lamps.

The most common types of flood lamps for still photography are the photofloods: the 250-watt or No. 1 lamp, the 500-watt or No. 2 lamp (both for use in reflectors), and the reflector floods, which have their own built-in reflectors and are available in broad-beam and medium-beam floods and spots. Wattage is generally 500 for the broad beams and spots, and 375 for medium beams. Photofloods have a color temperature of 3400° K and are intended for use with Type A color films or with any black-and-white film. Blue-glass photofloods have a color temperature of about 5000° K and are intended primarily as a supplementary light source to fill in shadows for pictures taken with daylight as the main light source and with daylight color film. They, of course, can also be used with black-and-white film.

Professional photo studios generally use another kind of flood lamp. These are 3200° K lamps for use with Type B color film or with black-and-white film. These are the so-called "professional" lamps, but there is no law prohibiting their use by amateurs. They are a bit more expensive than regular photofloods but last about ten times longer.

No more than three 500-watt lamps should be used on the usual electrical circuit. The number of lights that can safely be used on a single circuit can be determined by multiplying the voltage by the amperage of the fuse. For example, 110 volts times 15 amps, the usual fuse on a home circuit, equals 1,650 watts.

Exposure with floodlights should be determined with exposure meter readings. If a meter is not available, refer to the guide number chart printed on the carton in which the floodlights were packed.

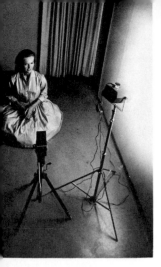

Figure 83. Bounce flash. Bounced off a wall here, although usually it is bounced off the ceiling. Exposure must be increased two to four stops, depending on the distance from the light to the reflecting surface to the subject and on the ability of the surface to reflect light. Bounce flash gives softer lighting with shadows and modeling.

Figure 84. Two lights. The subject has been caught at the intersection of the line of sight from the camera and the line between the key light and the accent or back light. This gives us an accent rim light, strong modeling, but leaves harsh shadows.

Figure 85. Three lights. The third light, a shadow-fill light, is added to the left and slightly behind the camera. This is a typical setup for triangular lighting. Note that we still have the highlights from the accent light but that the shadows thrown by the key light are now soft and natural.

Figure 86. Four lights. If the photographer has four lights available, he must decide whether to use the fourth on the background or as another accent or back rim light. Here we have used the fourth light on the background to lighten its tone and to subdue shadows.

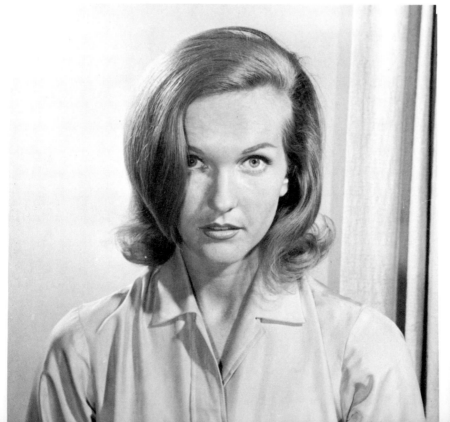

# Flash: Bulb and Electronic

Flash, the most practical of artificial light sources for photography today, has made picture-taking possible and relatively simple in almost any situation. But it was not always thus. As recently as the early 1930s flash photography was regarded, quite justifiably, as a risky undertaking, for it meant taking pictures with magnesium powder bonfires. A press photographer sprinkled one to three teaspoons of this explosive powder into a long, narrow pan. Then, with considerable perturbation, he held this pan overhead with one hand while he steadied his camera, usually a large and heavy Graphic or Graflex, with the other. He pressed a release on the flash-pan handle to fire a powder cap, igniting the magnesium, and to compress, simultaneously, the air in a rubber tube leading to the camera's shutter. The air pressure tripped the shutter as the powder exploded. If he worked quickly, the photographer could reload both flash-pan and camera in time to take a second shot before the smoke from the first drifted down to obscure the subject—assuming the subject was intrepid enough to stay around for a second performance. Often, for these indoor pioneer flash pictures, the photographer took with him as principal assistant a fireman who stood by with extinguisher in hand, and an extinguisher was needed often enough to make this a wise precaution.

Today firemen can attend to more conventional duties while photographers carry with them safe and easily portable supplies of light, instantly employed and precisely controlled. The photographer has his choice of two forms of packaged flash: the conventional and expendable flash bulbs or the reusable but initially more expensive electronic flash.

## Flash Bulbs

The conventional flash bulbs, some relatively large but many no larger than a fair-sized peanut, contain a wire filament covered with an explosive primer paste. The rest of the interior of the bulb is loosely filled with aluminum or zirconium wire or foil, surrounded by an atmosphere of oxygen at reduced pressure. An electrical current moving through the filament heats up and ignites the explosive primer, which in turn ignites the metal wire or foil, and it is the rapid, controlled burning of this metal bonfire that gives the picture-taking light, a short but intense flash.

The outer glass surface of all flash bulbs is coated with a layer of lacquer, sometimes a pale blue color and sometimes clear, to prevent a shattering explosion of the glass. The blue coating raises the color temperature of the light to match that of average daylight, so blue bulbs are intended for use with daylight color film. But they can be used with black-and-white film as well.

Flash bulbs are rated according to their light output, measured in lumen seconds. A *lumen* is a unit of light or luminous power, and the quantity of light in lumen seconds is the power of the source multiplied by the duration in seconds. A standard 100-watt light bulb produces approximately 2,000 lumens in one second. Flash bulbs produce 4,000 to 100,000 lumen

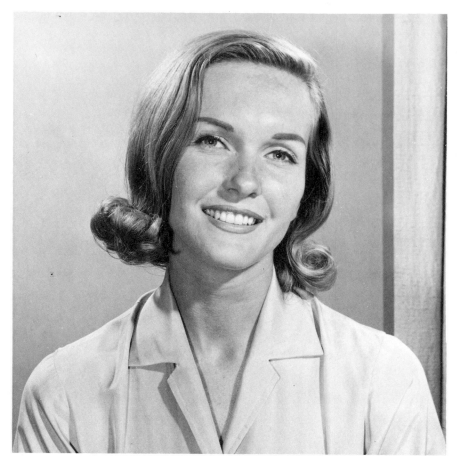

**Figure 87. Five lights. The background light is used again in this setup but a fifth light has been added as an accent light to rim the right side of the model's head. There are many variations of these lighting arrangements. Frequently the accent lights are spotlights.**

seconds in a time period that lasts, usually, less than 1/25 of a second. Small (AG-1 and M2) flash bulbs produce approximately 7,000 lumen seconds (4,000 to 6,000 if blue-coated). The No. 5 and No. 25 bulbs produce about 20,000 lumen seconds (9,000 if blue-coated), and larger bulbs produce from 33,000 to 100,000 lumen seconds.

Flash bulbs, like any bonfire, gradually build to a peak light output and then fall off to zero again. Because they vary in the time required to build to peak, bulbs can be classified on this basis as well. The two principal classifications are the medium-peak and slow-peak bulbs—M and S for short. M bulbs peak in 15 to 20 milliseconds, and S bulbs in about 30 milliseconds. An additional classification is the FP (or flat peak) bulb, designed for use with the focal-plane shutter; it reaches peak output in approximately 20 milliseconds and holds that peak for 20 to 25 milliseconds to give the focal-plane shutter time to move across the film. However, the more readily available flash cubes and the AG-1 bulbs will synchronize

with focal-plane shutters set at 1/125 of a second (and in some cases even at 1/250) because these bulbs give a fairly flat peak.

### Electronic Flash

In 1851 a British pioneer in photography, William Henry Fox Talbot, received a patent for the use of a high-speed electrical spark as a photographic light source. He had demonstrated his device by taking a picture of a London newspaper. Not a particularly remarkable achievement, even in those pioneer days of photography, except that the page from the newspaper was whirling rapidly at the time the picture was taken. The picture showed the printing unblurred; it was sharp and clear. This was in the day when exposures were made by removing a cap from the front of the lens and then replacing it after an estimated or counted exposure period. Talbot had made his photograph of the spinning newspaper by using an electric spark as his light source. The duration of the light from the spark was so brief that the movement of the image on the film was insignificant. This was the first electronic flash.

Taking pictures by the light of a spark did not become an everyday practice until after 1930 when a Massachusetts Institute of Technology professor, Dr. Harold E. Edgerton, perfected a number of significant improvements in Fox Talbot's technique. Dr. Edgerton used alternating current and modern electrical capacitors (devices that hold or store an electrical charge, also called condensers). Instead of an open-air spark gap he used a glass tube filled with one of the rare inert gases, usually xenon.

The typical electronic flash unit, patterned after the system developed by Dr. Edgerton, includes five fundamental parts:

1. A power supply that provides the electrical energy for
2. one or more electrical storage capacitors, which hoard this energy until
3. a triggering circuit, activated by the camera shutter, spills all the stored power through
4. a gas-filled flashtube, which converts the electrical energy into light, which
5. a reflector directs toward the subject.

The stored charge flashing through the gas-filled tube gives a powerful flash of light for a small fraction of a second. Most portable electronic flash units, the most popular for today's photography, give a flash duration somewhere between 1/500 and 1/2,000 of a second. After each firing the electronic flash unit needs a brief period to recharge the capacitors. This is usually referred to as the recycling time and it can vary from 4 to 12 seconds. Most units have indicator lamps that flash on when the charge has reached about 80 per cent of full capacity.

Automatic thyristor circuit electronic flash units provide shorter recycling times because of their energy-saving ability. This is accomplished by allowing the flash capacitor to release only the energy needed for a given

**Figure 88. Electronic flash unit.**

exposure, instead of its full charge. Energy saving is related to flash to subject distance. When the subject is close, a smaller quantity of light is needed for a proper exposure than when the subject is farther away. Therefore, if nickel cadmium rechargeable batteries are the power source, the unit, when fired continuously at $f/2$, will flash 500 times on a subject only two feet away, 150 times when 10 feet away and about 40 times when 20 feet away before it needs recharging. At the close distance the recycling time will be less than one second, while at the maximum distance the recycling time will be almost two seconds.

Advantages of the electronic flash unit include:

*Action stopping.* The brief duration of electronic flash can be used in the same way as high shutter speeds to get sharp images of moving subjects, as in indoor athletic events. However, the shutter speed must be high enough to prevent any ghost image from being formed by the existing light. This usually means a shutter speed of at least 1/60 of a second or shorter with a leaf-type shutter.

*No bulbs to replace.* Each electronic flash tube will last for 10,000 or more flashes; there is no need to replace a bulb after each picture. Batteries used with the unit need to be replaced or recharged occasionally, of course.

*Low operating cost.* The operating cost for each electronic flash picture is only about 1/10 of a cent, although, of course, the initial investment cost is relatively high.

*Daylight color temperature.* Electronic flash works well usually with daylight color film since the color temperature of the flash is about the

same as daylight. Some electronic flash units may have a color temperature higher than daylight, especially when new, and this can give a slight bluish cast to color photos.

*Not blinding.* Electronic flash is also easy on the eyes of the subject, because the brief duration of the flash does not have the same blinding effect as conventional flash bulbs. This makes it especially desirable for sports photography, and in fact, many athletic groups prohibit all but the electronic flash.

## Synchronization

Some method must be provided to ensure that the shutter of the camera is open while the flash is at its peak light output. This is called synchronization. With Instamatics and similar cameras that are designed to eliminate the burden of making exposure adjustments, inserting a flash bulb or cube into the flash socket on the camera automatically programs the proper synchronization. With other cameras the photographer is responsible for seeing that flash and shutter are properly synchronized. Often two synchronization settings are provided.

With the front (at the lens) leaf shutter, these two settings are generally an M setting and an X setting. The M stands for medium-peak bulbs, of course, and in this case an electrical contact fires the bulb first. A predetermined delay, established by a mechanical or electrical delay mechanism, gives the fire in the bulb a chance to get started, then the shutter opens. (See Figure 89.) The X setting is for electronic flash, which peaks in less than one millisecond. To synchronize electronic flash, the electrical

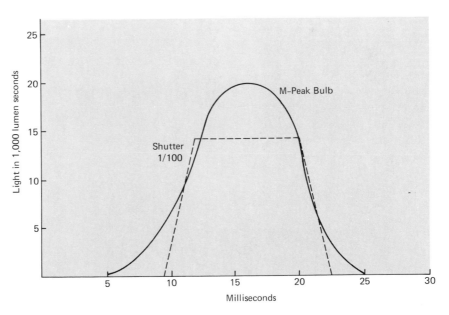

**Figure 89. Synchronization with medium-peak (M) bulbs. Shutter starts to open 4 to 5 milliseconds after the flash bulb has started to burn and then is wide open during flash peak (maximum light output).**

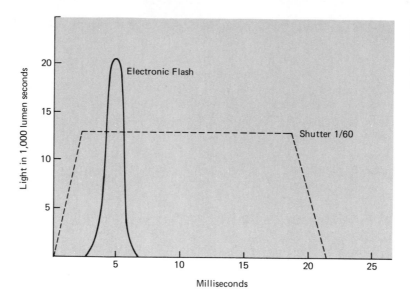

contact for firing the flash occurs only when the shutter blades reach the fully open position. (See Figure 90.)

Synchronization with the focal-plane shutter is somewhat different. You will remember that this shutter has a slit that travels across the film. The slit, for example, may be set to expose each point on the film for 1/250 of a second, but it may take 1/50 of a second for the slit to travel completely across the film. Obviously the light from the flash must be available for the full period of the slit's travel to provide even illumination. This is

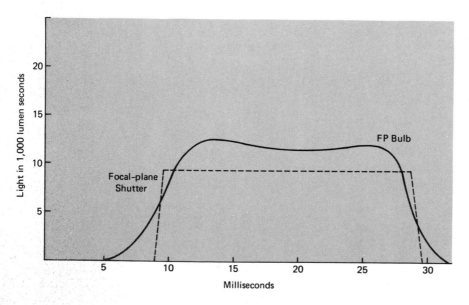

accomplished with the FP (flat peak or focal plane) bulb, since it maintains its peak light output for about 1/50 of a second. (See Figure 91.)

Another complication involved is when we use electronic flash with a focal-plane shutter. Electronic flash cannot provide a flat peak, so we must use the slow shutter speeds (1/60 of a second with most 35-mm camera shutters, 1/125 with a few) when the slit in the curtain is as wide as the film, thus exposing all the film at one fraction of an instant, and in that fraction of an instant the flash must fire. If your electronic flash shots taken with a single lens reflex camera show only about one-half or less of the negative frame exposed, it is an almost certain indication that your shutter speed was too high.

## Exposure with Flash

Distance between flash and subject is the critical factor in flash exposure. The amount of light falling on the subject is inversely proportional to the square of the distance. (See Figure 92.) The light spreads out as it travels so that it will cover four times as much area at 12 feet as it will at 6 feet. So exposure for a subject 12 feet from the flash must be four times (two f/stops) what it would be for a subject at 6 feet.

To simplify exposure determination, manufacturers of films and flash equipment publish *guide numbers* calculated by a formula that takes into account the lamp's effective light output at a particular shutter speed, the speed of the film, and the reflector factor. The reflector factor depends upon the shape and surface (polished or satin finish) of the reflector and the size of the flash bulb. The appropriate guide number is determined by consulting a chart furnished with flash bulbs, with film, or with the flash equipment. The photographer must know the speed of his film and usually must decide upon a shutter speed. With these two elements known, he can find the appropriate guide number from the chart. Dividing the distance in feet from the flash lamp to the subject into the guide number then gives him the f/number.

Guide numbers are only guides. The numbers are intended for average indoor subjects, in an average size room, with light-colored walls and ceiling. In a small room with many bright, reflecting surfaces use one stop less exposure than the guide number indicates. In a large room, such as an auditorium, and outdoors at night open up one stop.

Guide numbers are furnished with electronic flash units and the distance (in feet) between the flash and the subject divided into this number gives the f/number, just as with regular flash bulbs. However, we do not have to concern ourselves with the shutter speed because the duration of the flash from these electronic units is almost always shorter than the shutter speeds we normally use. Some of the latest electronic flash units have built-in devices that, given the film speed and f/number in use, will automatically quench the light when the light reflected back from the subject indicates enough exposure.

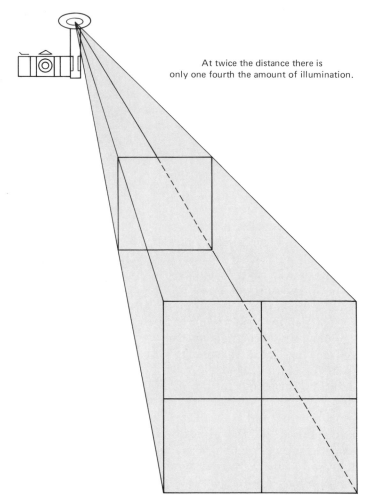

At twice the distance there is
only one fourth the amount of illumination.

**Figure 92. The inverse square law.**

The general principles outlined at the beginning of this chapter apply to lighting with flash. Subjects may be illuminated with a single flash lamp or with several, and the effect of each depends upon its placement in relation to the subject. Practice and experimentation with floods will provide invaluable background for anticipating results with flash, although flash lighting is more intense and builds greater contrasts in the image.

## Flash Technique

### Single-Flash Technique

A single flash at the camera, an *on-camera* flash, is the simplest method of making flash pictures. But this tends to produce flat lighting with no modeling effect; the roundness or volume of the subject is de-emphasized. (See Figure 93.) There are no shadows to create depth and texture. The

Figure 93. A single flash on camera produces a picture (left) lacking in modeling (roundness or volume); no tone separation exists between the subject's hair and the shadow. The model's face seems almost as flat as the gray scale. A single flash held 18 inches to the left and above the camera gives modeling to the face (right). There are shadows and a better separation of the subject from the background.

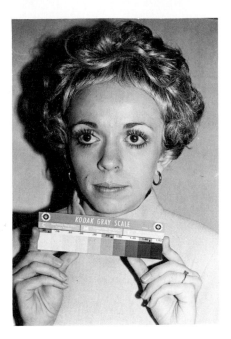 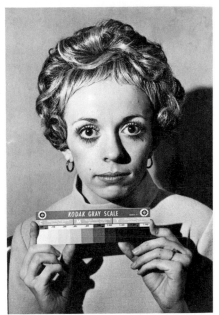

only shadows visible in such a picture are usually on a wall or other background, and often this results in tone mergers that make it impossible to tell where the image of the subject ends and the shadow begins. If the picture must be taken with an on-camera flash, whenever possible the subject should be more than 3 feet and less than 6 feet from the background. This will give enough room for the shadow to fall away to the rear, where it is hidden from the lens, but the background will not be so grossly underexposed as to place the subject in black and cavelike surroundings in the final print.

Significant improvement in the picture quality in flash pictures comes from a simple rule: use an *off-camera* flash whenever possible. If the equipment in use permits, the flash gun is removed from the bracket holding it to the camera. The lamp is then held at the end of its cord, or as high as the photographer can reach above the camera, and pointed down at the subject. The camera must be held in one hand and the flash gun in the other. This position for the flash, high and off a foot or two to one side or the other of the lens, will eliminate the flat, washed-out lighting of the on-camera flash. Shadows appear on the subject's face to add roundness or the third dimension. Black shadows on the background drop much lower and usually are well hidden. The subject stands out from the background, occupying space of its own, instead of appearing to be a flat cutout plastered on that background.

In placing any flash lamp, watch for mirrors, windows, enameled walls, eyeglasses, or other shiny surfaces that may bounce the light into the camera

lens. This is *specular reflection* and can be avoided simply by remembering that the angle of reflection will equal the angle of incidence.

Soft, diffused lighting for pictures that look very much as though they were taken with natural indoor lighting can be achieved with either *bounce* flash or *bare-bulb* flash. With bounce flash the light is aimed at a reflecting surface, usually the ceiling or a nearby wall. The resulting diffused light creates natural-looking highlights and open shadows with printable detail. Bare-bulb flash gives much the same effect if the bulb is placed high and away from the camera. This technique simply involves firing the bulb without a reflector.

Exposure must be recalculated with either bounce or bare-bulb technique because in both cases the light is not concentrated on the subject. This means much of the light is lost, so the exposure must be increased. How much to increase exposure depends upon the size of the room and the color of the walls and ceiling. For bounce, exposure can be estimated on the distance from the flash to the reflecting surface to the subject. Divide this total distance into the guide number for a basic *f*/number, then open up one more stop to compensate for the light absorbed and scattered by the ceiling or other reflecting surface. In general, a bounce shot requires two full stops more exposure than direct flash. If the ceiling

**Figure 94. Key light high to one side, fill light at the camera.**

is high, 12 feet or more, or dark in color, the lens should be opened one additional stop. High, dark ceilings, however, do not generally provide enough reflection for effective bounce flash. For bare-bulb flash the same rule of thumb applies: Open up at least two stops more than the indicated exposure for lighting with a reflector—more if the room is large, perhaps less if the room is small with many bright, reflecting surfaces.

Whenever the flash bulb is placed close (less than 6 feet) to a person who will not be shielded by the reflector or some other protector, always place a clear plastic shield over the flash bulb. There is always the one chance in a thousand that the bulb will explode.

Because the light falls off at twice the rate of the increase in distance, it is difficult to light a subject of depth, such as a row of persons or a crowd, with a single flash. Subjects close to the light receive a disproportionately high share of the illumination. If exposure is based on the distance to the closest person, the image of the farthest will be underexposed. If exposure is based on the distance to the farthest person, the image of the closest will be overexposed. Recommended procedure in such a situation involves removing the flash gun from the camera, holding it high and aimed at the most distant subject. Calculate the exposure for the distant subject. Let spill light from the edge of the reflector illuminate the close subject. It may also be possible to bounce the flash off the ceiling to cover a large area fairly evenly.

### Multiple-Flash Technique

Better pictures can usually be made with more than one flash lamp, either bulb or electronic. Multiple flash permits application of the basic principles outlined earlier in this chapter; modeling can be improved, contrast reduced, texture emphasized, and pleasing highlights created with accent lights.

The basic setup includes two lamps: one high and to one side of the subject and the other on the opposite side of and near the camera. (See Figure 94.) The first is the key light on which exposure is based, and the second is a shadow-fill light. The key light must put more illumination on the subject than the fill light. The balance of the light intensity from the two lamps can be controlled in several ways: by using different sized bulbs, by diffusing the light from the fill lamp, or by putting the key light closer to the subject.

Generally it is easier to use the same sized bulb in both lamps; then if the two lamps are the same distance from the subject, one layer of clean, white handkerchief over the fill light will cut its intensity about one half, giving a lighting ratio between the key and fill lights of approximately 3 to 1. (Two units of light from the key light plus one unit from the fill light will equal three total units on some parts of the subject. Parts receiving only the fill light will be illuminated by only one unit, hence, 3:1.)

Light ratio is also easily controlled with the same sized lamp by simply placing the key light closer to the subject than the fill light. Remembering the rule that the light intensity is inversely proportional to the square of the distance, then, if the key light is at 6 feet and the fill light at 12 feet, the lighting ratio is 5:1; key light at 6 feet and fill light at 10 feet, lighting ratio is 4:1; key light at 6 feet and fill light at 8½ feet, lighting ratio is 3:1.

A small amount of fill light can be obtained if the photographer holds the flash gun out in front at an arm's length and aimed back at his own white shirt front; this will give about one-eighth the light he would get aiming the flash directly at the subject.

More flash units can be added to the basic setup to give background lighting or highlight accents or to balance the illumination on close and distant areas of a subject in depth. The variations are infinite and can only be hinted at in a brief outline of techniques.

Multiple flash requires lamps on extension cords plugged into the flash gun at the camera or *slave* units. Extensions put an extra load on the batteries, which must be fresh or synchronization failures are likely. Slaves are self-contained flash units not connected to the camera's flash gun by wires. An electric eye built into the slave unit reads the flash at the camera and trips the slave flash. This takes place very quickly, but some delay is involved with conventional flash bulbs. It is best to use shutter speeds on the order of 1/30 of a second to be sure the shutter will still be open to catch the peak of all the slave-unit bulbs. With electronic flash units at the camera and as the slave units, leaf-shutter speeds of 1/200 of a second or faster are entirely feasible because electronic flash peaks in less than one millisecond. It is possible to buy special light-sensitive "photoeyes," which, when plugged into a regular electronic flash unit, will convert that unit into a slave.

Exposure calculation with a multiple flash is usually no different than with a single-flash lamp aimed at the subject. Exposure is still based on the distance (in feet) between the key light and the subject divided into the guide number. And the guide number is selected just as though only one flash bulb were being used. This is so because in normal multiple-flash setups each lamp is lighting a different part of the subject, and one, the key light, dominates to give coherence to the image. However, if you aim two or more bulbs at the same part of the subject to get more light, the following applies:

For two bulbs, multiply the single-flash guide number by 1.4.
For three bulbs, multiply by 1.7.
For four bulbs, multiply by 2.

Multiple-flash technique has sometimes been simulated, depending upon the subject, with a single-flash unit. This is the *open-flash technique.* Indoors

or out, wherever the existing illumination is quite low and the subject immobile, the shutter can simply be opened and the scene painted with light by repeated flashes from a single-flash unit. The existing light must be low, so that the film will not be overexposed during the long period the shutter is open. With the camera on a tripod or other firm support to keep it immobile, the photographer can move about, flash gun in hand, firing as many times as he wishes. This same technique can be used, with a time exposure, to burn in the image of weak light sources, candles, Christmas lights, or Fourth of July sparklers. The flash gun that has no switch to do this job can be flashed when it is not connected to the camera by shorting out the unit with a paper clip across the end of the cord that connects to the camera.

Open flash is sometimes used for subjects with considerable depth, and this requires a small diaphragm opening for extensive depth of field. Exposure can be established with the open-flash guide number for the film and flash bulb combination. This is usually the same as the guide number for shutter speeds up to 1/30 of a second. Dividing the *f*/number selected into this guide number gives the distance in feet that the flash should be held from the subject each time it is fired.

## Sun and Flash

Flash can be used to open up shadows cast by brilliant sunlight outdoors or to balance indoor lighting with the light on an outdoor scene that will be included in the picture through a window.

Using flash outdoors is usually intended to fill in the shadows enough to record some detail in those shadows. But it is important *not* to eliminate the shadows with the flash fill. This is an especially useful technique with color film, for which blue bulbs or electronic flash must be used so that the color temperature of the flash matches that of the sunlight.

Exposure is based on the sunlight. The distance the flash must be from the subject is calculated from the guide number and the *f*/number selected for the sunlight exposure. For example, if the exposure selected for the sunlight is *f*/16 and 1/125, look for the proper guide number for the film and flash bulb combination at that shutter speed. Assuming the guide number is 160, then dividing *f*/16 into 160 gives us 10 feet. That is the distance at which flash would approximately balance sunlight, in other words, eliminate the sunlight's shadows. But that we do not, ordinarily, want to do. Move the flash back to approximately 14 feet; the sunlight to flash ratio is then approximately 2:1. Moving the flash back to 20 feet from the subject would give a ratio of 4:1, sunlight four times as strong as flash.

If it is inconvenient, and it often is, to move the flash, then the reflector and bulb can be covered with a clean, white handkerchief. This will cut the light from the flash by one half; two layers of handkerchief will eliminate about three-fourths of the light from the flash. (See Figure 95.) Or the

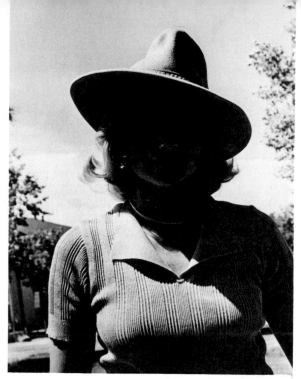
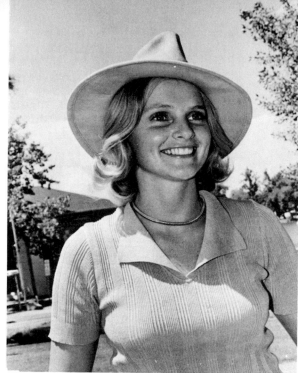
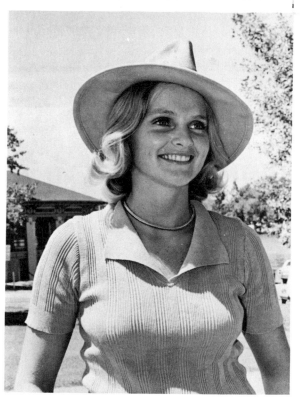
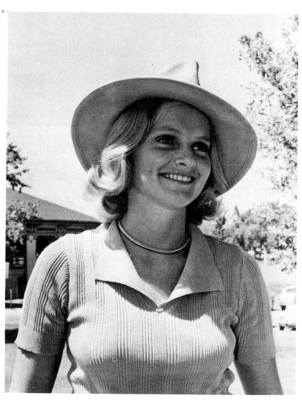

flash can be fired without a reflector, reducing the light by one half, or it can be bounced off a convenient reflecting surface.

With electronic flash you can juggle the flash-sunlight relationship by changing the shutter speed, for electronic flash exposure is controlled by the $f$/number only. Changing the exposure from $f$/11 at 1/125 to $f$/16 at 1/60 will give the same exposure as far as sunlight is concerned but will reduce the exposure from the flash.

Since electronic flash synchronization with a curtain type shutter is restricted to shutter speeds of 1/60 second or slower, it is easier to achieve a desired light balance between sunshine and electronic flash with a leaf type shutter (inside the lens) because it can be synchronized at all shutter speeds up to 1/500 second. Various combinations of $f$/numbers and shutter speeds can keep the sunlight constant while reducing or increasing the balance with electronic flash.

The exact ratio between sunlight and flash is largely a matter of personal preference. For color pictures the desirable ratio is often 2:1 or 3:1. Color shots intended for magazine or newspaper reproduction generally need a greater amount of fill light than color transparencies shot for projection on a screen.

The same general technique applies in lighting an outdoor subject in the shade with a background in sunshine, or in lighting an indoor scene to balance it with the sunlight on a scene visible through a window from the camera position. Exposure calculation begins with determination of the exposure for the sunlight; then the $f$/number so obtained divided into the proper guide number gives a distance from flash to subject. Adjustments must again be made to get the proper ratio between sunlight and flash, and this depends on the photographer's purpose, the personal interpretation he wishes to give the combined indoor-outdoor scene.

# Questions for Review

1. The principal source of illumination is called the _____ light.     key

2. A light used to throw some illumination into the shadows cast by the key light is called the _____ light.     fill

3. The background light is used to achieve tonal separation between _____ and the _____.     subject, background

4. The comparative Kelvin ratings for daylight and tungsten light show that _____ has the higher color temperature.     daylight

5. In general the higher color temperature of daylight means it has more of the _____ wavelengths than does tungsten light.     blue or short

6. Synchronization in flash exposure involves getting the shutter open when the flash is at its
   _____.                                                                                                          peak
7. M synchronization is intended for use with
   _____ peak bulbs.                                                                                          medium
8. X synchronization is intended for use with
   _____ flash.                                                                                                     electronic
9. Exposure with flash is based on the distance
   between the _____ and the subject.                                                                 flash
10. The number of feet the flash is away from the subject is divided into a guide number to get
    the _____.                                                                                                     $f$/number
11. If the guide number is 180, distance from flash to subject is 9 feet, the $f$/number should be
    _____.                                                                                                           $f$/20 or $f$/22
12. Flash is sometimes used outdoors in sunlight to
    _____.                                                                                                           fill shadows

# 11

# Filters for Black- and-White Photography

Filters are important tools in photography because they significantly increase the photographer's ability to control the image. Filters can make the image of white clouds stand out in dramatic relief against a dark sky, can penetrate haze, or put atmospheric haze into an image when little existed in the actual scene. Filters can put contrast into the black-and-white reproduction of two different colors of equal brightness, or they can make two different colors merge as a single brightness value in the print.

Filters can be used in two ways in photography: to modify the light falling on the subject (a filter over the light source) and to modify the light passing through the lens before it reaches the film (a filter in front of the lens). Filters designed to be used in front of the lens are the most practical, the most convenient, and thus the most important in black-and-white photography, and these are the ones we are concerned with in this chapter.

# Basic Principles

In black-and-white photography we attempt to translate a scene that the eye sees in color into a picture made up of blacks, grays, and whites. Doing that poses two major problems:

1. Contrasts in the scene are often the result of differences in color; two objects may reflect light equally but be clearly distinguishable because of a color difference. For example, red contrasts sharply with green in normal human vision even though the amount of light reflected by the two may be virtually equal.

2. The sensitivities of eye and film (even panchromatic film, which is sensitive to all colors) do not match. The eye's maximum sensitivity is in the middle of the visible spectrum (yellow-green), while panchromatic film shows a maximum sensitivity to the short wavelengths (violet and blue). Films are also sensitive to ultraviolet, which the human eye does not see at all.

To correct the translation from the eye's view in color to a black-and-white print, we use filters. By absorbing some colors and transmitting others, a filter alters tone relationships in the black-and-white print. The more of a given color a filter over the camera lens absorbs, the darker the area or object reflecting that color appears in the print. Other tones in the print, caused by light wavelengths not absorbed by the filter, will seem brighter by comparison.

A green filter will transmit green light and absorb (darken) red and blue. Actually filters do not work all that perfectly; the green filter will absorb some green light and not absorb all the light reflected from red and blue objects. (See Figure 96.) For one thing, an object that looks red is probably reflecting some green rays and possibly even some blue.

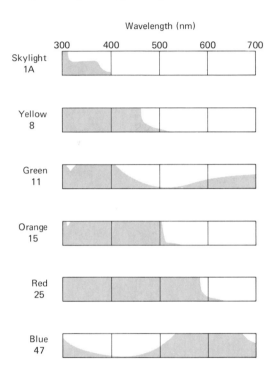

Figure 96. Filter absorption graphs. Shaded portions show approximate wavelengths absorbed by each filter, including ultraviolet wavelengths between 300 and 400 nanometers. Note that each filter tends to absorb those wavelengths farthest away from the filter's own color on the spectrum scale.

In black-and-white photography, the filters most frequently used are:

1. Correction filters—to build black-and-white contrast in the image to make the image appear about the same as the color contrast viewed by the eye.
2. Contrast filters—to build black-and-white contrast in the image between contrasting colors of nearly the same brightness or to exaggerate or emphasize contrasts in the actual scene.

   Additional filters, less frequently used are:

3. Haze filters—to reduce the effect of atmospheric haze on the image.
4. Polarizing filters—to reduce or eliminate certain reflections or glare.
5. Neutral density filters—to reduce the light of all colors that reaches the film to avoid overexposing the film.

## Filter Functions

## Correction Filters

Because of the film's excessive sensitivity to blue, it often gives us a print in which blue tones, such as the sky, are reproduced as too light a tone of gray—too light, that is, in terms of the way the actual scene appears to the eye. White clouds against a blue sky may not appear in the black-and-white print; the two tend to merge into a single tone because the film is nearly as sensitive to blue as it is to white.

To change the response of the film so that the image will more closely correspond to the subject, we turn to a correction filter. In the case of white clouds against a blue sky, the usual choice is a yellow filter, which will absorb the ultraviolet light and absorb enough of the blue to separate the white from the blue. In the print, the clouds will tend toward white and the blue sky will tend to be a middle or slightly darker gray.

A green or yellowish-green filter is also often used as a correction filter. It gives much the same control over the blue light reflected from the subject that the yellow filter gives, but in addition, the green filter absorbs some of the red. The green filter is useful, for example, in recording approximately correct tones in outdoor portraits, especially suntanned faces against a blue sky.

## Contrast Filters

Red and green look about the same if they are reproduced in their correct brightness values with panchromatic film. Red apples may appear almost the same tone of gray as the tree's foliage. Putting a red filter over the camera lens produces different results. This time the red apples stand out brightly against dark foliage because the filter absorbed most of the light reflected from the green foliage but only a small amount of the light reflected from the red apples. We would say that the red filter in this case was a contrast filter. (See Figure 97.)

The distinction between correction filters and contrast filters is not at all distinct. Controlling contrast is the purpose in both cases. If a filter is used to achieve a "natural" sort of rendition of the subject in black-and-white reproduction, we call it a correction filter. If a filter is used to heighten the difference in brightness values between colors or to exaggerate the difference, we call it a contrast filter. A red filter will make white clouds stand out dramatically against a blue (in the print almost black) sky. That is not a correction filter; that is a contrast filter.

## Haze Filters

Filters can be used for reducing the effect of natural, atmospheric haze, but not for penetrating smoke, fog, or smog. Normal atmospheric haze is caused by microscopic dust particles and water droplets in the earth's atmosphere. These minute particles interfere with the passage of light reflected from distant objects, especially in landscape scenes. (This is the aerial perspective discussed in Chapter 6.) The greater the distance between

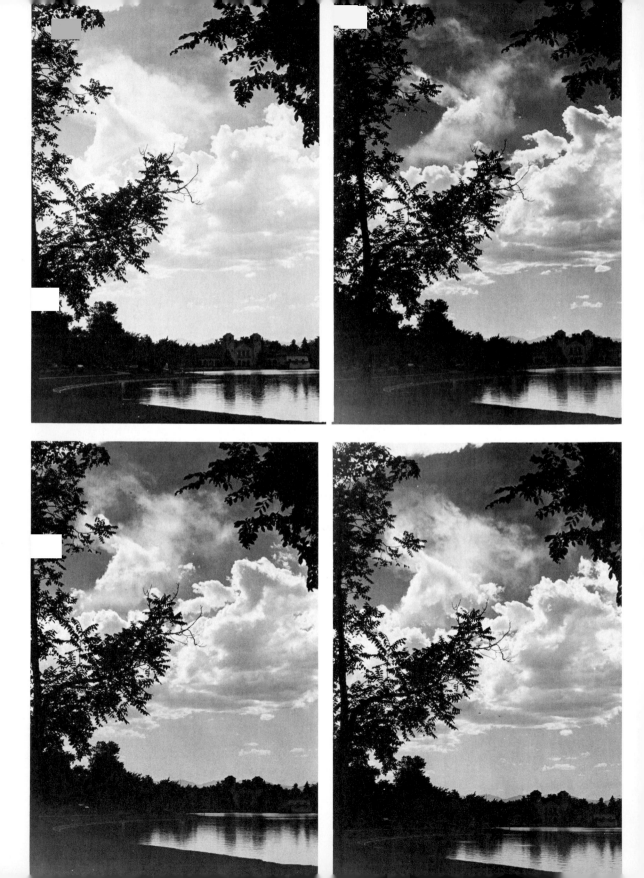

Figure 97. Filter effects. Top
left no filter; top right red filter;
bottom left green filter; bottom
right orange filter.

the observer and the mountain or building, the greater the haze effect. The haze effect manifests itself in three ways: over-all tones become lighter, the contrast between elements within the scene decreases, and the over-all color of the scene is distorted toward the blue.

The dust and water droplets in the air scatter the short wavelengths (ultraviolet, violet, and blue rays) the most. The result is that photographic film records more haze in the image than the eye sees in the actual scene because of the film's excessive sensitivity to these short wavelengths. If we can filter out these haze-creating wavelengths we can reduce and even eliminate the haze effect in the photograph. A medium yellow filter records haze approximately as the eye sees it; an orange filter reduces the haze effect on the film, and a red filter (especially if used with infrared-sensitive film) practically eliminates it.

## Polarizing Filters

These filters will absorb light that has undergone the change known as polarization. Reflections and glare (a special kind of reflection) from nonmetallic surfaces, such as glass, water, polished wood, or a waxed floor, is often polarized light—electromagnetic waves that are vibrating not in all directions at right angles to the ray but in only one such direction. Actually an electromagnetic wave has electric and magnetic vectors (vibrations) that are perpendicular to each other and to the direction of propagation. It is the electric vector that affects emulsions and light meters and this is the one we are talking about when we consider polarization. The polarizing filter can eliminate the one remaining plane of vibration in polarized light and, of course, eliminate the light because if light cannot vibrate, it cannot exist as light.

A polarizing filter is a sort of screen, a picket fence. A normal light ray, vibrating in all directions perpendicular to the ray, strikes the filter on one side, to emerge on the other side vibrating in only the one direction that corresponds to the gaps between pickets in the fence. But what about the light ray that is already polarized by reflection? If the direction of vibration in the ray does not correspond to the polarizer's pickets, it will not be able to pass through the fence. The ray will be stopped by the filter; thus, the reflected light never reaches the film, if the filter is over the camera lens.

The maximum effect of the polarizer occurs when the angle between the reflecting surface and the reflected ray is about 35°. At greater or lesser angles there is less polarization of the light. At a straight-on, 90° angle the reflections are largely unpolarized; therefore a polarizer will have almost no effect on these reflections.

The picket of the polarizer's fence, or its vibration plane, is in line with an indicator handle that projects from the mount of many of these filters specifically made for photographic use. Thus a ray of light will pass through the filter if its vibration is in line with the indicator handle.

A normal ray that is vibrating in all possible directions has, of course, one vibration plane that matches the vibration plane of the filter. But an already polarized ray may be stopped or absorbed, depending upon the position of the filter.

You can determine the relative positions of the polarized ray's vibration and the polarizer's pickets by looking at the photographic subject through the filter as you rotate it. Stand so your angle of view is about 35° to the reflecting surface. Gradually, as you rotate the filter, the glare or reflected light is reduced until it finally disappears. This is the position, as indicated by the handle, in which the filter should be placed over the lens to eliminate the reflection.

With the single-lens reflex camera, the polarizing filter can be placed over the lens at the beginning, and then the filter rotated as you look through the camera's viewfinder. When the glare or reflections disappear, the filter is positioned properly to eliminate them from the image.

Our discussion of the polarizing filter is not intended to imply that photographers should always attempt to eliminate all reflections and all glare. Reflections may add highlights and sparkle to a picture; glare may sometimes be a necessary part of the photographic interpretation. The use of the polarizer is indicated if reflections and glare are obscuring important texture and detail. This is often true when the photographer is attempting to shoot through glass; for example, through the glass of a store window to picture the window display. Remember, however, that the camera's angle of view must be about 35° from the surface of the window for the polarizer to subdue the reflections effectively. The same is true in eliminating reflections from water and other nonmetallic surfaces.

Because the polarizing filter's maximum effectiveness is limited to this rather critical angle its usefulness in photography is somewhat limited. In addition, don't expect to control reflections from shiny metal surfaces with this polarizing filter; it won't work. Light reflected from metal is not polarized, nor is the light reflected from paintings, murals, photographs, and other objects you may want to photograph. A polarizing filter over the camera lens alone is of little help. Control of reflections from metal or from pictures to be copied requires polarizing filters over the lights as well as over the lens.

The polarizing filter also darkens a blue sky, because light from the sky is reflected light, reflected or scattered by the atmosphere. Much of this reflected light is polarized. To use the filter to darken a blue sky, look at the sky through the filter as you rotate it. As the filter is turned, the sky darkens and then becomes lighter again as the filter is rotated further. You will note that the sky appears darkest when the indicator handle on the filter (if it has one) points at the sun. This means that the polarizing filter is most effective when the sun's rays come from a 90° angle to the line of direction between the camera and the subject.

Vibrations are filtered by the polarizer; wavelengths are not. The po-

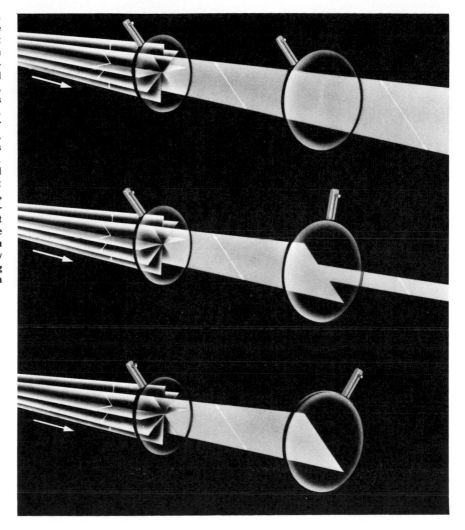

larizer has no effect on colors. It darkens a blue sky only because part
of the light from the sky is already polarized. Because it has no selective
effect on colors, the polarizer is an excellent filter for use with color films,
as well as with black-and-white. The polarizing filter is the only known
way of darkening the sky in color photography without altering the rendition
of other colors in the scene. This filter does not work well, however, with
hazy skies and has no effect at all on overcast days.

About one half the light reflected from the subject is absorbed by the
polarizing filter, and in order for this filter to be effective in darkening
a blue sky the camera must point at right angles to the direct rays of
the sun. This means the subject will be side-lighted or top-lighted, and

Figure 99. Reflection control with the polarizing filter. The photo at left was taken without the filter. Photo at right with the filter. Camera angle of view must be at or near 35° to the reflecting surface to achieve this effect.

this usually calls for an increase in exposure of one half to one full stop in addition to the increase necessary to compensate for the light absorbed by the filter.

## Neutral Density Filters

Neutral density filters reduce the amount of light transmitted to the film without selective filtering of any particular wavelengths, and they make no distinction between polarized and unpolarized light. These filters are neutral in the sense that they transmit and absorb equal amounts of all visible colors, and the relative brightness values in the subject remain unaltered. Neutral density filters have their primary application in shooting in bright sunlight with high-speed films, color or black-and-white. Some cameras cannot be stopped down enough to avoid overexposure with such a combination of intense light and fast film. In addition, even if the camera provides a shutter speed and $f$/number combination for correct exposure, the depth of field may be so great that it includes a sharply defined and distracting background. The neutral density filter provides the answer by

cutting the light that reaches the film to a level that makes a correct exposure possible or by permitting a large aperture for depth-of-field shallowness.

The following table shows the three most useful neutral density (ND) filters and how much each filter reduces exposure:

| Filter | Density | Reduces Exposure by (f/stops) |
|---|---|---|
| ND-3 (2X) | 0.30 | 1 |
| ND-6 (4X) | 0.60 | 2 |
| ND-9 (8X) | 0.90 | 3 |

Lower, intermediate, and higher densities are available giving exposure reductions in steps of one-third an f/stop. You can use two ND filters together to create greater exposure reductions: a .3 plus a .9 will give 1.2 (16X or 4-f/stop exposure reduction).

# Filter Factors

Because filters absorb some of the light, less light is reaching the film and exposure must be increased, either with a slower shutter speed or a larger aperture or both, to compensate for the light loss. The corrected exposure is determined by multiplying the no-filter exposure by a filter factor.

The filter factor depends upon:

1. The proportion of the light the filter absorbs.
2. The color sensitivity of the film.
3. The color of the light.

Generally, the deeper the color of the filter, the more of the light it will absorb and the higher the filter factor. In addition, the filter factor must be related to the useful light transmitted by the filter, and the useful light depends upon the color sensitivity of the film. Orthochromatic film, which is insensitive to red light, can be used with some filters, such as the polarizers, neutral density filters, and yellow, orange, and blue filters, but obviously not with red. Yet for all except the polarizers and the neutral density filters, the filter factor is different from that for panchromatic films. Also, the filter factor is nearly always less with tungsten light than with sunlight because tungsten light from photofloods, flash bulbs, and other incandescent sources contains a higher proportion of the long (yellow, orange, and red) wavelengths. The exception is the seldom-used blue filter, which requires a higher factor with tungsten light to compensate for the relatively small amount of blue wavelengths in the light.

If the filter factor is two, the shutter speed must be halved or the lens aperture opened one full stop. Either will double the exposure, or in effect, multiply the no-filter exposure by two. For example, if the no-filter exposure

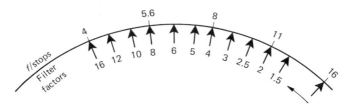

Figure 100. *Filter factors.* This diagram illustrates exposure corrections by changing the *f*/ number. It assumes an average sunlit subject with an unfiltered exposure of a shutter speed equal to or near the ASA number of the film and *f*/16.

is 1/125 at *f*/16 for a filter with a factor of two, correct exposure would be 1/60 at *f*/16, or 1/125 at *f*/11. If the filter factor is three, then correction can be accomplished by opening the lens one and two-thirds stops or by halving the shutter speed and opening the aperture about two-thirds of a stop. (See Figure 100.)

More than one filter can be used over the lens at one time, as for example, a polarizer and a colored filter. But then the two filter factors must be *multiplied,* not added, to get the correct factor for increasing exposure.

If exposures are determined with the guidance of a meter, the filter factor can be applied to the film-speed setting for the meter. Simply divide the factor into the normal film speed and set the meter for this new exposure index. *However, if you are taking your meter reading through the filter, as with a behind the lens meter of a single lens reflex camera, do not use the filter factor; the meter reads the light as corrected by the filter.* Some deliberate underexposure with a filter may result in enhancing the filter's effect on image contrasts. On the other hand, overexposures can reduce or even eliminate the filter effect.

Recommended filter factors are given in the following table for average conditions; for precise control of contrast, testing is usually necessary.

## Summary of Filter Effects with Panchromatic Film

Most photographers find use for filters of only three different colors, but they may use filters of two different intensities within one or more of these basic colors. The three are yellow, red, and green. Yellow filters are probably the ones used most frequently because they darken the rendition of blue, a wavelength of light to which film emulsions are overly sensitive.

In the list below we have included number and letter designations for the common filters that are frequently used because these filters are sometimes referred to by these numbers or letters rather than by color.

| Filters | Characteristics and Uses | Filter Factor |
|---|---|---|
| Medium yellow 8 or K2 | Absorbs ultraviolet, some violet, and blue. A correction filter in daylight. Useful in photographing scenery; darkens blue sky for cloud contrast. | Sunlight 2 Tungsten 1.5 |

| Filters | Characteristics and Uses | Filter Factor |
|---|---|---|
| Orange or deep yellow 15 or G | Absorbs ultraviolet, violet, and most blue rays. Contrast filter indoors and out. Darkens blue sky and blue water; enhances texture in outdoor subjects photographed under a blue sky; some haze penetration. | Sunlight 3 Tungsten 2 |
| Light green 11 or X1 | Absorbs ultraviolet, violet, some blue, some red. Correction filter under both sunlight and tungsten light. Excellent for outdoor portraits with sky as background, for landscapes and flowers. | Sunlight 4 Tungsten 3 |
| Medium red 25 or A | Absorbs ultraviolet, violet, blue, and green. Contrast filter. Spectacular effects with clouds, buildings, other objects against almost black sky; haze penetration; moonlight effects with slight underexposure in daylight; excellent for sunsets. Used with infrared sensitive film. | Sunlight 8 Tungsten 4 |
| Polarizer | Neutral gray in color, transmits rays of all visible colors; absorbs ultraviolet. Darkens blue sky; subdues reflections from nonmetallic surfaces to show texture and detail. Can be used with color film. | 3 or 4 |

*Note:* Filter factors given here are only approximate. Refer to the instruction sheet packed with the film or with the filter for exposure recommendations.

FILTER-USE GUIDE CHART

| Subject | Filter | Effect |
|---|---|---|
| Clouds, blue sky | Medium yellow | Natural |
| | Orange | Sky darker than natural |
| | Red | Very dark sky |
| | Red plus polarizer | Night effect |
| Marine scenes (boat, beach) | Medium yellow | Natural |
| | Orange | Dark water |
| | Polarizer | Cuts reflections |
| Sunsets | Medium yellow | Natural |
| | Orange or red | Brilliant contrast |
| Landscapes | Blue | Adds haze |
| | Medium yellow | Natural |
| | Orange | Haze reduction |
| | Red | Greater haze penetration |
| | Red with infrared film | Haze eliminated |
| Landscapes from airplane | Yellow | Natural |
| | Orange or red | Haze penetration |
| Outdoor portraits | Light green | Natural |
| Dark wood (like mahogany) | Red | Emphasis on grain pattern |
| Yellow wood (like oak, maple, walnut) | Orange | Emphasis on grain pattern |

| Subject | Filter | Effect |
|---|---|---|
| Light, blonde wood finishes | Medium yellow | Natural |
| Polished surfaces | Polarizer | Subdues reflections, detail revealed |
| Printed signs | Complimentary color to lettering | Increased contrast |
| Floral displays | Green | Lightens foliage, accents flowers |
| | Close to color of flower | Light blossom against dark foliage |
| Fall foliage | Yellow | Lightens yellow leaves |
| | Red | Strong contrast of red leaves against blue sky |
| Copying stained documents | Color matching stain | Subdues or eliminates stain |
| Blueprints | Red | Strong contrast |
| Glass objects (also pottery, china) | Polarizer | Subdues reflections |
| | Complementary color | Increased contrast to emphasize design or patterns |

# 12

# Action: The Fourth Dimension

The scene in front of us, which we may attempt to photograph, has three dimensions in space and a fourth dimension in time. In the generally accepted modern view, time is an inseparable part of material existence and pictures of the real world have greater validity and often greater interest if they convey a sense of both space and time. We depict the three dimensions of space on the surface of a photograph, which has only two dimensions, by using perspective and shading to create the illusion of the third, depth. But what can we do about depicting at least an illusion of the time dimension in a still photograph?

We become particularly aware of the time dimension when we notice objects moving about within the surrounding space. (Let's call it the *surround.*) Since this movement can take place only within the time dimension, if we can create an illusion of movement within the picture then we have also created an illusion of the time dimension. This gives not only a fuller depiction of the real world's dimensions, but it also gives animation to the picture. The animate is (or seems to be) alive, vital, dynamic; the inanimate is lifeless, passive, spiritless.

## Three Basic Techniques

We can represent movement in a still picture in three basic ways:

1. By a suggestion of suspended or potential movement.
2. By a blurred object against a sharp surround.
3. By a sharp object against a blurred surround.

### Potential Movement

A subject can be sharply imaged in a pose or position that unmistakably implies movement held in abeyance; that is, the image clearly implies that movement preceded the moment of exposure and continued the instant following. The visual implication of action momentarily suspended, or of action about to begin, can make dull photos into lively photos. It can be used effectively not only with the track star breasting the tape but with portraits and everyday scenes. Too often photographers ask the subject to "hold still" for the picture. The result is often dull, still, obviously posed. Try the other approach: don't hold the subject still; hold the image still. This technique has been called "stop-action" photography, but we really do not stop the action; we restrict the image movement on the film, enough so the finished print shows little or no evidence of motion blur. This we can do by using (1) fast shutter, (2) electronic flash, or (3) peak of action techniques.

*A fast shutter* will give us a sharp image if the image can move only very slightly while the shutter is open. How fast that will be depends upon these factors:

1. Our critical standard.
2. Speed of the subject.
3. Camera-to-subject distance.
4. Direction of the subject's movement.
5. Focal length of the lens.

To arrive at recommended shutter speeds for sharp pictures of action, let's use a fairly stringent standard: the movement of the image on the film must be restricted to approximately 1/400 of an inch. This is strict enough for enlargements of 35-mm negatives and we can use an actual shutter speed somewhat less than the formula's answer, if need be, without getting too much image blur.

Effect of the second factor is obvious: as subject speed increases, the chance for image blur increases, so the greater the speed the greater the need for a high shutter speed.

Distance is also a fairly obvious factor. You have no doubt noted that a subject moving at a constant speed will seem to be moving faster as it gets closer. This is because the closer the subject the larger the image on the eye's retina (or camera's film) and the apparent movement of the image increases with its size. The closer the subject the greater the need for a high shutter speed.

At any distance or any speed, the blur is greatest when the subject is moving *across* the field of view (at a 90-degree angle to the direction the camera is pointed). Hold your hand out in front of your eyes and move it directly toward and then away from you; the movement is only apparent in a fairly gradual change in size. Now move your hand from right to left. Obviously a higher shutter speed would be needed to stop that right-to-left movement.

Lens focal length affects movement of the image at the film plane in the same way as distance because the larger the focal length the greater the size of the image.

There is a mathematical formula that will allow us to apply all these factors and come up with the slowest shutter speed that will restrict the image movement enough to eliminate noticeable blur:

$$\text{Shutter Speed} = \frac{\text{Distance in feet} \times \text{acceptable image movement}}{\text{Focal length in inches} \times \text{subject speed in feet/second}}$$

A sample situation:
Distance from camera to subject: 50 feet.
Greatest permissible image movement: 1/400 of an inch.
Focal length of the lens: 2 inches.
Speed of subject: 20 miles an hour (30 feet per second).

So applying the formula:

$$\text{Shutter Speed} = \frac{50 \times 1/400}{2 \times 30} = \frac{0.125}{60} = \frac{1}{480} = \frac{1}{500}.$$

This is the answer (1/500 of a second shutter speed) for a subject moving at a 90-degree angle to the axis of the lens. For movement at approximately a 45-degree angle, the minimum shutter speeds can usually be one-half as fast (1/250 in this case), and for motion head-on, one-fourth as fast (1/125).

More image movement is permissible as negative size increases because the enlargement factor decreases. But this is counteracted by the fact that a larger negative size also normally means a longer focal length lens. So speeds figured for one camera with its normal lens will be reasonably accurate for other cameras. However, if you use a telephoto lens on any camera, the shutter speed must be increased. Roughly, figure that doubling the focal length of the lens is the same as reducing distance by one-half.

This formula can give us a set of suitable exposure times such as those included in the following table:

| Speed of Movement | Subject Distance in Feet | Shutter Speeds for Subjects Moving | | |
|---|---|---|---|---|
| | | Directly Head-on | At about 45° | At about 90° |
| Less than 5 m.p.h. (7.3 feet/sec.) | 12 | 1/125 | 1/125 | 1/500 |
| Pedestrians, parades, construction work. | 25 | 1/60 | 1/125 | 1/250 |
| | 50 | 1/30 | 1/60 | 1/125 |
| 15 to 25 m.p.h. (22 to 35 feet/sec.) | 25 | 1/250 | 1/500 | 1/1000 |
| Sports, city traffic, bicyclists, horse | 50 | 1/125 | 1/250 | 1/500 |
| racing. | 100 | 1/60 | 1/125 | 1/250 |
| About 50 m.p.h. (75 feet/sec.) | 25 | 1/500 | 1/1000 | 1/2000 |
| Fast moving cars, | 50 | 1/250 | 1/500 | 1/1000 |
| motorcycles, trains. | 100 | 1/125 | 1/250 | 1/500 |

Keep in mind that increasing the shutter speed requires increasing the size of the aperture to maintain correct exposure, and the wider the aperture the less the depth of field. Since we cannot focus precisely on a moving subject we must rely to some extent on depth of field to help us keep the image sharp. But we can often pre-focus on the spot where we expect the subject to be at the moment we trip the shutter. This is a technique used frequently in sports photography.

**Figure 101. High-shutter speed
reduces image blur.**

Of course, you cannot take time at the scene of action to work out
answers with this formula. Nor are you likely to carry a table of figures
around in your head. But either formula or table can give you an idea
of shutter speed requirements for various situations you may expect to
photograph. In practice we usually use the fastest shutter speed that the
circumstances—lighting, lens aperture, camera shutter, and film speed—will
permit. Keep in mind secondary movements that often exist, the swinging
arms and legs of a running person, which move much faster than the body.
If unwanted image blur still seems likely, we maneuver, if possible, to
get the subject approaching the camera at about a 45-degree angle or less,
or we try one of the following techniques.

*Electronic flash* is often used by sports photographers for indoor activities
and for outdoor night events. The flash from many of these units will
last only about 1/1000 to 1/2000 of a second, perfect for "stopping" almost
any athletic action. We rely on the duration of the flash to act in the
same fashion as a high shutter speed. You must, however, use shutter
speeds and lens apertures that will prevent an existing light exposure; this
can cause a "ghost" image of the moving subject. Also, with most of the
35-mm cameras that have focal-plane shutters you must use a shutter speed
of 1/60 of a second (1/125 with some cameras) to fully expose the negative
frame with the flash. (See Chapter 10.)

*Peaks of action* occur in many sports when the action is spasmodic,
so moments occur when the action is poised or suspended momentarily.
(See Figure 103.) Many of these peak of action moments provide some
of the most interesting and dramatic pictures. This is true of football,
baseball, diving, high jumping, and pole vaulting. In pole vaulting the
best picture is usually the one made as the athlete clears the bar, a time
when movement is virtually suspended for a fraction of a second. Shooting
at such a "peak" reduces the need for high shutter speed.

This technique puts particular emphasis upon:

1. *Knowledge of the sport,* important in any case, but particularly essential
   for catching peaks of action.
2. *Anticipating the action,* so you are in position for the climactic moment
   before that moment arrives. Check exposure and focus ahead of time
   as well.
3. *Timing the shutter release,* so the shutter is open at the climax of action.
   Get the picture as the boxer's blow lands, as the football reaches the
   pass receiver's hands. If you wait until you see the climax in the
   viewfinder, the shutter will be too late. The decision to fire must be
   made a fraction of a second before the climax. Learn how to take
   up the slack in your camera's shutter release so you can hold it just
   short of the tripping point until the crucial moment arrives. (See Figure
   104.)

Figure 102. Framing the action. In photographing a moving subject, it is generally best to give the subject room within the frame to move into. It is a bit disturbing to see the subject slamming into the picture's border.

Figure 103. Peak of action. Catching the subject at peak of action often provides the most interesting and story-telling photo and usually requires only moderate shutter speeds.

## Blurred Moving Object

In many situations it is worth considering deliberately shooting for a blurred image. A photograph of "stopped" action sometimes looks like no action at all. The sharp, unblurred image of a racing automobile against a sharp, clear background looks like it was taken when the car was standing still. Sharp images have their advantages, since they reveal aspects of the movement that we cannot see sharply with the eye, but if a sharp image of movement at a precise moment is not the important thing, a sense of motion can be imparted through the still photograph by letting all or parts of the image blur. (See Figure 105.)

Hold your hand in front of your eyes and move it back and forth rapidly while holding your eyes and head still. The moving hand blurs. A blurred photographic image triggers in the viewer's mind the memory of his previous observations of blurred movement and he associates the blur with the idea of movement. The blurred image of a moving object can be achieved, of course, simply by setting the shutter so it will remain open long enough for the moving object to achieve an appreciable change in position. The shutter speed needed to record a particular degree of blur will depend upon the factors discussed in the previous section.

A shutter speed slower than that needed to "stop" the movement will show a blurred subject against a sharp surround. If 1/500 of a second is needed to give a sharp image of the moving subject, 1/250 should give

**Figure 104. Timing. Catching the crucial moment in action shots is often a matter of timing the shutter release.**

**Figure 105. Blurred motion. Indication of movement can be conveyed in the still photograph with a blurred image.**

some noticeable blur, 1/125 should give pronounced blur. Usually we want to record enough of the basic form of the subject so it is recognizable; too much blur will destroy this basic form. Sometimes a shutter speed will be fast enough to record a nearly sharp image of a runner's torso but his arms and legs will be blurred—an effective illusion of motion and the time dimension.

### Sharp Object, Blurred Surround

Hold your hand out in front of your eyes again. This time move your head so your eyes remain fixed on the hand as it moves from right to left. Notice now that the background blurs while the hand remains fairly sharp. We can duplicate this effect in photography with a technique called *panning*, the final basic method of shooting action. Panning involves moving the camera with the moving subject. (See Figure 106.)

Imagine that your head is the hub of a wheel and the line of sight through the viewfinder of your camera is a spoke running from camera to subject. Keep that imaginary spoke straight by keeping the subject framed at a selected position in the viewfinder. (Not necessarily centered. It is often better to leave more space in front of the moving subject than behind it, so it seems to have space to move into.) This will force you to pivot with the moving subject, moving camera, head, arms, shoulders as one unit. Then trip the shutter *without halting the pivoting motion.*

With camera moving at the same speed as the subject the image stays in the same spot on the film while the shutter is open. This gives a relatively sharp picture of the moving subject, but the background will be blurred by the movement of the camera. It is important to keep the camera moving steadily and smoothly and essential that you follow through; keep moving with the subject while you trip the shutter and for a moment after.

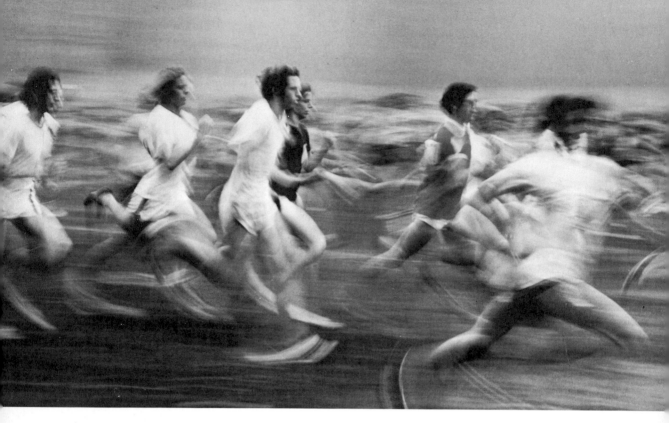

A sequence of images will also convey a sense of change with time, thus movement, but to be most effective this technique requires special equipment. In one sense, blur of a moving subject is a sequence of images, but we are referring here to a series of separate exposures in rapid sequence. You can manage about one shot a second with a cartridge-load camera or a 35-mm camera. To record a sequence of still photos of a moving subject at a faster pace requires a motor drive for advancing the film and tripping the shutter. Or a sequence of exposures can be placed on a single sheet of film with stroboscopic light—a light that flashes at intervals of a fraction of a second—as the subject moves.

**Figure 106. Panning. By panning the camera with the bodies they are kept relatively sharp, but arms, legs, and surroundings are blurred.**

The most important things to remember in photographing action are:

1. *Planning* for the expected situation based on all the knowledge you can accumulate about the situation in advance.
2. *Selecting the shutter speed and technique* for the situation and for the kind of image you want. When the action is repeated, try different techniques.
3. *Anticipating the action* so you are in position to take the picture before the time to shoot arrives.
4. *Timing the shutter release* to catch an important moment of the action.

## Summary

# 13

## A Little Darkroom Magic

Manipulations of the photographic image in the darkroom can produce a number of variations that sometimes seem to be a form of magic, although the basic processes are relatively simple and not difficult to learn. In this chapter we have included brief instructions for the basic techniques. Advancement to more complex manipulations is largely a matter of experimentation.

Figure 107. A photogram.

Photograms are photographic images made without a camera. Simply place a piece of enlarging paper on your regular easel, arrange whatever small objects are handy on the light-sensitive surface of this paper, expose with the enlarger light (or any strong exposing light), and develop. The result will be reverse (white) shadow images of the objects placed on the paper.

Experimenting with various objects arranged on a plain sheet of writing paper under regular room light can help you arrive at a pleasing composition. Then the objects can be moved to the enlarging paper under the darkroom safelight. You may find that a high-contrast enlarging paper (No. 4, 5, or 6), especially a paper that gives strong blue-black tones, will give the most satisfactory result. (See Figure 107.)

Use opaque, semi-transparent, or transparent objects to place on the paper, for example, small tools, string, flowers, leaves, plastic objects, bolts, screws, glass objects. Irregular glass objects break up the light into interesting patterns. Semi-transparent objects produce interesting patterns and tones. And you can apply your imagination in other ways than in selecting objects to be used: try multiple exposures on the same sheet of paper; try moving the objects between two exposures on the same sheet; try using the first photogram as a paper negative for contact printing a positive.

# Photograms

Textured prints can be produced in various ways, including the use of texture screens, deliberate graininess, and reticulation.

## Texture Screens

Texturing applied to appropriate photographic subjects can be a pleasing addition to suitable images, although adherents to the "straight photography" school would not generally approve. It is a matter of personal choice.

Commercial screens (ready-made texture screens on film) are available but rather expensive. These commercial screens come in sizes—8 × 10 or larger—for top-of-the-paper printing and also in small sizes for sandwiching with the negative in the enlarger. The large screens placed directly on top of the paper during exposure give a texture effect that is constant regardless of the degree to which the negative is enlarged. The small screens sandwiched with the negative give a variety of effects, depending upon the degree of enlargement, and sometimes the texture is enlarged so much that it overpowers the image.

You can make your own texture screens. A simple one can be a piece of white typing paper on which you have brushed soft pencil strokes. Lay this over the enlarging paper. Or you can coat clear acetate sheets with gels or petroleum jelly for brush-stroke textures. Apply the jelly while it is warm and liquid, brush it, then let it dry. Or you can make your own negative-size screens by simply photographing various textures such

# Textured Prints

as wood grain, brick wall, carpet, peeling paint, window screen. Meter carefully, then underexpose one stop so the negative will be thin for sandwiching with your picture negative.

## Graininess

The natural graininess of the negative can contribute an effective texture with some subjects. Graininess shows up most in middle-gray areas, so grain texture is best with scenes that have large gray areas and prominent or large forms. It usually is not effective with subjects that contain busy detail and an extensive range of tones. Low contrast scenes such as foggy scenes and seascapes are usually best. (See Figure 108.)

We deliberately develop graininess by treatment of the film. Use high-speed film because it has potentially large grain. If you can find a roll, try a recording film such as Kodak 2475 in 35-mm size. To deliberately produce grain, expose a number of frames to the same subject with a variety of exposures so you will have a choice of effects. Compose in the viewfinder so you will be enlarging a small part of the frame, a quarter or less, because the more you enlarge the greater the graininess effect.

Develop the film in a vigorous developer, such as Dektol diluted 1:1, for 2 to 4 minutes at 70°F (21°C). To print use high contrast enlarging paper or variable contrast paper with a high numbered filter.

**Figure 108. Texture from grain in the negative.**

Graininess can be added to the print made from a normal negative by using a grain screen as suggested in the previous section on texture screens, by sandwiching a grain screen with the negative or by double exposing: one exposure for the negative, the second for the grain screen. You can make your own grain screen for this purpose by taking a picture of a clear sky with high-speed film, develop in a vigorous developer, then raise the enlarger to its maximum height to get the largest grain image. It may require very long exposures.

## Reticulation

Film emulsions will usually crack into a crinkly pattern if the film is switched from a cold bath to a hot one, or vice versa. This effect is called reticulation. Experiment with copy negatives to avoid spoiling originals. You can make a copy negative simply by taking a photograph of an enlargement made from the original negative.

In processing this copy negative, develop it as you would ordinarily but use a non-hardening fixer, if possible, or leave the negative in a hardening fixer only about half the usual time. A hardened emulsion has a tendency to resist reticulation

Then chill the film in water at 50° F (10° C); follow immediately by immersion in hot water at 180° F (82° C) for two or three minutes. It may be necessary to repeat. Return the film to a hardening hypo or to a hardening solution of 10 per cent chrome-alum. The reticulated negative will give an effect somewhat like a texture screen, but different films and different temperatures will give different reticulation patterns.

# Bleaching

Potassium ferricyanide, in combination with hypo, acts as a bleaching agent on the photographic image because it dissolves the metallic silver that forms the image. (Potassium ferricyanide and hypo form what is sometimes referred to as Farmer's Reducer.)

The working materials you will need are a jar of powdered potassium ferricyanide, some wads of cotton, some small cotton swabs, a camel's hair brush or two, a small graduate (4 to 8 ounces), and we suggest that you don a pair of rubber gloves for this process. If you can find artist-type small brushes without the metal binding, these will be safer to use. The metal tends to react with the ferricyanide and can cause stains. If you must use brushes with metal, try placing a few drops of fingernail polish on the metal and down over the junction of brush and metal.

Dissolve about ¼ teaspoon of the powdered ferricyanide in 4 ounces of water; you want a solution that has a pale, lemon-yellow color. Mix only the amount you think you will need; the solution oxidizes and turns from yellow to green, so it cannot be saved. The exact strength of the solution is not important, except that you will not want it too strong. The

stronger it is the faster it bleaches and the easier it is to make a mistake in using it.

Lift the print to be bleached out of the hypo and let it drain well. You want it free of surface hypo; if necessary swab off the surface hypo or blow it off. Lay the print on a flat surface, like the bottom of an inverted print developing dray. Then apply the ferricyanide solution with a cotton swab or a brush with a fine point, depending upon the size of the area to be bleached. Apply the solution lightly and cautiously. It is best to do the bleaching in stages: apply a little bleach, then return the print to the hypo, where more bleaching will occur, for a few seconds, then examine. If more bleaching is needed, repeat. If you try to rush this, doing it all at once, you may find you have overdone it. One of the major dangers is using too much bleach.

Finally, the print must be thoroughly fixed, then washed and dried. A dried print can be returned to the hypo for a soaking and then bleached.

Ferricyanide can also be used to improve the print from an extremely flat negative. Print the negative on No. 4, 5, or 6 paper (or on variable contrast paper with a high numbered filter). Expose the paper normally or a little more than normally and overdevelop it to the point where it is very dark. Put it in the fix for a minute or two and then immerse the entire print in a weak (pale yellow) solution of potassium ferricyanide in a tray. Alternate the print between the hypo and the bleach until the desired image is achieved, then fix and wash as usual. This treatment increases the contrast of the image because the ferricyanide attacks most vigorously at the areas that have the least silver deposit, thus it removes densities from the highlights faster than it does from the shadows or the black areas.

## Dropout Prints

This technique involves printing for the highest possible contrast—only black and white. We must begin with a suitable subject, one with strong design elements (bold shapes and lines); we do not need rich detail. Expose your regular film in your camera in the usual way and develop as usual. Place the negative in the enlarger and prepare for the first step to high contrast or a dropout print—we are going to drop out the halftones, leaving only black and white.

You will need litho film, such as Kodak's Kodalith Ortho, and a red safelight because this film can be fogged by ordinary yellow safelights. Best results usually come from developing this film in Kodalith developer. It comes in A and B solutions, which are mixed for use 1:1. But you can use your paper developer. Development time is usually about 2½ minutes in Kodalith developer and about 2 minutes in Dektol. Use your usual stop bath and hypo. It is best to use 4 × 5 sheets of the litho film or even larger; if you expose 8 × 10 sheets you can then make contact

prints later on. And handle this film with extra care; fingerprints show up very readily and dust spots are a particular problem. The darkroom should be as clean as possible and it is a good idea to handle the film with clean, lintless cotton gloves.

Expose the litho film to the original negative and develop to a film positive. Litho film dries rapidly and you can speed the drying with a hair dryer. When the film positive is dry, print it by enlarging or by contact on another sheet of litho film to produce a negative. At this point you should have a negative in which most of the halftones have been dropped out. Repeating through the film positive and a second negative should drop all halftones. You can stop at any time and make a paper print with any of the positive or negative film images. (See Figure 109.)

Because white spots in areas that should be black are difficult to avoid completely, you should be prepared to paint out these light holes in the film negative or the film positive with artist's opaquing paint or with black ink concentrate that will adhere to the film, a product you may also find at art supply stores. You simply paint out the light holes caused by dust.

A variation of the dropout print is the bas-relief print. To make this proceed as suggested above in making the film positives and film negatives for dropout prints. Now tape the film positive to a clean piece of glass, emulsion side facing the glass, making certain it is flat. Place the negative (emulsion down) on top of the positive, and with a light underneath the glass position the negative so its image is slightly offset from that of the positive; now tape the negative down to the glass.

**Figure 109. Dropout prints. Photo at left is a positive print from a negative on litho film. Photo at right is a negative print from a positive on litho film.**

**Figure 110. Bas-relief print.**

Turn the glass over and place it film side down on top of a sheet of enlarging paper. Expose with the enlarger light or some other light source. Run test strips to determine the correct exposure. (See Figure 110.)

A variation of the bas-relief print: match the negative with the positive as exactly as possible. Place again with film side down onto a piece of enlarging paper but this time have the paper on a support that can be revolved—a lazy susan from the kitchen will do. Start the turntable spinning at about one revolution a second, then turn on a light in a reflector that has been positioned off to one side and aimed down at the turntable at about a 45-degree angle. Keep the turntable turning all during exposure. Exposure will depend upon the speed of the paper emulsion, the densities of the positive and negative, and the intensity of the light. Running a test strip or two should establish the correct exposure. Develop the exposed paper in your normal way. You should get a bas relief effect similar to that in Figure 110. The light slips through between the opposite densities of the negative and positive at the point where image lines occur.

An image that seems to be a combination of both positive and negative elements is commonly referred to as a solarized image. It is created by re-exposing the print (or film) part way through development and then continuing the development. The result is a partial reversal of the image, an effect discovered by a French doctor and scientist, Armand Sabattier, so it is also called the Sabattier effect. True solarization is the reversal of the image by extreme overexposure, about 1,000 times what would normally be given.

The image shown in Figure 111 was produced in the following way: a normal exposure was given the enlarging paper from a normal negative. The paper was placed in a standard paper developer with agitation started immediately and continued constantly for about 20 seconds. Then, when the print image appeared to be no more than 30 per cent developed, it was jerked from the developer, quickly placed on an inverted developing tray and wiped as quickly as possible with a large sponge, damp with plain water. The moist sponge picks up the surface developer solution. This must be done quickly to avoid streaks from uneven development.

Then the print was flashed with white light, in this case merely by switching on the overhead darkroom light, a 150-watt bulb about 10 feet

# Solarization

**Figure 111. Solarized print. A regular print from the same negative is shown for comparison.**

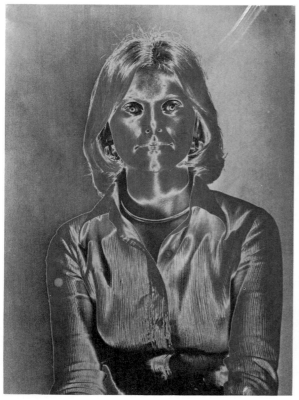
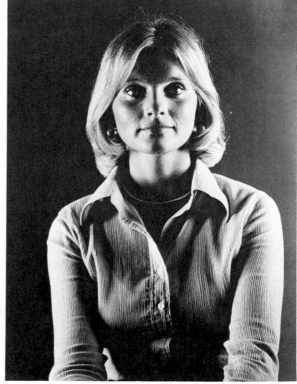

from the print; the light was switched on and off as rapidly as possible. Next the print was returned to the developer and again agitated constantly for about 10 seconds. (It can vary from 7 to 15 seconds.) Pull the print from the developer before it turns black. Finally, it is processed as any normal print, through stop, hypo, and wash.

Results with the solarization technique can be unpredictable; only experience and detailed records of every procedure followed during each step make it possible to develop control. The variations are many. You will probably find that using a contrasty negative and high-contrast paper will generally give the best results; solarization tends to flatten the image. Results vary particularly with the length of the first development period and with variations in re-exposure. Some photographers rinse the print in a tray of water for about 30 seconds after the first development instead of wiping it with a damp sponge.

Still another variation involves solarizing the film instead of the print. Usually this is done by exposing the original negative to a sheet of Kodalith film and developing it as described in the procedure for dropout prints. This will be a film positive and it is used to expose a second sheet of litho film to get a negative, which is solarized by partial development, re-exposure, and further development.

# Spotting and Mounting

White spots or lines on a print are usually caused by dust or lint on the negative during exposure of the paper. The best practice is prevention: keep negatives protected as much as possible; keep the darkroom clean; clean negatives carefully before printing. When white spots do show up, you may find it possible to "gray" them to about the same tone as the surrounding image with a soft lead pencil, if the print is on a matte surface. On a luster or glossy surface, pencil marks will not stick, so you will have to use either water-soluble spotting colors (such as Eastman Spotting Colors) or dyes (such as Spotone).

The water-soluble paints stay on the surface of the emulsion and thus tend to reflect light differently than the surrounding print surface. But they can be wiped off easily if you make a mistake in spotting. It may be worthwhile to practice with these water-soluble paints before trying the dyes, which are absorbed by the print emulsion and cannot be removed once they have soaked in.

Dyes come in various tones, but a neutral black is probably the most useful, or you can buy a set of three (neutral, blue-black, and olive) which can be blended to match many print tones. Using a water color brush that will give a fine point, dip a brushful of dye into a saucer, then a brushful of water next to the dye. Mix to get the tone you think you need. Then wipe the brush on a blotter or paper towel, stroking lightly

to form a fine point and until most of the liquid has been removed from the brush.

Holding the brush vertically, or nearly so, touch the point lightly to the margin of the print. That will show the tone of gray you have in the brush. If it matches an area surrounding a white spot in the image, then attempt the spotting by touching the point of the brush to the spot. Use a stippling technique, gradually building up the tone by repeatedly touching the brush point to the spot. Practice with a waste print.

To get darker tones, use more dye, less water. Work slowly and with brush more dry than wet. The best that can be done with some spots is simply to subdue them, not eliminate them.

## Mounting

Mounting prints on mount board is best done with dry-mounting tissue and a mounting press. The dry-mounting tissue is a shellac-impregnated sheet placed between the print back and the mount board; heat melts the shellac and, under pressure, print and mount stick together.

Preheat the print to make sure it is flat and dry. Then tack the tissue to the back of the print by touching the tissue at a spot near the center with a hot tacking iron or point of a clothes iron. Trim tissue and print together.

Preheat the mount board to drive out moisture, then place the print on the mount and tack the tissue to the board by lifting the print corners. Slip print and mount into the preheated (about 250° F) mounting press. Put a clean sheet of paper over the face of the print, then close the press for 15 to 20 seconds.

It is possible to do this with a clothes iron with heat control set between silk and wool. Tack tissue to print and mount, then place wrapping paper over the face of the print and apply the hot iron with slight pressure to the center of the print area and move the iron outward to the edges of the print, repeating several times from center to all corners and all edges. Check to see that the print has adhered to the mount; if not, repeat.

Unless you trim print and mount flush, it will usually look best if the bottom mount border is wider than the top border (about 30 per cent wider), so the print will not seem to be slipping. Side borders should be at least as wide as the top border.

# 14

# The Chemistry of the Emulsion

In this chapter and the following two we will be involved, although not really deeply, in some of the scientific aspects of photography, with the chemistry of image formation, specifically, and with analysis of the image. A feeling for what goes on in the emulsion can give the photographer a greater feeling of understanding and control over his medium, in the same way as understanding what happens to light as it is gathered and focused by the lens can give us greater control.

First we must deal with the recording of the image formed by the lens, and this gets us involved with photochemistry, the transformation of radiant energy (light) into chemical energy. Examples of photochemical reactions include the production of vitamin D in the tissues of living animals, the tanning (or in the case of an overdose of light's energy, the sunburning) of skin, and the fading of dyes in the living-room couch fabric where sunlight strikes it regularly. Living plants combine the energy (the quanta) from sunlight with chlorophyll to make carbohydrates (sugar and starches) and carbon dioxide and water, a process known as photosynthesis. The photochemical reaction important in recording the photographic image is the opposite of synthesis; it is a decomposition.

A photochemical reaction is one that involves the absorption of light energy, but not all such reactions are of any value in photography. For photography we must have a system that:

1. Responds in a highly predictable way to the impact of light.
2. Reacts in direct proportion to the amount of light absorbed.
3. Provides a permanent result, will not fade or decompose.
4. Has high sensitivity to light.

Certain compounds of silver meet these demands. These silver salts are unstable; that is, they decompose readily under the impact of light energy, and in decomposing they form finely divided metallic silver, jet black in color. This decomposition is, under normal circumstances, proportional to the amount of light absorbed, and the silver is a relatively stable product that gives a permanent or fixed account of the reaction.

But can the silver compounds pass the fourth test, high sensitivity to light? They must be exposed to strong light for a long time before their decomposition becomes visible in the form of a deposit of metallic silver. (You can check this. Put an unexposed piece of film, emulsion side up, beneath a strong light, then place a coin or other small, opaque object on the film. Lift the coin after an hour or so.) But the silver salts are very sensitive to light, only a small amount of light (a few quanta) will initiate the decomposition of the salts. This beginning is so small we cannot detect it even under the most powerful of microscopes, but later develop-

ments prove that the change, however small, does exist. We need a name for it. It is traditionally called the *latent* (that is, invisible) *image*.

To get a visible image we must move on to the second stage in the process: *development* of the latent image, a purely chemical reaction in which light energy plays no further part. During development the latent image is built upon and greatly magnified until it becomes visible.

Most silver compounds are photosensitive, but for photographic purposes the ones of transcendent importance are those compounds in which silver combines with one of the *halogens*, a family of very active chemical elements. The family includes fluorine, chlorine, bromine, and iodine. When any member of this family combines with silver the result is a *silver halide*, and the silver halides are among the rare compounds that form a latent image. Only three of the silver halides are in general use in photography:

## The Halides

1. Silver chloride, used for slow (contact) printing papers.
2. Silver bromide, used for films and fast (enlarging) papers. Many enlarging papers contain a mixture of chloride and bromide.
3. Silver iodide, used in small amounts with silver bromide in fast film emulsions.

Of the three halides, by far the most important in photography is silver bromide. The bromide grains take various sizes and shapes, but most are hexagons or triangles that measure 1/1,000 to 4/1,000 of a millimeter (1

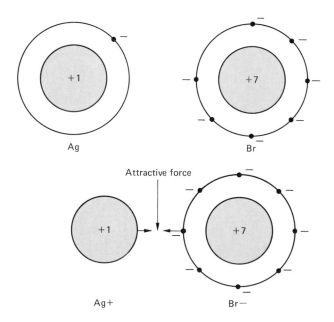

Figure 112. Silver bromide. An atom of silver has one electron (a minus electrical charge) in its outer orbit, balancing the plus charge of its nucleus. A bromine atom has seven electrons in its outer orbit, but would like one more to fill that orbit. So when a bromine atom gets near a silver atom, the bromine grabs silver's lonely electron. This produces two ions: a bromine ion with a minus charge because it has that extra electron and a silver ion with a plus charge because it has lost that electron. Opposite electrical charges attract each other, so the two ions are held together by this attractive force in an ionic compound called silver bromide. Such ionic compounds are as common as table salt, a combination of sodium and chlorine ions.

**Figure 113. The bromide crystal. The silver and bromine ions in the silver bromide crystal form a three-dimensional lattice structure. The two kinds of ions arrange themselves alternately in every direction so that each silver ion is normally surrounded by six bromine ions and each bromine ion is surrounded by six silver ions.**

to 4 microns) in width. In forming these crystals the silver and bromine take the form of ions. (See Figures 112 and 113.) Each silver bromide crystal (or other halide crystal), so tiny it can be seen only under a powerful microscope, is made up of one billion or more silver ions and an equal number of bromine (or other halogen) ions, arranged alternately in every direction, except for irregularities or cracks where one or the other ion is missing. Some of these cracks are on the surface of the crystal and they are very important, as we shall see in the next chapter.

## The Emulsion

To be useful in photography, the silver halides must be suspended in some sort of medium that will keep each crystal or grain separate from its neighbors. Gelatin, a colloid extracted by boiling animals' bones, hooves, horns, and hides, will do this and more. The gelatin used in photography generally comes from the ear and cheek sections of calf hides. Gelatin made from the hides of calves or cows is especially useful in photography because cows like a bit of spice in their diet; they eat hot-tasting plants, such as mustard, which contain sulfur compounds, and these sulfur compounds aid in the photochemical reaction that creates the latent image.

In addition to providing minute amounts of sulfur compounds, which act as sensitizing agents, gelatin is the ideal medium for preparing the photographic emulsion because:

1. It is liquid when warm but sets to a gel when cool.

2. It dries to a hard compact, uniform layer.
3. It swells in water or processing solutions but does not dissolve or disintegrate at temperatures normally used in photographic processes.
4. It holds both the silver halide crystals and the developed silver image firmly in place.
5. It is insoluble in cold water but absorbs up to ten times its weight in water.
6. It can be hardened with such agents as formaldehyde or alum.
7. It is a bromine acceptor; that is, it combines readily with small quantities of bromine freed from the halide crystal during the photochemical reaction that creates the latent image.

Making an emulsion can be conveniently divided into five basic steps: precipitation, ripening, washing, digestion, and coating.

## Precipitation

First the silver halide is precipitated in a dilute gelatin solution. This is accomplished by adding silver nitrate ($AgNO_3$) to a solution of a soluble halide, such as potassium bromide (KBr). The reaction is a simple double decomposition that produces silver bromide (AgBr) and potassium nitrate ($KNO_3$).

$$AgNO_3 + KBr = AgBr + KNO_3.$$

The silver bromide is almost insoluble, so most of it separates out or precipitates. All other compounds involved on both sides of the equation are soluble, but because the silver bromide is not, it will coagulate or clot into a pale yellow mass or curd and settle to the bottom.

This coagulation and settling of the silver bromide can be prevented by letting this reaction take place in the presence of gelatin. The gelatin and the potassium bromide are dissolved together in water and then the silver nitrate is added. Each grain of silver bromide formed by the chemical reaction is held in suspension by the gelatin, prevented from coagulating with its neighbors and prevented from settling out. The silver halides at this point in the process are not very sensitive to light. The precipitation stage of emulsion-making is usually performed under a dim red light.

The method of mixing the silver nitrate and potassium bromide solutions is important. If the nitrate solution is dumped quickly into the potassium bromide-gelatin solution, many small crystals of silver bromide will be formed. If the silver nitrate is added very slowly, the first few crystals of silver bromide will act as collection centers for further crystals, and the result is larger and fewer crystals.

Many small crystals give an emulsion of low sensitivity (or slow film speed) but high contrast; fewer but larger crystals mean high sensitivity (or high film speed) but relatively low contrast.

Other controls are also available during the precipitation stage. Still finer grain emulsions are usually prepared by increasing the quantity of

gelatin involved. Varying the concentrations of silver nitrate and potassium bromide will also alter the grain size. Potassium bromide is generally in excess, that is, present in quantities larger than necessary to react with all the available silver nitrates. (We shall see why when we reach the next stage of emulsion-making.) For high-speed emulsions some iodide is added. This changes the size and shape of the crystal grains of silver bromide and boosts their sensitivity to light, probably because it affects the nature of the cracks or imperfections on the surface of the crystal lattice. The importance of this will become clearer during the discussion of the latent image theory in the next chapter.

## Ripening

The second stage in emulsion-making is ripening. It may, in practice, be combined with the first stage. Ripening simply involves heating the gelatin solution to 90° F (32° C) or perhaps higher and keeping it at this high temperature for from 30 minutes to several hours. During this process the silver halide grains decrease in number but increase in size. At the same time, they increase in light sensitivity (or film speed) as well because large grains are more sensitive than small ones. Silver bromide is slightly soluble when an excess of the alkali halide (potassium bromide in this case) is present in the solution. The solubility of the silver bromide can also be increased somewhat by the addition of ammonia. Small silver halide grains dissolve and then recrystallize out on the large grains; the large grains grow larger at the expense of the smaller ones. In addition, the ripening process may be increased by two or more adjacent grains overcoming the cushioning effect of the gelatin under the influence of the heat. In that case they may come together to form a single large crystal.

Steps one and two in emulsion-making, taken together, help explain how manufacturers achieve a variety of emulsions. If rapid precipitation and short ripening are combined, the result will be a large population of small silver halide grains distributed thickly throughout the emulsion (low speed, high contrast). If slow precipitation is combined with a long ripening period under high heat, the result will be larger grains but significantly fewer of them in any given area of the emulsion (high speed, low contrast).

## Washing

Near the end of the ripening period more gelatin is usually added, and then the solution is allowed to cool so that it will set or gel. Next it is shredded into noodles and washed to eliminate the soluble potassium nitrate, the excess potassium bromide, also soluble, and any other unwanted elements or compounds, such as ammonia, added to aid ripening.

## Digestion

During digestion, also called after-ripening, the emulsion is remelted and kept heated again for perhaps several hours. The compounds that made the silver bromide soluble during the first ripening period are now gone, so there is no further growth in the size of the grains. But there is an increase in sensitivity and contrast, which is largely controlled by the nature of the particular gelatin added at the end of the first ripening period. This change occurs because chemical sensitizers added with the additional gelatin attach themselves to the surfaces of the halide crystals. It is here that the sulfur compounds, ingested by cows or added by the manufacturer, play their role. Gold compounds and even silver may also be added as chemical sensitizers. These sensitizers produce specks of silver sulfide, or of gold or silver, or a mixture of these on the surface of the

silver halide crystals. These specks, or sensitivity centers, tend to form at the cracks in the crystal lattice. It is generally agreed that these specks play an important role in the formation of the latent image, although there is some disagreement on precisely what this role is.

After digestion is complete, hardening agents may be added to the emulsion to increase the gelatin's resistance to stress and strain caused by the swelling it undergoes during developing, fixing, and washing. Hardeners are usually salts of aluminum or chromium (alum or chrome alum) or formaldehyde.

At this stage further chemicals are often added to achieve an emulsion of the desired characteristics. Among the most important of these for modern-day films are the *optical sensitizers*. These are dyes used to extend the color sensitivity of the silver halides, which are normally sensitive only to the radiation energy of ultraviolet, violet, and blue, with some small

sensitivity in the case of silver bromide into the green range of the spectrum. Dyes added to the emulsion in extremely small amounts stick to the surface of the halide grains and sensitize the grain to all the wavelengths the dyes absorb. A red dye, for example, absorbs green light and thus sensitizes the halide crystals to green. A cyan-colored dye that absorbs red light sensitizes the halides to red.

Thus we have three general classifications of emulsions according to their spectral (color) sensitivity:

*Orthonon* (ordinary or sometimes color-blind) emulsions have not been optically sensitized. (No dyes have been added.) They are sensitive only to violet and blue. Printing papers may be coated with this type of emulsion, but only a very few films, designed for special purposes such as copying, have this undyed emulsion.

*Orthochromatic* emulsions, like the orthonon type, are naturally sensitive to violet and blue but have been dyed so they are also sensitive to green.

*Panchromatic* emulsions are sensitive to all colors of the visible spectrum, including red. Most films used in ordinary photography today are panchromatic. (If "pan" appears in the name of the film it is a panchromatic

film, as Panatomic-X; but others are also panchromatic even though "pan" is not included in the name, Plus-X and Tri-X, for example.)

## Coating

Only one process is now left: coating the emulsion on a suitable support—paper, celluloid or plastic film base, or glass. The liquid emulsion is fed onto the support to give a layer about 1/1,000 of an inch thick, although this may vary according to the use for which the emulsion is intended. In some cases a double coating of emulsion is used. A top dressing or super coating may also be added; this is a thin layer of plain gelatin to protect the silver halide emulsion from scratches and bruises. In the case of printing papers, a substratum coating may be put on the paper base first. Usually this is a layer of barium sulfate (often called baryta), an inert, intensely white substance that forms an excellent reflecting surface. This sublayer can be modified to give the matte, semimatte, or glossy effects.

Still another coating is often applied to the rear surface of films. This is to prevent halation and is called the *antihalation backing*. Light from a bright source often penetrates emulsion and support but is scattered by deflection off the halide grains; some of these rays may be reflected from the rear surface of the film base. This means they return through the support and reach the emulsion again to expose more halide crystals. The result is a ring or halo effect around the original image of the bright light source. This is *halation*. This effect commonly occurs in night photographs when street lights or other bright point sources of light are included in the picture. Because these bright image spots are overexposed, there are enough light rays involved to create the halo effect; with weak light sources, this effect does not occur because the halo image is sublatent, that is, so weak it does not cause enough photochemical change in the silver halide crystals to make them developable. The antihalation layer contains a dye that absorbs the light that penetrates and prevents it from returning to the emulsion layer. The effect of halation can also be reduced by using a very thick film base or by using a gray base to absorb much of the halo reflection. (See Figure 114.)

The antihalation backing is incorporated in a gelatin layer, which also helps keep the film from curling toward the emulsion side. The dye disappears during the processing of the film because its color is destroyed by one of the chemicals in the developer solution.

**Figure 114. Film cross-section. This drawing of a cross-sectional view of film shows the various layers greatly enlarged.**

Top coating
Emulsion

Film base

Antihalation backing

Once all necessary layers have been coated on the emulsion support it is ready to be chilled to set the emulsion, dried, and cut to whatever size is wanted. Billions of silver halide crystals wind up in the emulsion of each sheet of film or paper, and they make up 30 to 40 per cent of the weight of the emulsion layer itself, although individually they are extremely small. If the silver bromide crystals were approximately the size of your little fingernail, the emulsion would be a foot thick.

# 15

# The Chemistry of Exposure and Development

The light that surges through the lens for the moment or fraction of a moment that the shutter is open is enough to bring about an invisible change in some of the billions of silver halide crystals in the emulsion of the film. That change is the latent image.

The creation of the latent image is apparently quite complicated and more than a little bit perplexing, in fact, so much so that theories about it are based to some extent upon guesswork, although very educated guesswork. It appears, however, that the formation of the latent image proceeds in these four steps:

1. Light energy (in the form of quanta or photons) is absorbed by the silver halide crystal.
2. The light energy knocks a few electrons free from the halogen ions in the silver halide crystal. These electrons can then dash about within the crystal more or less at will. The more light energy absorbed the more free electrons.
3. The electrons are quickly trapped, however, by the cracks and alien chemicals in the crystal structure.
4. A negative charged electron attracts a positive charged silver ion; the two join to form an atom of silver at the trap site. Still more electrons are trapped; more silver ions arrive; more silver atoms are formed. This colony of metallic silver is the latent image.

All of this, beginning with the exposure to light, takes place in the smallest possible fraction of a second. It is virtually instantaneous. Electrons, ions, and atoms dash about within the halide crystal at tremendous speeds, and they need to travel less than 1/1000 of a millimeter before they are trapped.

The larger the silver halide crystal the more light energy it intercepts and the more likely it is to have cracks and sensitivity centers that form effective traps where colonies of silver collect. Therefore, the larger the crystal the more likely the formation of a latent image. This appears to be the reason that grain size and film speed increase together.

# Development Theory

Once the latent image has been formed, we can proceed to the development of the visible record of the exposure. The essential function of a developing solution is to convert to metallic silver those silver halide grains that were partly decomposed by exposure to light. Development amplifies the latent image by depositing more silver upon the colonies of metallic silver created by the exposure. This amplification is of major proportions. If we assume

Figure 115. Photomicrographs of halide grains. The photomicrograph at the right shows grains from a typical negative emulsion. The left photomicrograph shows the same grains after development. Magnification is about 2,500 times.

that the latent-image deposit of silver on a single halide crystal contains perhaps ten atoms of silver, then development increases this amount at least one hundred million times, and perhaps as much as a billion times. To develop or magnify the latent image we get additional metallic silver from the silver halide crystals themselves, through the process the chemist refers to as reduction. (See Figure 115.)

## Reduction

If the atoms of one element (such as silver) give up electrons to another element (or group of elements), the two form a combination or compound. (See Figure 112.) Oxygen is the prototype of the elements eager to lap up extra electrons, but the halogens (fluorine, chlorine, bromine, and iodine) are even more eager in this respect. The chemists have developed a terminology for discussing such a reaction or interchange of electrons. They say the element that gave up electrons has been *oxidized* (a victim of oxygen's or some other element's electron greed). At the same time the element (or group of elements) that acquired the electrons has been *reduced*. *Reduction*, then, means electrons gained; *oxidation* means electrons lost.

If we bring silver and bromine together, the result is silver bromide. The silver has been oxidized (lost electrons) and the bromine has been reduced (gained electrons), leaving silver ions linked with bromide ions in a compound. Now, if we can make this reaction reverse itself, each silver ion will gain an electron to become again an atom of silver. In this reverse reaction the silver will be reduced.

Substances, then, that are capable of breaking up such combinations

as silver bromide are called reducing agents; they provide electrons to replace those lost by the silver. These agents are themselves oxidized in the process. We might think of development as, essentially, a two-step process:

1. Reduction: Reducing agent $\longrightarrow$ free electron + oxidized reducing agent.
2. Oxidation: Free electron + silver ion $\longrightarrow$ silver atom.

The actual development reaction is more complex than this, but it is essentially a transfer of electrons from reducing agent to silver.

When film (or paper) is immersed in a developing solution, the colonies of silver atoms on the surfaces of the exposed silver halide crystals act as development centers because they are transfer points for electrons moving from reducing agent in the solution to join silver ions in the halide crystals. Thus the entire exposed crystal can be converted to black, metallic silver, and this is the amplification of the latent image to the point where it becomes a visible image. In normal development only crystals that were hit by light, and thus have development centers, will be reduced.

### Reducing Agents
Among the reducing agents that have just the right energy level for photography are a number of organic compounds, that is, compounds

containing carbon. Most photographic reducing agents in general use are derivatives (chemical "cousins") of benzene, a compound of carbon and hydrogen.

Perhaps the most popular reducing (developing) agents are Metol, hydroquinone, Amidol, and Phenidone.

Metol was the original trade name for a complex compound first used as a developing agent in 1891 and still widely used today. Its proper chemical name is quite formidable (but also chemically quite descriptive): paramethylaminophenol sulfate. But in photography it is referred to as Metol, or by one of its other trade names. For example, it appears in some Eastman Kodak developers in a form somewhat altered to improve its stability as Elon. Metol is a powerful developer that works rapidly and is effective in producing shadow detail—in other words, it will go to work even on those silver halides that received a bare minimum of light.

Hydroquinone (in proper chemical terms: 1,4-benzendiol) has relatively low energy and as a result is a sort of reluctant performer and loses shadow detail in the image. But it works well on image highlights, especially so

as development time increases. Formulas which combine Metol and hydroquinone are among the most popular and satisfactory of the developers used today. The combination gives a balanced developer that works well on both image shadows and highlights, keeps well, and gives predictable image contrast under changes in development time. They are frequently referred to as MQ developers.

Amidol (2,4-diaminophenol dihydrochloride) is energetic and can even develop films in a weak acid solution. But it oxidizes readily upon contact with the air, and so does not keep well in solution. Amidol developers can produce rich black tones in prints.

Phenidone is the most commonly used developer that is not a benzene cousin. It is a concoction (1-phenyl-3-pyrazolidone) introduced and protected under the Phenidone trade name by Ilford, Ltd., of Great Britain. Small amounts of this chemical give effective developing solutions that often have fine-grain characteristics.

Dissolve any one, or even two, of these agents in water, place the exposed film in the solution, and you will very probably be disappointed. Reducing agents are essential, but other ingredients are needed, too, for a photographic developing soup that is effective under ordinary conditions.

# The Developing Solution

Photographers may, and often do, prepare their own developing solutions, and these mixtures sometimes contain almost everything short of eye of frog and ear of newt. Ready-made developers are also available in packages and cans that contain all the necessary ingredients, usually in granulated form. Dissolving the powder in water is all that is necessary in the darkroom. Whether a do-it-yourself or a ready-made product, the photographic developer generally contains five basic ingredients, basic because each is added to perform a basic function regardless of the details of the solution formula. Quantities and individual chemicals may vary, but the classification of ingredients based on function remains the same. The five basic components of a developer solution include, of course, the developing or reducing agent, which has already been discussed in general terms. The four others are the solvent, the activator, the preservative, and the restrainer.

## Solvent

Essential, of course, is a solvent in which the chemicals can dissolve, and this is nearly always plain water. It is seldom necessary to use distilled or chemically pure water, although occasionally impurities can cause trouble.

The water, in addition to acting as a solvent, has other uses in photographic development. It penetrates and swells the gelatin of the emulsion. In penetrating the gelatin, the water carries the other chemicals of the developing solution to the silver halide crystals; no reaction can take place,

of course, unless the silver halides and the developer come into actual contact.

## Activator

Most photographic reducing agents perform their appointed task promptly and efficiently only if they are in an alkaline solution. This means we must add an alkali to the developing solution to activate the reducer. The alkali, in effect, encourages the reducing agent to ionize or dissociate, that is, to split in solution into positive and negative ions. When this happens, the negative ions have electrons available that they readily donate to the positive silver ions of the silver halide crystals.

The type of alkali used and the amount used to a large extent control the activity of the developer. A strong alkali produces a rapid-acting developer that also produces high contrast; a weak alkali gives a relatively slow developer and less contrast. Alkalies used most often as activators in photographic developers, listed in order of increasing activity, are

Borax or sodium tetraborate
Kodalk Balanced Alkali (a sodium metaborate)
Sodium carbonate
Sodium hydroxide

Why not always use a strong alkali such as sodium hydroxide, since it means rapid development? The alkali, in addition to promoting ionization of the reducing agent, also softens the gelatin of the emulsion, and the stronger the alkali the greater this softening effect. If this is carried too far it may result in damage to the emulsion during processing. Also, a strong alkali can result in fog when the reducing agent attacks the unexposed silver halide crystals. The strongest alkalies are usually avoided, except when the objective is a high-contrast negative.

## Preservative

In a solution of reducing agent and alkali, the reducer is not particularly selective about the elements with which it reacts. In fact, it reacts very readily with the oxygen from the air and in the process is oxidized. As a consequence it is no longer an agent for reducing the silver halides. To preserve the reduction potential of the agent until it can reach the silver halides, a preservative is added to the developing solution. Almost without exception this is sodium sulfite.

The reaction of the reducing agent with oxygen from the air is another extremely complex one, and just how the sulfite inhibits this reaction is not precisely known in the case of every developer with which it is used. The sulfite itself has an affinity for oxygen, but this alone does not satisfactorily explain its functions as a preservative. Apparently the reducing agent, in reacting with the oxygen, forms intermediate compounds such

as quinone. These intermediate compounds act as catalysts that encourage further reaction between the reducer and oxygen. It is believed that the sulfite puts a stop to this catalytic action by reacting with and thus canceling out the intermediate compounds.

Sodium sulfite is also a mild alkali and as such can act as a very mild activator; in a few developing solutions the sulfite is permitted to play both roles, activator and preservative, and no additional alkali is added.

## Restrainer

Sometimes a mixture of the various developer solution ingredients results in exactly the right combination except that the reducing agent displays a tendency to reduce the unexposed silver halides as well as the exposed ones. This obviously undesirable lack of discrimination needs to be checked, so a fifth ingredient is added to the solution, the restrainer. This is usually potassium bromide. The action of the potassium bromide is still another of those complex and not fully understood processes in photographic chemistry. It appears, however, that the compound ionizes in solution and the bromide ions that carry a negative charge attach themselves (the chemical term is *adsorb*—note this is not the same as *absorb*) to the silver halide grains. This forms a barrier of negatively charged ions, which the electrons of the reducing agent find difficult to penetrate, except, apparently, at points on exposed grains where latent-image specks exist. The bromide retards reduction of the silver halides in general, but its effect is greatest on the unexposed crystals. Thus it restrains the formation of fog, which is nonimage silver.

Tossing all these ingredients into a single pot will produce not, as it might seem, a noxious witch's brew, but an effective photographic developer. Actually, for special purposes some additional chemicals may be added, or one or more of the so-called basics may be omitted. Potassium bromide is most often left out of today's developers because it does have a tendency to reduce the effective speed of the film emulsion. The bromide tends to restrain the reducing agent's attack on silver halide crystals that received a marginal exposure, that is, just barely enough exposure to form a minimum in developable latent-image silver. Other antifoggants may be added in addition to or as substitutes for potassium bromide. For developers that must be used at high temperatures, sodium sulfate is sometimes added because it prevents the gelatin from swelling too much. Fine-grain developers sometimes include a silver solvent, such as sodium thiocyanate, which dissolves a portion of each grain of image-forming silver, thus reducing grain size. However, this is, in effect, a reduction of film speed, and these powerful solvents, even though used in small amounts, can cause a scum to form on the film surface. The formulas are not published for many developers sold in packaged form under trade names, and they may contain chemicals other than those mentioned here.

An array of the many different packaged developers available can be just about as confusing as an array of the dozens of different cameras available. One good way to reach a decision on what developer to use is to read the instruction sheet that came with the film you are going to develop. It usually lists recommended developers and development times. But you still may have to choose between two or three developers. Make your choice on the basis of your needs and your knowledge of photographic developers.

Will time in the developer be a factor? Will a deadline be imminent as you step into the darkroom? Some developers are compounded to produce the full negative image in a brief time, and if the contrast and grain of the image produced by such developers meet your needs, one of these may be your best choice.

Some developers have higher capacity than others; that is, they maintain

developing activity even after a large amount of photographic material has been processed. Some film developers are best used as "one-shot soups." When using these, you process one roll of film and then pour the developer down the sink drain. Other film developers can be kept near their original energy level by adding a replenisher.

Some developers give fairly coarse grain, others moderate grain, a few fine grain. If you need low graininess and maximum sharpness of detail, try one of the moderately fine-grain or one of the fine-grain developers.

Still other developers are especially useful if the need is high contrast in the negative or print.

Labels on cans or boxes in which the prepared developers are packaged give information on the characteristics of each. The formulas for some of the standard developers are known, and from the list of ingredients one can learn what to expect.

### Sample Developer Formulas

A developer solution that contains all the standard ingredients is Eastman Kodak's D-72, a paper developer similar to Kodak Dektol. (Dektol is a proprietary product and its formula has never been made public.)

KODAK D-72 PAPER DEVELOPER

| | |
|---|---:|
| Solvent—Water (125° F or 52° C) | 500.0 cc |
| Reducing Agent—Elon | 3.1 grams |
| Preservative—Sodium sulfite (desiccated) | 45.0 grams |
| Reducing Agent—Hydroquinone | 12.0 grams |
| Activator—Sodium carbonate, monohydrated | 80.0 grams |
| Restrainer—Potassium bromide | 1.9 grams |
| Solvent—Cold water to make | 1.0 liter |

A fast, high-contrast developer. (Note: Always mix solutions in the order in which the chemicals are listed in the formula.)

KODAK D-76 FILM DEVELOPER

| | |
|---|---:|
| Water (125° F or 52° C) | 750.0 cc |
| Elon (or Metol) | 2.0 grams |
| Sodium sulfite, desiccated | 100.0 grams |
| Hydroquinone | 5.0 grams |
| Borax, granular | 2.0 grams |
| Cold water to make | 1.0 liter |

D-76 is widely used developer. Since it contains both Metol and hydroquinone, it is one of the general family known as MQ developers, the

M referring to Metol and the Q standing for the quinone of hydroquinone. The activator in D-76 is a mild one, borax, and the solution contains no restrainer. It is a relatively slow developer, gives moderate contrast and moderately fine grain.

KODAK D-23

| | |
|---|---|
| Water (125° F or 52° C) | 750.0 cc |
| Kodak Elon | 7.5 grams |
| Kodak sodium sulfite | 100.0 grams |
| Cold water to make | 1.0 liter |

Fairly slow developer, gives "soft" negatives (low to medium in contrast).

After development is complete, the image-forming silver is present in the emulsion layer, but so are the unexposed and undeveloped silver halides that were not needed to form the image. These residual halide crystals, if left in the emulsion, would darken on exposure to light and spoil the image, so they must be eliminated.

Dissolving the unexposed and undeveloped silver halides is the principal function of the fixer (hypo). Since the silver halides are insoluble in water, they must be converted to other chemical compounds that can be washed away. This the fixer does with a chemical that has been in use since the first successful daguerreotype. That chemical is sodium thiosulfate, once called sodium hyposulfite, from which came the commonly used term hypo. To cause this chemical reaction to occur fully, the hypo solution must get into the gelatin layer of the emulsion, so do not forget to agitate the film or paper occasionally while it is in the hypo.

A TYPICAL GENERAL PURPOSE FIXING BATH (KODAK F-5)

| | |
|---|---|
| Water, about 125° F (52° C) | 600.0 cc |
| Sodium thiosulfate | 240.0 grams |
| Sodium sulfite, desiccated | 15.0 grams |
| Acetic acid, 28% | 48.0 cc |
| Boric acid, crystals | 7.5 grams |
| Potassium alum | 15.0 grams |
| Cold water to make | 1.0 liter |

Obviously there is much more in a fixing bath than just the hypo or sodium thiosulfate. Those additional ingredients each have a purpose:

*Sodium sulfite.* A preservative, just as it is in the case of developer

# Fixing the Image

solutions; in hypo baths the sulfite prevents the formation of sulfur in the bath.

*Acetic acid.* A neutralizer, to neutralize any of the alkaline developing solution that might still be present in the emulsion.

*Boric acid.* A buffer, to counteract the tendency of the alkaline developing solution carried into the fixer to reduce the acidity of the fixing bath.

*Potassium alum.* A hardener, to prevent excessive swelling and softening of the gelatin. This is usually potassium aluminum sulfate (called potassium alum or simply alum) or it can be potassium chromium sulfate (chrom alum).

Many darkroom workers prefer what is called a rapid fix, a hypo solution that effectively shortens the time in the fixing bath without endangering the permanence of the silver image. These rapid fixers contain ammonium thiosulfate rather than sodium thiosulfate. Recent research indicates that the ammonium thiosulfate speeds up the fixing process because it penetrates the gelatin of the emulsion at a faster rate than ordinary hypo and thus gets to the leftover silver halides sooner. Those halides cannot be removed until the fixer gets to them.

With any fixing bath there is some danger that the thiosulfate may dissolve some of the silver image if the negative or print is left in the bath for too long a time. This is especially true of the rapid fixers, so you should take care not to exceed the maximum recommended time in such solutions.

An alternative to fixation is a process called *stabilization*, which is often used in the rapid processing of papers, for example, in document-copying machines. It is also applicable to processing regular photographs, but the resulting prints are generally more susceptible to fading and discoloration than are prints that have been fixed. Fixing, followed by washing, removes the unstable residual silver halides. Stabilization converts the silver halides into comparatively stable, colorless compounds that are simply left in the emulsion. Regular hypo can, as a matter of fact, be used as a stabilizer rather than as a fixer.

## Washing

After fixation, if hypo and the compounds it has formed with the unexposed silver halides are left in the gelatin emulsion, and in the case of prints in the paper base, a reaction can occur between these compounds and the silver of the image that produces a yellowish-brown silver sulfide. This reaction is similar to the production of tarnish on table silverware. When it appears in old photographs it is generally referred to as fading. High temperatures and moisture speed up this reaction, and eventually the silver sulfide may be oxidized slowly to silver sulfate, which is both white and soluble. Thus, the image actually disappears, beginning with the lowest densities, the highlight areas of a print.

Both the hypo and the soluble compounds that were formed by the combination of silver and hypo during fixation must be removed. This is the purpose of washing.

Washing aids are available. These are the hypo-clearing agents mentioned in Chapters 4 and 5. Experiments conducted for the United States armed services disclosed that processed films and prints could be washed more rapidly in sea water than in fresh water. Sea water is a 2.6 per cent solution of sodium chloride. Why such a solution should increase the efficiency of washing is not definitely known, but the presence of the salt—sodium chloride—was apparently the key factor, since adding table salt to fresh water produced the same results. But sodium chloride proved to be harmful to the permanence of the photographic image, so although sea water got rid of the fixation residue rapidly, no time was saved because then the sodium chloride had to be washed out with fresh water. But an avenue for investigation had been opened, and soon other salts were discovered that proved to be harmless to image permanence. The result has been such washing aids as hypo neutralizers or clearing agents.

# 16
# Sensitometry

Trial and error, if carried through enough trials and enough corrected errors, can lead to a decision on the exact combination of film, exposure, and development needed to produce a satisfying photograph of a particular subject. But there is a realm of photographic science known as sensitometry that can help shorten this process.

The definition of sensitometry is implied by the word itself: it deals with the measurement of sensitivity. In sensitometry we measure the sensitivity of a photographic emulsion by measuring its response to exposure and development.

The aim is to eliminate, or at least greatly reduce, the trial-and-error work necessary to establish what results can be expected from a standardized method of treating the light sensitive emulsion. Exact sensitometric methods are available only in a properly and elaborately equipped laboratory, but, even so, a knowledge of sensitometry can be of aid in the practical area of taking pictures. The more we know about the way the emulsion responds to light the greater our chances of getting the images we want with a minimum of trial and error.

Sensitometry is based on investigations conducted near the end of the nineteenth century by two Englishmen, Ferdinand Hurter, a chemist, and Vero C. Driffield, an engineer, both of whom were also amateur photographers.

# The Characteristic Curve

Hurter and Driffield found that it was possible to establish exact relationships between exposures and the resulting densities of silver deposits in developed film emulsions, so they were able to plot those relationships on a graph. Such a graph, showing the way deposits of silver increase as exposures increase, is still sometimes referred to as "an H & D curve," but today they are more frequently called "characteristic curves." This term is somewhat more useful because it indicates that each film-developer combination produces a unique (or characteristic) curve that pictures the way the film responds when given a specific degree of exposure and a specific degree of development. The response of the film shows up in what are called densities.

### Density

The contrasts between various silver deposits in the photographic image establish the nature and quality of that image. The blackening created by the silver deposits is referred to as the density of the image. There are two general aspects of density:

1. Average density—an average of the overall blackness of the image.
2. Density range or scale—the difference between the blackest and the lightest parts of the image; density range, then, is simply another way of referring to image contrast.

To understand the meaning of density precisely enough so that we may better understand sensitometry, we must learn two other terms:

1. Transmission—the light-passing characteristic of any negative area. It is determined by dividing the amount of light that gets through an area by the amount of light that hits that area.
2. Opacity—the light-stopping characteristic of any negative area. It is determined by dividing the total amount of light that hits any area by the amount of light that gets through that area.

Obviously then, opacity is the reciprocal of transmission, simply transmission turned upside down. To illustrate: if the incident light, the light falling on the negative area, is given an arbitrary value of 100 and we then measure the amount of this light that passes through the negative and find it to have a value of 50, we would then say the negative is transmitting one half, 50/100ths, or 50 per cent of the light. Inverting the transmission value to get opacity:

$$50/100 \text{ inverted} = 100/50 = 2 \text{ (opacity)}.$$

Opacity describes the extent of blackness created by the silver deposit in any selected part of the image, but it is not a useful concept in sensitometry because it varies in an arithmetical fashion and thus provides a long and clumsy series of numbers to deal with. In addition, opacity is not directly related to the way we see the differences in tones within the image; we see those differences not as an arithmetical scale but as a logarithmic scale. That is, the difference between 1 and 10 looks the same as the difference between 10 and 100, or 100 and 1,000.

Logarithms are a sort of mathematical shorthand. They make it possible to express the relationships between large numbers in a few small numbers. We have printed here, on the top line, an arithmetic series of numbers; on the second line, a geometric series of numbers:

| 0 | 1 | 2 | 3 | 4 | 5 |
|---|---|---|---|---|---|
| 1 | 10 | 100 | 1,000 | 10,000 | 100,000 |

Now any number in the arithmetic (top) line is the logarithm of the number paired with it in the geometric (bottom) line. The numbers on top are logarithms to the base 10 and are known as common logarithms. For example, the common logarithm of 1,000 is 3.

Density relates directly to opacity; density is the logarithm (to the base 10) of the opacity. If the opacity is 2 (one half of the light transmitted, one half of it stopped), the density is the logarithm of 2, or 0.3.

Some typical transmission, opacity, and density values are as follows:

| Transmission | Opacity | Density |
|:---:|:---:|:---:|
| 1 | 1 | 0.0 |
| ½ | 2 | 0.3 |
| ¼ | 4 | 0.6 |
| 1/10 | 10 | 1.0 |
| 1/16 | 16 | 1.2 |
| 1/100 | 100 | 2.0 |
| 1/200 | 200 | 2.3 |
| 1/1,000 | 1,000 | 3.0 |

Densities larger than three are rare, since to exceed that density more than 99.9 per cent of the light would have to be absorbed.

## Reading the Curve

For any given degree of development, the density at any point in the negative depends on the exposure given the film at that point. So we can prepare a characteristic curve by following a four-step procedure:

1. Expose the film with a standard series of exposures. Each exposure step should exceed the preceding step by a constant factor, such as two or the square root of two (1.41). An instrument capable of giving such a series of accurate and repeatable exposures is known as a sensitometer. (Or you can use a step tablet, Kodak Photographic Step Tablet No. 2 or No. 3. Simply make a contact print of this tablet on the film for which you wish to make a curve.)
2. Develop the film according to a prescribed (and repeatable) procedure. If you are doing this in your own darkroom, use your standard procedure.
3. Read the densities.
4. Measure the densities in the negative. This requires an instrument known as a densitometer.
5. Plot the densities against the common logarithms of the exposures used to produce them. (We use the logarithms of the exposures because the density is logarithmic.)

The resulting graph should look something like the imaginary characteristic curve we have produced in Figure 116. The one shown here is not an actual curve for any given film-developer combination, but it shows the typical form of such curves and the relationship between exposure and density, as well as the various parts of all such curves and the various kinds of information you can obtain from them.

First note that density is charted along the vertical scale on the left. We have also shown here opacity and transmission values but these values do not normally appear on curve charts. Note that density increases from bottom to top.

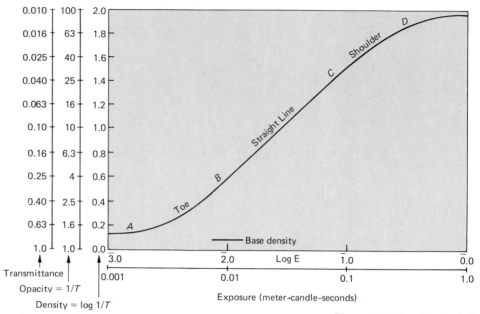

**Figure 116. The characteristic curve.**

Exposure, charted along the bottom of the graph, increases from left to right. We have shown exposure values here in two scales. The bottom scale is exposure in meter candle seconds, a measure of illumination—the light from a standard candle one meter away from the film for one second. You will note that the maximum exposure represented on the graph in Figure 116 is only one meter candle second. Just above the meter-candle-seconds scale is exposure in common logarithms: $Log_{10}E$. The Log E scale is the one that normally appears on curve charts.

The line of the curve moves upward from left to right because increased exposure brings increased deposits of silver in development, and these deposits of silver form the densities.

At the very beginning of the curve, at the bottom left, we note that the line starts above the base of the graph. This is because a certain minimum density is contributed by the film base and gelatin. We also note that the line is nearly horizontal as it begins to move toward the right with the first few increments in exposure. Those first few units of exposure are not enough to create any response in the film.

Soon, at the threshold of the emulsion, some slight silver deposits begin to build density and the curve turns upward. The portion of the curve from *A* to *B* in Figure 116 is the toe of the curve. The toe represents the region of low and minimum exposures. In this region, as the curve of the line shows, successive units of increasing exposure result in progressively larger increases in density until we reach the straight-line portion of the curve (*B* to *C* in Figure 116). Here equal increases in exposure

bring equal increases in density. In other words, from *B* to *C* the relationship between exposure and density remains constant. This does not necessarily mean that density doubles as exposure doubles, but rather that density increases at a uniform rate with uniform increases in exposure.

Finally, we note that the line near the top right, at about point C, begins to turn back toward the horizontal. This region (*C* to *D*) is the shoulder of the curve where uniform increases in exposure again do not result in uniform increases in density.

### Speed

One of the most important functions of sensitometry is to provide us with guides to the sensitivity of film emulsions, or film speed, on which we base exposure calculations.

The greater an emulsion's ability to respond to low levels of exposure, the greater its speed. But for practical purposes this must be assessed as the emulsion's ability to separate two or more low-level exposures into recognizably different density levels, for it is only the difference in tones that gives a photograph meaning. Low-level exposures, usually the shadow areas of a subject, are recorded on the toe of the characteristic curve. As these exposures reach a point where the curve begins a perceptible rise, minimum density differences begin. The speed of the film lies somewhere along this section of the curve. Modern speed-rating systems are based on the gradient (the rate of ascent or steepness) of the curve at the point where these first usable differences in density appear. The smaller the exposure at this point, the greater the speed of the film. The closer the toe of the film's curve gets to the left end of the Log E exposure scale the faster the film.

Photographers frequently establish their own personal exposure index for a particular film, based on their standard method of exposing and developing that film. This index may be either higher or lower than the film's ASA speed. The ASA speed of a film applies only to the figure established by sensitometric testing. Any other figure used in determining exposures is really an exposure index.

### Exposure Range

The exposure range, or *latitude*, of the film appears on the characteristic curve as that section between the toe and the shoulder, or approximately the straight-line portion of the curve. The straight-line portion is that area in which equal increments of exposure produce equal increments of density. Here the tone relationships in the negative most accurately reflect the contrast relationships in the subject. However, we have already seen that some of the toe region is advantageous. So we had better modify our definition of exposure range to the range of exposure values through which density increases at a useful rate. This would carry our exposure range both down and up to the points (on toe and shoulder) where the curve

begins to flatten out. We can use the shoulder of the curve, but we shall find that the toe section is much more useful. The least exposure that will give useful separation of tones (detail) in the shadows will place those shadows on the toe of the curve but will keep the highlight areas, for most subjects, well below the shoulder. This means that highlight areas in the negative will have useful tone separations—they won't be blocked up—and they will serve to modulate the light that strikes the printing paper, giving us detail and sparkle in the print highlights.

Many scenes we photograph do not have a brightness range (difference between darkest and lightest objects) long enough to use the whole characteristic curve. In fact, they may not even use the full straight-line portion of the curve. So we can actually shift the recording of the scene up or down on the curve and still get printable negatives; this is exposure latitude. Wider apertures or slower shutter speeds will give more exposure, thus shifting the recorded densities of the scene to the right or upward on the curve; smaller apertures or faster shutter speeds will give less exposure, shifting the densities to the left or downward on the curve. (See Figure 117.)

## Contrast

When used in relation to negatives, the term contrast means the range of brightness values that have been recorded on the film in silver deposits or densities. In a contrasty negative there is a noticeably wide separation between the extremes of the almost clear, minimum density regions (the deepest shadows) and the black, maximum density regions (spots that will

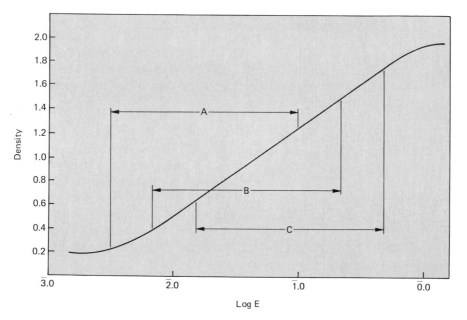

Figure 117. Exposure latitude. Here we have indicated three different negative density ranges that might result from three different exposures. Exposure B is twice (one stop) that of exposure A and exposure C is twice that of B; therefore C is four times more exposure (two stops) than exposure A. Yet all exposures fall well within the most usable range of the film's characteristic curve.

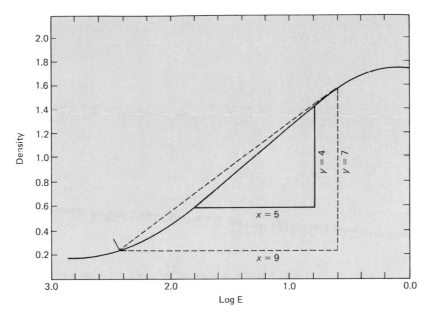

Figure 118. Contrast. The slope of the straight-line portion of the characteristic curve tells us how the film, with a given degree of development, will record the scene. The degree of slope is called gamma and is an indication of contrast. Gamma can be figured simply by dividing $y$ by $x$. The $x$ line moves right for 5 squares; and the $y$ lines moves up 4 squares. Gamma then is 4 divided by 5 or .80. The dotted lines represent the contrast index: 7 divided by 9 = .77.

print white). There may or may not be a great number of individual density steps between the two extremes.

This same contrast that we visually judge by looking at the negative is also depicted by the slope of the straight-line portion of the characteristic curve. The steeper this line, the higher the contrast. (See Figure 118.)

Exposure range and, to a large extent, although not entirely, speed are properties of the emulsion alone. Each emulsion also has a certain inherent contrast, but the contrast in the image, especially with negatives, also depends upon development.

Development factors that affect contrast are the choice of developer, time, temperature, and agitation during development. If we increase time, temperature or agitation, we steepen the straight-line section of the curve. That is, we increase contrast due to development (gamma). Certain emulsions can be developed to a much higher contrast than others, and certain developers, notably those with a large proportion of alkali or a strong alkali, produce a higher contrast than others. In practice, photographers find that they can control gamma best by development time: to increase image contrast for a picture of a low-contrast scene (perhaps an outdoor scene on a cloudy, dull day), we increase the time the film is left in the developer, perhaps 25 or 50 per cent, normally coupled with some reduction in film exposure. Reducing development time, of course, will reduce gamma (contrast).

Contrast index is also a measure of development contrast of a film. It is a measure of the average gradient of a curve. The average gradient is the slope of a straight line drawn between two points on the characteristic

curve, points that represent, respectively, the minimum and maximum densities normally found in quality negatives. (See Figure 118.)

Whenever you snap the shutter of your camera, you register a series of exposures on the film because various parts of the scene in front of the lens reflect different amounts of light to and through the lens. These various exposures are eventually developed to various densities in the negative. So we see that there is a direct relationship between the various brightnesses in the original subject and the densities in the final negative. The characteristic curve gives us a graphic description of that relationship.

A negative that is underexposed will fall on the toe of the curve. Shadow areas will be clear in the negative (black in the print) and thus will lack detail. Middle tones will look "flat" and rather uniformly gray because they too have fallen to the toe region where differences in exposures give only small differences in densities. And it is the difference in densities that make for contrast in the image.

Figure 119. Exposure-development adjustment for high-contrast subject. Overexposure (two stops) gives more detail and contrast in the shadows. Underdevelopment (about 40 per cent) keeps the highlights from blocking up.

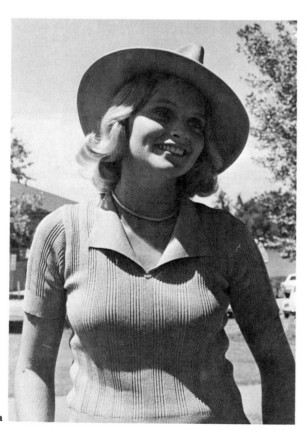

a

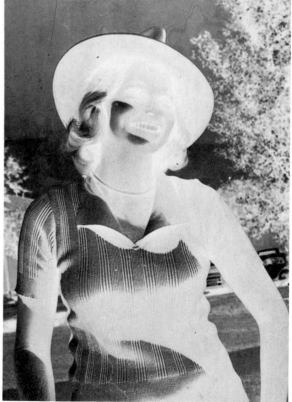

b

**119a.** Print from normally exposed and developed negative.

**119b.** Normally exposed negative developed for 5 minutes at 75° F in undiluted D76 with agitation at 60-second intervals.

**119c.** Curves of two negatives based on measurements with a densitometer.

**119d.** Overexposed (two stops) negative underdeveloped (3 minutes at 75° F in undiluted D76 with agitation at 60-second intervals).

**119e.** Print from overexposed and underdeveloped negative.

KODAK Curve Plotting Graph Paper

High Contrast Subject in Sunlight
—— normal exposure & development
------ overexposed & underdeveloped

DENSITY

c

d

e

a

b

c

d

**Figure 120. Exposure-development adjustment for low-contrast subject. Underexposure (one stop) keeps highlights from blocking up while overdevelopment (about 30 per cent) extends contrast in the image.**

**120a.** Normally exposed negative developed for 5 minutes at 75° F in undiluted D76 with agitation at 60-second intervals.

**120b.** Print from negative given normal exposure and development.

**120c.** Underexposed (one stop) negative overdeveloped (6 minutes at 75° F in undiluted D76 with agitation at 60-second intervals).

**120d.** Print from underexposed and overdeveloped negative.

**120e.** Curves of these two negatives based on measurements with a densitometer.

KODAK Curve Plotting Graph Paper

Low contrast Subject & Low light level

——— normal exposure & development

- - - - under exposed & over developed

An overexposed negative is pushed up on the shoulder of the curve. Then shadows and dark areas of the subject may be reproduced with full contrast, but the brightest areas of the scene will be quite dense in the negative and will print flat because they have reached the point where the curve flattens out on the shoulder.

A correctly exposed negative usually falls on the film's characteristic curve so that the shadow areas just reach the bend in the toe and the brightest areas of the subject fall short of the shoulder. This takes full advantage of the speed of the film, gives image contrast very like the subject

*The Curve and Your Negatives* **235**

contrast, and gives a negative that is easy to print for sparkling highlights with minimum of grain and maximum sharpness.

The emulsion of a photographic paper responds to light in essentially the same way as the film emulsion does. Therefore, characteristic curves can also be drawn for papers. The highlight densities of the negative (ideally kept below the shoulder of the film's curve) are reproduced on the toe portion of the paper's curve. This means that if the highlights in the negative fall on the shoulder where contrast is compressed, they will be compressed even more on the toe of the paper's curve. The result is a cumulative loss of contrast and detail in the highlights, both vitally important for a sparkling print with a full tonal scale. Shadow areas of the negative, on the other hand, although somewhat compressed on the toe of the film's curve, are helped by the paper because in normal circumstances they fall on the straight-line portion of the paper's curve where the contrast is highest.

# 17

## Color As
## We See It

Color photographs are not necessarily better than black-and-white photographs, but they are different. Color is, in fact, largely a luxury. We could manage reasonably well if we saw all things in contrasting tones of gray, like a black-and-white print, in which we distinguish objects largely by form. But color is a delightful luxury and it adds another dimension to our sight, since we can distinguish many things by their color. And color can be an added dimension in photography, extending our reach for the illusion of reality recreated.

Color, however, is not an undiluted blessing; if it extends our reach in photography, it also expands our problems. Color photography retains all the demands of black-and-white photography, and adds a considerable number of its own.

## What Is Color?

Color can be described in purely physical terms as electromagnetic radiation of different wavelengths. This is color objectively analyzed and neatly measured down to the tiniest fraction of a millimeter by the science of physics. However, photography is concerned not with light analyzed in the physicist's laboratory but with light analyzed by human vision.

Color vision is physiological in that light-stimulated signals move along nerve fibers from the eye's retina to the brain. And color vision is also psychological because the brain makes the interpretation of these signals. Because of this important role that the brain plays—and very little is known about it—color vision is highly subjective, a significant point for photographers. We must make a clear distinction between the physical nature of colors and our mental perception of them. These are two quite different, although related, aspects of color.

We know that light constitutes part of the radiant energy spectrum, a part the human observer is aware of because the radiation within that comparatively narrow band can be received by his eyes, much as the radio station's broadcast radiations are received by the radio set in your home. However, the eye, unlike the radio set, does not sort out one particular wavelength and ignore all others. If the stimulation presented to the eye includes all or nearly all the visible wavelengths in approximately equal amounts, the brain makes the interpretation of white or colorless light. But the light is not colorless in the terms of physics; it contains many different wavelengths and thus many different colors.

### Color Vision

Not all the details of the mechanism with which we distinguish colors are known. We do know that the retina of the eye is equipped with millions

of light-sensitive cells that send electrical impulses along the optic nerve. When those impulses arrive in the brain, they are sorted out and interpreted as things seen. The light-sensitive cells in the retina are of two distinct kinds and shapes:

1. *The rods* have the greater sensitivity to light and are the cells we rely on primarily for night vision, but they are color-blind. Light is simply light, whatever its wavelength, as far as the rods are concerned.
2. *The cones* have less sensitivity to light but they can tell the difference between at least some wavelengths.

One theory of color vision holds that the cone cells form three separate systems for light reception, each of the three responding to about one third of the visible spectrum with, probably, some overlap. One set of cones responds to the shorter wavelengths, one to the middle wavelengths, and the third to the longer wavelengths, or roughly, the three sets respond separately to blue, green, and red. Thus if only the first set of cones is stimulated by the light then the brain makes an interpretation that we have labeled "blue." If the signal comes from the second set, then the light is "green," and if from the third set, "red." Various combinations of stimulations create the sensation of other colors, and if all three sets of cones are stimulated simultaneously we see "white."

This theory does not explain all the marvels of color vision, but it does give us a quite useful model with which we can explain nearly everything we need to know about color photography.

## Why Grass Is Green

The range of colors in the visible spectrum is, of course, familiar to us. We have seen it in the rainbow and many of us in the splitting of white light into colors by a prism. (See color illustrations.)

But the colors we are concerned with are not those spread out for us by a prism that has dispersed the wavelengths of white light. The colors we deal with in everyday life, and in photography, are those reflected to our eyes by objects around us and, less frequently, those transmitted directly to our eyes from a light source or through a transparent medium.

All the reflected light our eyes receive is a mixture of wavelengths, but often not a complete mixture. If some wavelengths are missing the eye-brain receiving mechanism may report a sensation we identify as color. In such a case the object that reflected the light contained a pigment whose molecules swallowed up the missing wavelengths. Such light-absorbing pigments are present in almost everything around us, in plants, metals, wood, stone and in paints, dyes, and inks.

The sunlight that falls on grass contains all the visible wavelengths and so is white, but the pigment molecules of the chlorophyll in the grass absorb or subtract most of the short (violet and blue) wavelengths and most of the long (orange and red) wavelengths. Only the middle wave-

lengths (green) are not absorbed; they are strongly reflected. Thus, we say, "The grass is green."

The molecular structure of other pigments is such that they absorb other parts of the spectrum. Carrots are orange; dandelions are yellow; some roses are red; paints, inks, and the dyes in our clothes can be almost any color.

It all depends upon which wavelengths are absorbed, which are reflected—or transmitted. For the same is true of a transparent medium, such as glass, that is colored. A sheet of green glass subtracts most of the wavelengths except those we interpret as green.

## The Primaries

Because of the nature of color vision, which divides light, roughly, into three separate and limited bands of wavelengths, any color can be produced with red, green, and blue light as the basic stimulants. Red, green, and blue are the primaries of physics because to work with these colors to produce all other colors we must work with beams of light in a darkened room. If we set up three slide projectors to project round spots of light on a white screen, we can demonstrate the way in which these primaries function. We will put a red filter over one projector lens, a green filter over the second, and a blue filter over the third. (See color illustrations.) When the light beams from each are projected separately on the white screen we see spots of red, green, and blue color. If we superimpose the spots, new colors appear. Overlapping blue and green produces, quite understandably, a blue-green, since both blue and green wavelengths are reflected from the same spot on the screen to the eye. This combination of blue and green we call cyan. Overlapping blue and red produces a purplish red called magenta. Red and green superimposed produce a visual sensation that we call yellow. All three of these primary colors superimposed on the same spot give white. This, we can see, is the *addition* of two or all three colors, so we have:

*The additive primaries:* red, green, and blue.

These three colors will work as primaries (that is, produce the visual sensations we translate as other colors) if you are using colored light, adding one to another. They will not work as primaries if you are mixing dyes, as in paints or in color filters. Each of these colors transmits only one third of the visible spectrum and subtracts two thirds. What one filter transmits the other subtracts.

But let's try the set of colors that red, green, and blue light will form by addition. These mixtures—cyan, magenta, and yellow—are the opposites of (or the colors complementary to) the additive primaries. Yellow is the opposite of blue (it contains no blue); magenta is the opposite of green;

cyan is the opposite of red. The opposite of addition is *subtraction;* therefore we have:

*The subtractive primaries:* yellow, magenta, and cyan.

Each of these colors subtracts only one third of the visible spectrum and transmits two thirds; therefore the combining of any two of these subtractive primaries in paints, dyes, filters, and so on, will still leave one third of the spectrum. It will help in understanding color photography if we think of the subtractive primaries in the following way:

Yellow   = minus blue
Magenta = minus green
Cyan     = minus red

To produce the additive primaries:

Yellow (minus blue) and magenta (minus green) leaves red.
Yellow (minus blue) and cyan (minus red) leaves green.
Cyan (minus red) and magenta (minus green) leaves blue.

We can produce other colors by varying the relative strengths of the subtractive primaries. If we mix all the subtractive primaries together we will subtract all wavelengths and the result is obviously zero or black.

Photography's color films and color prints depend on the subtractive system. A color transparency viewed by light transmitted through it as through a colored pane of glass or a color print viewed by light reflected from its surface must permit just the right amount of blue, green, and red light to reach the eye if it is to look like the original subject. This is accomplished by forming in the emulsion layers during processing a yellow dye to absorb blue where the subject did not reflect blue, magenta to absorb green where there was no green, and cyan to absorb red where there was no red. Varying amounts of the subtractive color dyes will, of course, give varying degrees of subtraction.

## Color Attributes

To conduct an intelligible discussion of color we must have a minimum number of terms with which to describe colors and keep clearly in mind what we are describing. Color is not a physical characteristic of an object, but color is a characteristic of the light reflected from the object. Our problem is not solved by describing the physical nature of the light either. What we are really attempting to describe are sensations.

Sensations that give rise to the perception of color are affected by the three main attributes of color:

1. *Hue* is what changes when wavelength changes. If we describe a color

as red or yellow or blue, we are identifying it by hue. We can identify about two hundred different hues.

2. *Saturation* is the purity or vividness of the hue, its degree of concentration; a saturated hue contains little or no white.
3. *Brightness* is the degree of luminance—a bright as opposed to a dark red; a bright hue contains little or no black.

Two sweaters may give rise to the same hue sensation—both may be red, for example—whereas their colors appear quite different to the eye. One sweater may be a brilliant red, a scarlet, and the other a pale red, a pink. They are the same hue but they differ in saturation. (Saturation is sometimes referred to as chroma.)

Two sweaters may be of the same hue and saturation, yet we may describe one as a light red and the other as a dark red. Our mental image of one has greater luminance than the other, and when we describe it as a light red we are evaluating its brightness. (Brightness is sometimes referred to as value.)

Any color is a combination of the three color attributes. For example, the light from a tungsten lamp is yellow in hue (although it may look white because of the color adaptation of the eye), weak in saturation, high in brightness. The usual darkroom safelight used with printing papers is also yellow in hue, stronger in saturation, but weaker in brightness. A banana is yellow in hue, moderate in saturation, and weak in brightness.

Mixing a color with white desaturates that color; diluting it with black (or gray) degrades (darkens) it. A mahogany brown is a degraded red; a pale pink is a desaturated red.

# Effects of Lighting and Contrast

The colors we see in an object depend not only upon the light absorption and reflection characteristics of that object, but upon two other factors as well: lighting conditions and surroundings.

Lighting conditions can vary quite widely and in a number of ways. First, and most important, variations exist in the energy distribution of light sources; that is, they vary in the proportional amounts of the different wavelengths they contain. Light sources that depart markedly from sunlight, for example, are the sodium vapor and mercury vapor street lights. Sodium lamps radiate energy almost entirely confined to the narrow yellow band of the spectrum, whereas mercury lamps give off a decided blue-green illumination. A blue coat under a sodium lamp tends to look black because there are relatively few blue wavelengths to be reflected to the eye. A red coat under a mercury lamp is also degraded toward black. Actually, two other factors play a considerable role in determining what color changes either coat undergoes. In ordinary circumstances some additional light

sources are present to add some blue and red light to the general illumination, and rarely will a dyed fabric reflect only blue or only red light.

Less obvious examples of color distortion created by a light source occur under fluorescent lights, some of which are relatively rich in some wavelengths and poor in others. Their energy distribution is not a full continuous spectrum but a mixture of separated bands of wavelengths. This is why dress or suit buyers often take the clothing to a store window or even outside to check the fabric colors. One or more of the dyes used may fall within a gap in the indoor lighting's spectrum, and thus the colors appear darker or may even exhibit a shift in hue.

Differences we notice still less frequently occur under illumination from a clear blue north sky, under direct sunlight, and under indoor tungsten lighting. The proportion of blue wavelengths is highest in the sky light, least in the tungsten light. This is, in effect, a fall in color temperature (see section on color temperature in Chapter 10), which alters colors; blues tend to decrease in saturation and brightness under tungsten light, and yellows and reds tend to increase in the same attributes. The eye adapts itself quickly to relatively minor changes in illumination, with the result that we may notice a yellow tone to tungsten light as we step inside from the sunlight, but after a few moments the indoor lighting seems a normal white. It is important that the photographer remember his color film is quite incapable of any similar automatic adaptation.

Intensity of the illumination also affects the colors we see. The cone cells of the retina, the color receptors, are relatively inactive in dim light, when most of our vision results from the messages sent by the color-blind rods. This explains why colors seem desaturated and dull at night. Color photographs that are dark, with desaturated colors, look as if they were taken at night even though they may have been taken in full sunlight. Also, if lighting is diffuse, as it is outdoors under an overcast sky, colors look desaturated and dull. If lighting is direct, such as full sunshine, colors look bright and strong.

Surroundings affect the quality of colors in two ways, through the reflected light coming from nearby colored surfaces and through contrast between neighboring colors.

Obviously under normal lighting circumstances objects are not illuminated solely by direct rays from a light source, but by reflected light as well, and this reflected light is often colored by the reflecting surfaces. Strongly colored reflected light, such as that coming from the painted side of a red barn, changes the color of objects near it. This factor of reflected light from surroundings is a very important one in color photography. Skin tones in outdoor portraits may be noticeably altered by reflected light from green foliage or from a blue sky. Our vision, strongly guided by what we know to be true, often fails to notice these green or blue flesh tones, but color film sees things as they are, not as the brain believes they should be. These color shifts can be quite obvious in a color photograph

even though to the eye at the original scene they went completely unnoticed. Color shifts may occur from light reflected from surfaces not even included in the pictures.

All of the foregoing leads to the conclusion that much of our puzzlement over the apparently unreal results we sometimes get with color films is created by our own failure to look critically at the colors of the original scene, to force our brain to edit preconceptions and color memory. The eye tends to see what its partner in vision, the brain, wants it to see. We see shadows in a snow scene under a cloudless sky as normal shadows, when in fact they are more than likely strongly tinted with blue, reflected from the sky. We know a white house at sunset to be the same white house we saw at noon; but color film sees it as rosy pink at sunset.

This brings us to the admonition that cannot be repeated too often: The photographer must learn to see what is really there, not what he wants to see there or what memory tells him should be there.

The second factor created by surroundings, color contrast, is important only if the surrounding color is included in the picture. Colors seem to change in hue, saturation, and brightness with a change in surroundings. A blue-green looks blue against a green background, but the same hue looks green against a blue background. This is apparently the result of adaptations that occur on the retina of the eye. When we see two different colors that overlap or are close together, we tend to see an exaggerated difference between the two.

Almost any color will take on greater saturation and a higher brightness level against a dark background. A pale pink may look almost red against green; blue looks bluer against orange, still bluer against red. The effect of this color contrast is greatest if the colors are complementary to each other. There is even some hue shift when two colors are not complementary; the eye tends to see them as if they were; gray tends to shift toward blue when viewed simultaneously with a bright red.

The additive primary colors are
_____ , _____ , and _____ .     red, green, and blue

The subtractive primary colors are
_____ , _____ , and _____ .     cyan, magenta, and yellow

Combining the two subtractive primaries
cyan and magenta will give _____ .     blue

Yellow and cyan will give _____ .     green

Magenta and yellow will give _____ .     red

# 18

# Color As We Photograph It

Casual photography with color film has become as simple as black-and-white photography. But serious color photography, like serious black-and-white photography, has never been simple and probably never will be. The serious photographer wants consistent, predictable results, and planning based on knowledge always produces a higher percentage of successes than the law of averages. Consistent success with color film demands an understanding of at least the basic structure and processing of the film.

Producing full-color photographic images involves only two basic steps:

1. Extracting separate records of the additive primary colors in the light reflected from the subject.
2. Reassembling those separate records into a unified positive image that will match the subject in color as well as in form.

The first step is not so difficult. Almost any camera, firmly placed and focused on an immobile subject, will do this. We simply expose three sheets of black-and-white panchromatic film one at a time, one through a red filter, one through a green filter, and one through a blue filter. The three images thus obtained are called separation negatives. But this method is impractical for a subject that may move between exposures and obviously, then, would be impractical for general use.

We can overcome this difficulty with the one-shot color cameras, which split the beam of light from a single lens into three parts to form three images identical in form but varying in densities according to the primary color filter placed in front of each sheet of film. The light is split by using pellicle mirrors, very thin semitransparent sheets that reflect only part of the light and transmit the rest. The first mirror set at an angle behind the lens deflects roughly one third of the light to the blue record film. A second mirror divides the remaining light, deflecting approximately one half to the red record film and passing the other half to the green record. The camera, a necessarily bulky affair, is constructed so that each sheet of film is held at the correct focal distance and all three images are sharp and identical in size.

So separation records are not difficult to get, but what of the second step, reassembling those records into one image? We can do it with the additive primaries if we use light, or with the subtractive primaries if we use dyes. If we have a set of three separation negatives we can combine them in a number of ways. Let us briefly examine three of them.

1. *Projection transparencies.* We can make a positive transparency on film from each of the negatives. Then we place each transparency in its own projector. The positive red record is projected through a red filter, green through a green filter, and blue through a blue filter. Color addition

gives colors matching the original when all three are projected on a white screen simultaneously and in accurate superimposition. But this is complicated and limited in practical use.

2. *Photoengravings.* We can also make black-and-white prints from the separation negatives. The prints, in turn, can be used to make photoengravings for full-color reproductions in books, magazines, and newspapers. The engravings are used to print colored inks that represent the subtractive primaries to form a mosaic of dots that the eye of the viewer will blend into a full-color reproduction. The color illustrations in this book were produced in this way. Examine these illustrations with a glass that magnifies at least five times and you will see the mosaic of yellow, cyan, and magenta dots. But this does not give us an original colored photograph.

3. *Imbibition process prints.* We can make a full-color print from the separation negatives, with three dyed positive images superimposed exactly on a single sheet of white paper. The imbibition process involves tanning development, a process that hardens the gelatin of the emulsion to a depth proportional to the amount of silver developed. The unhardened gelatin is then washed away and the hardened gelatin that remains forms relief images that are dyed with the subtractive primaries. The three colored images are then superimposed in exact register. The Kodak Dye Transfer process is a method of this sort and it can produce fine, full-color prints, but this method demands a great deal of time and skill.

## The Integral Tripack

Let us go back to the first step once more and try another approach. Why not arrange the three emulsions into a kind of triple-decker sandwich so that one exposure will strike all three, with red light recording on one, green on another, and blue on the third? At first this seems like a good idea, but we soon encounter a problem: If each emulsion is coated on a separate base it is impossible to place all three in contact, so the image cannot be focused sharply on all three at the same time.

The answer to simplified color photography finally came from this sandwich idea, however, in the form of the *integral tripack*, three emulsions coated in a triple-deck stack, all on the same base.

Two musicians—and amateur photographers—Leopold Mannes and Leopold Godowsky, were primarily responsible for the first practical application of the multilayer principle. They became interested in color photography when they were sixteen years old and conducted their first experiments in the bathrooms of their homes in New York City. They somehow found time to study physics and mathematics as well as music, and in 1930 they accepted an invitation to join Eastman Kodak in a concentrated attack on the color photography problem. For five years the research and testing went on in Kodak's laboratories in Rochester, New York, with

Mannes and Godowsky occasionally timing development in the darkroom by whistling classical music.

In 1935 Kodak announced the first integral tricolor film. Kodachrome, the film that became the standard by which all other color films were judged for many years. A year later Agfa in Germany announced a tripack film. The principal difference between the two involved the method of producing the color in the three separate emulsions. Kodachrome did not (and does not today) contain dye couplers, as they are called, within the emulsion layers: these were provided by the developing solutions. Agfa, however, had solved the problem of preventing the molecules of dye from wandering from one emulsion to another and so had placed the couplers in the emulsions along with the silver halides. Thirty years after these first practical color films were placed on the market, there were thirty different color films available, most of which anchored the color couplers in the emulsion layers by means of giant molecules too big to meander about. We shall return to the problem of the dye couplers when we discuss processing principles, but first we must examine the basic structure of the integral tripack color film.

The basic structure, three layers of emulsions stacked on one film base, is common to both types of the current color films. The two types are:

1. Reversal color films, which produce positive color transparencies or slides. The exposed film is first developed to a negative and then the same film is reversed to a positive. These films are designated almost universally by the suffix *chrome;* examples are Kodachrome and Agfachrome, but General Analine and Film products are simply called GAF Color Slide Film.
2. Negative color films, for making color prints. These are generally designated by the suffix *color;* Kodacolor, Ektacolor, and Fujicolor are examples. GAF Color Print Film is again an exception.

The top emulsion layer in the color films is sensitive to blue light only; green and red light pass through it without affecting the halides in this top emulsion. The next (middle) layer is sensitive to green light. The bottom layer is sensitive to red. Because there is no way to make silver halide crystals in the middle and bottom layers insensitive to blue light, some way had to be found to prevent blue wavelengths from penetrating beyond the top emulsion. This was accomplished by coating a yellow filter layer just below the top emulsion. The yellow filter, formed of finely divided silver known as Carey-Lea silver suspended in gelatin, absorbs any blue light that penetrates beyond the top emulsion but freely passes green and red light. The yellow color of the filter layer is destroyed during processing.

The middle emulsion layer directly under the yellow filter is orthochromatic, sensitive to blue (which cannot reach it) and green, but not to red. So the red light passes on to the bottom panchromatic emulsion, which is sensitive to blue (which cannot reach it) and red. This bottom layer

| Blue sensitive emulsion |
| --- |
| Yellow filter |
| Blue and green sensitive |
| Blue and red sensitive |
| Film base |
| Antihalation backing |

Figure 121. Cross-sectional diagram of color film.

is somewhat sensitive to green light, but to such a slight degree that it is not important.

The exposure, then, is made simultaneously in the three extremely thin emulsion layers, each layer responding to one and only one of the additive color primaries.

## Processing the Tripack

The key to all tripack processes lies in the *coupler* (color-forming) *development*. You will remember from Chapter 15 that during development, when the exposed silver halides are reduced to metallic silver, the developing agent is oxidized. The oxidation product is highly reactive and will immediately join in a chemical reaction with other substances incorporated either in the color-film emulsion or in the color-developer solutions. These substances that react with the oxidation product are the couplers. The reaction forms the dyes of the colored image. The insoluble dyes formed are the colors of the subtractive primaries, and they appear in the three emulsion layers in exact proportion to the amount of silver developed in each layer. The coupler in the top layer forms a yellow dye to subtract blue where there was no blue in the photographic subject; magenta is formed in the middle layer to subtract green, and cyan is formed in the bottom layer to subtract red.

It is in the processing that Kodachrome and a few other films depart from the majority of color materials. Kodachrome cannot be processed by the photographer because of the extreme complexity of the technique involved. Since the color couplers are not placed in the emulsions of Kodachrome, they must be supplied in the developing solutions. This means each emulsion layer must be given separate processing, a difficult technique that requires considerable training and extensive equipment.

However, if the couplers are incorporated within the various emulsion

The world in color. We might
well ignore that old rule of keep-
ing the sun over our right
shoulder except when we are
shooting pictures of the earth
from outer space.

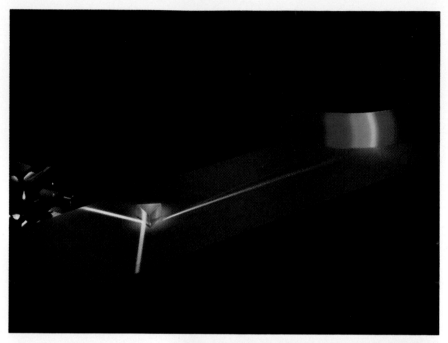

The prism bends the light of the shorter wavelengths more than the light of the longer wavelengths, thus spreading a narrow beam of white light out into the visible spectrum. (The beam extending toward the bottom of the picture is reflected from the surface of the prism without entering it.)

A red filter between prism and screen allows only light of the longer wavelengths to pass.

A green filter passes only the center part of the spectrum. It absorbs blue and red light.

A blue filter passes only the light of the shorter wavelengths. It absorbs green and red light.

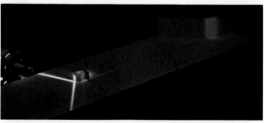

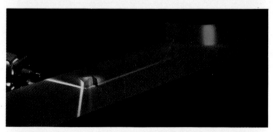

Additive mixture of the colored light from projectors covered by red, green, and blue filters. Combined in pairs, the beams give cyan, magenta, and yellow. Where all three beams overlap, all three of the visual-receptor systems are stimulated, and the screen appears white.

A yellow filter absorbs blue light and transmits green and red light.

A magenta filter absorbs green light and transmits blue and red light.

A cyan filter absorbs red light and transmits blue and green light.

Cyan, magenta, and yellow filters partially superimposed. The combined subtractions of the filters in pairs give red, green, and blue. Where all three filters overlap, no light is transmitted.

Cyan, magenta, and yellow water colors. Cyan and yellow have been mixed to make green, just as they did when filters were used.

The range of colors produced by mixing, in varying proportions, the primaries at upper right. Toward the center the quantities were decreased and the white paper shows through more. At right, all three primaries were mixed in varying amounts, in the proportion required to produce a neutral. The result is black shading through a scale of grays to white. (Reprinted with permission from a copyrighted Eastman Kodak publication.)

When mountain climbers, as a publicity stunt, descended the side of a skyscraper, a dramatic photograph resulted from using a "fisheye," 18-mm lens on a 35-mm, single-lens reflex camera. The climber was within arm's reach of the camera. The Kodacolor X film was exposed at 1/60 of a second at *f*/22. The picture won the grand prize in the Asahi Optical International Photo Contest. (Floyd H. Mc-Call)

Carefully planned lighting is often needed for effective color shots. Five electronic flash units were used for this picture: a key light off camera, two background lights, an accent light, and a shadow-fill light at the camera. Professional Ektacolor Type S film was used in a Rolleiflex with the shutter set at 1/500 of a second. Note that the complementary colors (pink against blue) brighten each other. (Floyd H. McCall)

Color film properly exposed can reproduce delicate pastel colors. Sunlight was the back light for this shot of fourth graders re-enacting the Spirit of '76. One electronic flash was placed on a stand 5 feet from the camera with a remote trip cord to the camera. No light was used at the camera. (Floyd H. McCall)

The end of a happy day at an amusement park. Clouds tinted by sunset light gave the rosy glow to this picture. The film

layers (as they are with most color films other than Kodachrome), a single developer will reduce the exposed halides to silver and will form the appropriate color in all three emulsions simultaneously. The dye color formed is controlled by the chemical structure of the couplers incorporated in each layer. This greatly simplifies the process and makes color developing in the home darkroom quite feasible.

In general, color developers are similar to black-and-white developers. They contain the same basic ingredients of developing agent, activator, preservative, and restrainer. However, proportions differ, the color-developing agent is a more complicated compound, and the solution contains additional special ingredients. Stronger alkalies, often two, are used as activators in color developers and, in addition, benzyl alcohol is frequently added as a booster to accelerate the penetration of the reducing agent into the three emulsion layers. A silver halide solvent is also included to help produce transparencies with clear whites by removing any excess silver halides. The concentration of the preservative (sodium sulfite) is much less than in black-and-white developers, because the oxidation products must be free to react with the couplers. A high concentration of sulfite would inhibit this; yet some preservative is necessary to curb aerial oxidation and to prevent stains. Citrazinic acid is sometimes added to color developers to control contrast by reacting with oxidation products to form colorless compounds.

### Reversal Processing

Reversal films are first developed to a negative silver image in a developer that does not form any color and thus produces the same sort of negative as black-and-white development. The film is then re-exposed, either to a strong, white light or by chemical treatment, to form latent-image silver on all remaining halide crystals. Because the negative-image silver has already been exposed and developed, whatever silver we can develop from the remaining halides must form a positive image.

After the second exposure the film goes into the second developer, a color-coupler developer, which not only develops the positive silver image but develops the color image at the same time. Then all the silver is bleached out of the three emulsions and only the color image is left. The result is a positive transparency which, when placed over a white light, will transmit the colors of the original subject by subtraction. Where cyan and magenta dyes appear in the transparency (the two dye images overlapping), only blue will be transmitted; yellow and cyan will transmit only green; yellow and magenta, only red. If there is a heavy dye deposit in all three layers, all light will be absorbed and black is the result; white appears if there is no dye in any of the layers. (See Figure 122.) Colors other than blue, green, red, yellow, magenta, and cyan are produced by partial absorptions in various layers. Orange will result from heavy absorption of blue light by the yellow dye in the top layer, from partial absorption

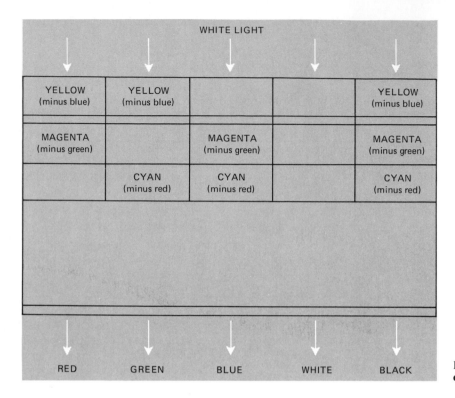

WHITE LIGHT

| YELLOW (minus blue) | YELLOW (minus blue) | | | YELLOW (minus blue) |
|---|---|---|---|---|
| MAGENTA (minus green) | | MAGENTA (minus green) | | MAGENTA (minus green) |
| | CYAN (minus red) | CYAN (minus red) | | CYAN (minus red) |

RED     GREEN     BLUE     WHITE     BLACK

**Figure 122. How color is reproduced in a positive transparency.**

of green light by some magenta dye in the middle layer, and from very little or no absorption of red in the bottom layer.

The following is a summary of the essential steps of reversal processing:

1. First development—to reduce exposed silver halides to the negative silver image. (A rinse follows, with treatment in stop or hardening bath if recommended.)
2. Reversal exposure—to expose the undeveloped silver halides.
3. Color development—to reduce all remaining silver halides to the positive silver image and, at the same time, to produce dyes in the three emulsions. (Another rinse, and a clearing bath if recommended.)
4. Bleaching—to convert all silver to silver salts. (Another rinse.)
5. Fixing bath—to dissolve all silver salts and leave only the dyes in the three emulsion layers. (Final wash.)

The bleach used in color processing must remove the silver without affecting the dyes. A common bleach used after the second development contains potassium ferricyanide and potassium bromide. The silver in the emulsions is converted back to silver bromide, the reverse of the development reaction, and the silver bromide is removed in the customary fashion, in hypo.

Frequent rinsing, part of the reason for the lengthy time required in

color processing, is vitally important. All chemicals left in the film after each treatment must be removed to prevent contamination of subsequent solutions. Plain running water is usually sufficient for rinsing, although sometimes chemicals may be added to neutralize or remove the residue of the previous bath.

Solutions cannot be used indiscriminately with all color materials. Baths in various processes perform similar functions but do not have the same chemical composition. The manufacturer works out a process in detail to match a specified product, then he supplies a prepared chemical kit for use with that product. Instructions for mixing and processing should be followed closely, although some experimentation may be necessary to determine slight variations that may be required with particular equipment.

Color materials must be processed carefully if the result is to be a proper balance between the three different emulsions. Temperatures, times, and agitation must be controlled accurately. The first development is particularly critical with reversal film because too little or too much development leaves either too much or too little silver for the positive image formed in the second developer, thus giving either a transparency that is too dark or too light. In most steps following first development, the chemical action goes to completion; too little time or too little agitation is the greatest danger.

Whereas exposure and development latitude in negative materials is quite considerable, it is almost nonexistent with color reversal films because there is no printing stage when corrections and manipulations are possible. For a good quality image with reversal films, exposure and first development must be accurately balanced; any variation inevitably degrades picture quality.

### Processing Negative Color Films

Color couplers are incorporated in the emulsion layers of all color negative films. After exposure these films are put through only one developer—a color developer, which produces a negative color image at the same time that it forms the negative silver in each layer. Blue skies are recorded as brownish-yellow in a color negative; greens appear as magenta, and yellow as blue. The silver image and undeveloped silver halides are removed by bleaching and fixing. The dye images are the same old friends, the subtractive primaries—yellow, magenta, and cyan, reading from the film's top emulsion layer to the bottom one. These colors are the negative or complementary colors to those of the subject that caused the exposure in each layer.

The essential steps in color negative processing are:

1. Development—exposed silver halides form the silver negative image and, simultaneously, negative dye images form in the three layers. (Film goes through stop bath, hardener, and rinse.)

2. Bleaching—silver negative image is converted back to silver salts that can be removed. (Another rinse.)
3. Fixing—removal of both the unused original silver halides and the bleached negative image. (Final wash.)

The color negative is used to expose three emulsions with incorporated color couplers that have been coated on paper. Processing of this material in a color developer, bleaching out the silver image, and fixing out the undeveloped silver halides, leaves a positive color image, formed again by the subtractive primaries. The negatives may also be used for exposing film for making color transparencies, or they may be used to expose a special panchromatic emulsion coated on paper to produce black-and-white prints.

Making color prints from color negatives has been greatly simplified for the photographer, since the manufacturer has built into the films—for instance, Eastman's Kodacolor—masks formed of color couplers. This is the reason Kodacolor negatives have a strong, over-all orange cast. This built-in mask corrects for the imperfect functioning of the subtractive dyes.

In addition, the photographer can control color-rendering in the final print, but he must use various filters in combinations to alter the light that reaches the emulsions of the printing paper. This is the reason one type of negative color film can be used for all subjects regardless of the nature of the illumination. Any distorted color values created by the illumination can be corrected during printing. Here, in fact, lies a major advantage of the color negative process. Just as in black-and-white processing, the negative and the positive are separate stages and can be separately controlled to permit corrections. Dodging and fundamentally all the other controls available in black-and-white printing are also available in color printing from color negatives.

# Color Exposure

For anyone who has taken even a few photographs with color film it will come as no surprise to be told that exposure is critical. Exposure is, in fact, the single greatest technical problem. In black-and-white photography, processing is normally divided into two stages, and shortcomings evident after the negative stage can often be corrected during the positive stage. The same is true, to a somewhat lesser degree, with color negative film, for it, too, involves the two processing stages. But with color reversal films negative and positive are inextricably linked in a single series of processing steps. This means that the original exposure of the film in the camera determines both the negative and the positive images.

The positive image is formed from the silver halides left in the three emulsions after the negative image is developed. For purposes of illustration, let us assume 100 silver halide grains are available for image formation in a small section of the film where an image highlight has been recorded. We shall further assume that we need a minimum of 20 of those grains to form adequate highlight detail and adequate color in the positive image. If exposure has produced latent-image silver on 90 of those grains, all 90 will be reduced in the first developer. We have only 10 left for reduction and color-forming in the second development. The connection between cause and effect is obvious. Too much exposure in the camera will produce a thin picture in pastel colors, and the highlight detail will be lost.

If the reverse is true, if the film in the camera is underexposed, then too many of the halides are left for the second (color) development. This results in a transparency that is too dark.

In general, we assume the exposure latitude of color films to be only about a half stop on either side of correct exposure. Actually, this is true only of subjects of average contrast. When the brightness range of the subject is short, exposure latitude with color film may be as much as two stops.

An exposure meter, properly used, will significantly increase the percentage of successful exposures with color film. Close-up meter readings

are advisable, if feasible, of the lighter (but not the very lightest) areas of the subject. For most subjects correct rendition of the colors with light or medium brightness is most important. Even after the exposure has been determined by the photographer's best judgment, based on an exposure meter's reading, it is often advisable to take three shots, bracketing the indicated exposure at one-stop or half-stop intervals.

Underexposure of reversal color films is generally preferable to overexposure. In fact, a slight underexposure may result in the most pleasing transparency because it gives saturated colors. If there is a general rule on exposure with color film, it is the opposite of the one often suggested for black-and-white film. With black-and-white film we expose for the shadows, favoring overexposure, but with color film we expose for the highlights, favoring underexposure.

A subject of high contrast (dense shadows and brilliant highlights) may be beyond the limited exposure range of color film. No exposure will be correct for all parts of the scene. This requires a decision favoring the most important part. As a photographer begins work with color film he generally needs some experience with various subjects before he learns to recognize those with a brightness range exceeding film latitude. A major part of our difficulty stems from a remarkable characteristic of the mechanism with which we have been equipped for seeing, a characteristic that normally operates to our great advantage. It is only in photography that it becomes something of a handicap.

## Tricks of the Eye

The eye adjusts in two ways to meet the fluctuations in illumination. Nearly everyone is familiar with the dilation and contraction of the iris of the eye. When the iris is wide open it admits about sixteen times as much light to the retina as when it is fully stopped down. But in addition, the retina itself changes, automatically decreasing its sensitivity in bright light. By this system of *brightness adaptation*, the eye maintains a relatively constant level of response and gives us approximately equal vision indoors and out. But this also means that our eyes are unreliable as instruments for estimating levels of illumination. Think for a moment of how bright the light from an incandescent lamp seems in a room at night, and then compare it in memory with how feeble the same lamp seems when the room is flooded by sunlight during the day.

Still another characteristic of vision is involved here, a characteristic mentioned previously in Chapter 17 in connection with the way we see color. We tend to see objects as we know them to be, rather than as they actually are under a given light. Thus, a man's white shirt is still white, although he may be standing in a shadow, and it looks brighter to us, perhaps, than another man's gray shirt in direct sunlight. Actually the gray shirt may be reflecting more light. This characteristic of vision has been given the name of *brightness constancy*.

## Lighting Problems

Brightness adaptation and brightness constancy are important in all photography, but they take on increased importance with color-reversal films because of the short latitude of these films. Shadows always appear darker in the print or transparency than they did in the actual scene. This explains why flat lighting is so often recommended for color photography. The recommended lighting will look flat to the eye because of brightness adaptation and brightness constancy, but it will not be recorded as flat by the film.

Recommended lighting for color film gives only two or three times as much illumination to the highlights as to the shadows. All areas of the subject must be adequately lighted if we are to avoid shadow regions so dark that color and detail are lost.

Problem shadow areas confront the photographer both indoors and out. He can either sacrifice a part of the picture, or he can throw some light into the shadows to establish a closer balance between them and the highlights. Reflectors may serve the purpose, and sometimes natural reflecting surfaces, such as sand or water, are inherent in the situation. Reflectors (mentioned in Chapter 10) can be used effectively with color film as long as they do not change the color of the light. The flash-fill technique (also discussed in Chapter 10) will work with color film, too, if the film and flash are properly matched in color temperature.

## Color Balance

An important factor in color photography is the color quality of the light that illuminates the subject. Again, we are dealing here more with a characteristic of the mechanism of vision than we are with the idiosyncrasies of color film. Just as the eye is capable of brightness adaptation, so it is capable of *general color adaptation*. It seems that when our eyes are adapted to daylight the three receptor systems are about equal in sensitivity, and so the general illumination appears to be white or colorless. When we move indoors to a room illuminated by ordinary incandescent (tungsten) lamps we may at first notice a slight yellowish hue to the lighting. But soon this impression fades and the light indoors seems as white as the light we just left outdoors. The artificial lighting is yellower than daylight because tungsten light sources are weak in the blue end of the spectrum and somewhat weak in the green region. The eye, adjusting for this variation from the spectral-energy distribution of daylight, increases the sensitivity of the blue-light receptor system a good deal, and increases the sensitivity of the green-light receptor system somewhat. Thus, a sheet of white paper viewed outdoors in daylight and then taken indoors under tungsten light should look yellow because the illumination indoors is definitely yellow compared with the daylight. But the eye and brain report that the paper is unchanged; it is still white. The color-receptor systems of the eye have adjusted to keep it so.

Furthermore, another phenomenon known as *color constancy* is involved. All normal colors tend to appear as they do in daylight regardless of the color quality of the illumination. Part of this is the result of general color adaptation, but part seems to be the result of color memory, our tendency to see colors as we know they should be.

Now, no color film as yet manufactured has either color adaptation or color memory. A film that correctly records a white sheet of paper as white in daylight records that same sheet of paper as a pale yellow in tungsten light. The film is given a particular color balance at the time it is made, and this cannot be altered. It is, however, possible to make changes in the color balance during the printing operation with color negative film.

There are basically two types of reversal films in terms of color balance:

1. Daylight-type films.
2. Tungsten-type films.

Daylight-type films obviously cannot be manufactured to give equally accurate color rendition in all possible daylight situations. Color quality varies significantly between the time when the sun is shining directly on a subject and when the sun is momentarily obscured by a passing cloud. A radical difference occurs between sunrise and noon, and between noon and sunset. Daylight-type film is color balanced for use in sunlight on clear and hazy days between midmorning and midafternoon. These daylight-type films can be used for flash exposures with electronic flash or with blue flash bulbs. In effect, the blue tint in the lacquer covering the bulb's outside surface raises the color temperature of the light to approximately the level of daylight. The blue coating accomplishes this by filtering out some of the yellow, orange, and red wavelengths while letting all the blue rays pass.

Films for use with tungsten light are divided into two types:

1. Type A films balanced for the light from photoflood lamps rated at 3400° K.
2. Type B films balanced for the light from 3200° K lamps. These are lights intended for use in professional studios.

Reversal color films that are balanced for one particular kind of light source can be used with other sources if the appropriate filter is used over the camera lens. The filters alter the color quality of the light reaching the film. Greater and more diverse needs exist for filters with color than with black-and-white, and as a result filters for color films seem to exist in prodigal profusion. To keep this from becoming mere confusion, remember that filters for color films fall into four general classifications:

## Filters for Color

1. *Conversion Filters.* These are used to change the color quality of the light to match the color balance of the film, so they are also sometimes referred to as light balancing filters. Filters that make relatively large shifts in the color temperature of the light are blue (the No. 80 series in Wratten filters) to raise the color temperature, or amber (the No. 85 series in Wratten filters) to lower the color temperature. Other filters, because their bluish or yellowish tint is less, will provide smaller color temperature shifts, and these are often the ones being referred to by the term light-balancing filters, such as the No. 82 series (bluish) and the No. 81 series (yellowish) in the Wratten filters.

2. *Color-Compensating Filters.* These are aids for the professional photographer striving for precise color results. They come in six colors—magenta, yellow, cyan, red, green, and blue—and in six or seven

strengths (or densities) in each color, ranging from light tints to those strongly colored. A filter in the CC series may be designated, for example, as a CC10Y, indicating it is a color-compensating filter with a density of 0.10 in yellow. The density is a measurement of the light-absorbing power of the filter. Each filter absorbs its complementary color or colors, of course. A yellow filter absorbs blue; a red filter absorbs both blue and green (or cyan, red's complementary).

3. *Color-Printing Filters.* These are the same colors and values as the CC filters but color-printing (CP) filters are made of acetate for use in the color heads of enlargers and are more resistant to heat than CC filters.

4. *Specific Purpose Filters.* The most commonly used filter in color photography is the skylight or ultraviolet filter. The Kodak Skylight Filter (No. 1A), which is almost clear but has a slight pinkish cast, is an example. These filters are used to absorb unwanted ultraviolet and some violet that often gives excessive exposure to the blue-sensitive layer of color films. The result of this excessive exposure is the familiar bluish look in images of subjects in open shade under a blue sky or the bluish shadows in snow scenes on a bright day. The second most useful filter for ordinary color photography is probably the polarizing filter which will produce deep blue skies, increase color saturation, eliminate or subdue reflections in nonmetallic surfaces, and penetrate haze (when the camera axis is at right angles to the sun).

# Glossary

Many of the terms and concepts included in this glossary are discussed more extensively in the text. Please consult the index.

**Aberration:** Any one of a number of faults in a lens that can cause unsharpness or distorted lines in the image.

**Acetic acid:** A compound used in highly diluted form as the rinse bath (short stop or stop bath) following development of film or paper. The acid in vinegar. Glacial acetic acid is the concentrated (99%) form; its vapors, sharp and penetrating, are flammable and in this concentrated form acetic acid can burn, so it must be handled with caution. When diluting, pour acid into water; do not pour water into acid.

**Achromat:** A lens partially corrected for chromatic aberration; it is corrected for two colors. Most photographic lenses in use today are achromats.

**Activator:** Chemical catalyst, usually an alkali such as sodium carbonate or borax, used in developing solutions to increase the activity of the reducing agent.

**Agitation:** Movement of the processing solution to ensure a uniform and complete chemical reaction.

**Alkali:** One of many compounds with a pH value greater than 7, commonly used in photographic developers as activators. Generally, fast-working developers contain strong alkalies or relatively large amounts of mild ones. See *pH value*.

**Ammonium thiosulfate:** Fixing agent used in rapid fixers.

**Anastigmat:** A lens that has been corrected for astigmatism, using a converging element and a diverging element so the astigmatism of one is nullified by the equal and opposite astigmatism of the other.

**Angle of view:** The portion of a scene that is seen by a camera lens.

**Anhydrous:** Without water; dry. Opposed to the crystalline form of chemicals, which normally contain a substantial amount of water, which adds to weight. Thus, it is important to specify in chemical formulas if certain compounds involved are anhydrous.

**Aperture:** The opening in the diaphragm of the lens through which light passes, usually calibrated in *f*/numbers, which are fractions of the lens focal length.

**Apochromat:** A lens corrected for three colors to nearly eliminate chromatic aberration. These are not required for ordinary photography and they are expensive to manufacture.

**ASA:** Initials of the American Standards Association, which is now known as the American National Standards Institute. But ASA is still used before numbers designating film speeds (ASA 125).

**Astigmatism:** A lens aberration; rays from a point on the subject are not brought to a sharp focus. A lens corrected for this is an anastigmat.

**Automatic camera:** A camera with a built-in exposure meter that automatically adjusts the lens opening, shutter speed, or both for an exposure based on the light reflected from the subject and on the speed of the film.

**Available light:** Lighting the photographer finds existing at the scene.

**B:** A symbol for bulb, used on camera shutter scales to indicate the setting that allows the shutter to stay open as long as the shutter release is depressed.

**Bas-relief:** In sculpture, low relief or slight projection of figures from background. In a photographic print, an apparent low relief effect in the image.

**Between-the-lens shutter:** A shutter of several metal blades placed between two elements of the lens; also called a leaf shutter.

**Bleach:** A chemical solution that dissolves the silver image.

**Bleed:** Mounting a picture without a border or placing a picture in a book or magazine so the image extends to the edge of the page.

**Blocked up:** Description of an overexposed area of a negative that is so dense it prints as solid white with no texture or detail.

**Blowup:** An enlargement; a print that is bigger than the negative.

**Bounce light:** Flash or flood lighting reflected from ceiling, wall, or other surface.

**Bracket:** To make a number of different exposures of a single subject when there is doubt about the correct exposure. The exposures range above and below an estimated correct exposure at half-stop or full-stop intervals.

**Bromide:** Chemical compounds (salts) containing bromine, such as potassium bromide or silver bromide. Silver bromide is a light-sensitive salt commonly used in photographic emulsions.

**Bromide paper:** A paper for making enlargements; the emulsion contains mostly silver bromide.

**Bulb:** A term for a shutter setting that indicates the shutter will stay open at this setting as long as the shutter release is depressed. The setting is indicated on the shutter scale by a B. Used for time exposures. The term refers to a rubber bulb and hose device, seldom used today, that can trip the shutter with air pressure through the hose when the bulb is squeezed.

**Burning-in:** Additional exposure for an area of the print. Also called printing-in.

**C:** Abbreviation for Celsius or centigrade thermometer scale.

**Cable release:** Flexible cable screwed into the camera shutter release so the shutter can be tripped by depressing a plunger in the end of the

cable. Used to reduce the danger of jiggling the camera, especially with B settings.

**Cadmium sulfide cell:** A light sensitive device used in exposure meters; often abbreviated as CdS.

**Camera angle:** The viewpoint from the camera position, partially controlling the relationships of various elements in the scene.

**Capacitor:** A device for storing electrical energy; used in electronic flash units. The amount of energy it can store is called capacitance. Also called a condenser.

**Catchlights:** Reflections of light sources in a subject's eyes or glasses. Generally desirable in eyes, undesirable in eyeglasses.

**Celsius:** Same as centigrade thermometer scale, invented by Anders Celsius, a Swedish astronomer.

**Chlorobromide:** An emulsion made of a mixture of silver chloride and silver bromide; common in paper emulsions, giving medium speed for enlarging.

**Chromatic aberration:** Inability of a lens to bring all wavelengths of light to the same point of focus because of dispersion.

**Chrome:** From Greek chroma meaning color or colored.

**Circles of confusion:** Blurring of the image caused when light rays are not precisely focused. Unfocused rays form tiny circles instead of points on the image.

**Clearing time:** Time needed for the hypo to clear the milky appearance (and thus the unused silver halides) from the film.

**Clearing agent:** A chemical that neutralizes hypo in film or paper, reducing washing time needed to provide a stable image.

**Click stops:** Settings on the diaphragm or shutter scale that are indicated by a slight bump and/or click as the ring or lever is moved.

**Close-up lens:** A supplementary lens that, when placed in front of the normal camera lens, permits focusing at shorter distances.

**Coated lens:** A lens covered with a very thin chemical coating, often magnesium fluoride, to reduce the amount of light reflected from the surfaces of the lens. A coated lens is faster (transmits more light) than an uncoated lens and creates less flare light.

**Cold tone:** A bluish-black tone in the black-and-white image.

**Color balance:** The ability of a film to reproduce the colors of a scene. Color films are balanced for exposure to light of a certain color quality (daylight or tungsten). Color balance may also refer to the reproduction of colors in color prints.

**Color separations:** Images on either film or paper that represent the intensity of the primary color components in a full-color image, usually made for engravings for printing color pictures in newspapers and magazines.

**Color temperature:** Method of defining the color of light based on light emitted by a black body heated to a known temperature; expressed in degrees Kelvin.

**Compensating developer:** A developer that tends to work vigorously in areas of low exposure (shadows) and less so in areas of high exposure (highlights), thus compensating for high contrast in the subject. Most developers will give some compensating action if highly diluted and used with infrequent and gentle agitation.

**Compur shutter:** Trade name for a between-the-lens, leaf shutter with independent mechanisms for time exposures and instantaneous exposures (1 second to 1/500).

**Condenser:** Electrical device for storing a charge; also can mean the condenser lens in an enlarger.

**Condenser enlarger:** An enlarger with a condenser lens above the negative that concentrates all the light rays on the negative.

**Contact print:** A print made by placing negative on top of paper, emulsion to emulsion, then exposing the paper with light that passes through the negative.

**Contrast:** In black-and-white photographs, the difference in visual brightness between one part of the image and another.

**Contrast grade:** A number from 0 to 6 designating the contrast of a printing paper; 0 is lowest, 6 highest.

**Contrast index:** The gradient of a straight line drawn between two points on the characteristic curve that represents the highest and the lowest useful densities in a normal negative. The value of the contrast index is the tangent of the angle that this straight line makes with the horizontal.

**Cropping:** Eliminating part of the negative image when making the print.

**Curtain shutter:** A focal-plane shutter; it operates much like a curtain as it moves a slit across the film to make the exposure.

**Cut film:** An individual piece of film for one exposure; also called sheet film.

**Cyan:** One of the subtractive primary colors; it is a blue-green that subtracts red.

**Definition:** The impression of clarity or sharpness given by an image.

**Dense:** A black area in a negative; the silver deposit is heavy because exposure was heavy.

**Densitometer:** An instrument for measuring the density of an area in a negative or print.

**Density:** The blackness of an area in an image.

**Depth of field:** Distance between nearest and farthest objects that appear in acceptable focus in a photograph.

**Depth of focus:** Distance the film can be shifted inside the camera and still permit a sharply focused image; not the same as depth of field.

**Diaphragm:** A light barrier of thin metal leaves arranged between elements of the lens; an opening at the center of the diaphragm is adjustable to form the *f*/number settings that establish the intensity of the light reaching the film.

**Diffraction:** The deflection of light rays as they pass the edge of an opaque body or through a narrow slit.

**Diffuse:** Spread in all directions, thus even.

**Diffusion enlarger:** An enlarger that scatters light above the negative so the negative is evenly illuminated.

**DIN:** Deutsche Industrie Normen, the German scale of film speeds. DIN numbers can be converted to approximate equivalents in the ASA system by beginning with DIN 16, which is approximately equal to ASA 32. Then, as the DIN number increases or decreases by three, the ASA number doubles. Thus, DIN 13 equals ASA 16 and DIN 19 equals ASA 64.

**Dispersion:** Separation of white light into its various wavelengths (or colors), as by a prism. This can also occur with a lens and is called chromatic aberration.

**Dodging:** Holding back light from a part of the paper during exposure to lighten that area in the print image.

**Double exposure:** Two images on one film frame or on one print.

**Dropout:** A high contrast print from which most if not all of the grays or halftones have been eliminated, leaving only black and white.

**Dry mounting:** Attaching prints to cardboard or other mounting material with shellac impregnated tissue that creates a bond between print and mount under heat and pressure.

**DW:** Double weight (paper).

**Dye transfer:** Method of making color prints by transferring three dyed images (cyan, magenta, and yellow) to a single sheet of paper.

**Easel:** In photography usually refers to the device used with enlargers to hold the printing paper during exposure.

**Electronic flash:** Light for still photography, produces a very brief (usually less than 1/500th of a second) flash of light by the discharge of electricity through a gas-filled glass tube. Sometimes called "strobe" light, from stroboscope, although the flash devices used in still photography are not stroboscopic lights.

**Element:** One unit, usually meaning one single piece of glass, of a compound lens containing two or more such pieces, but it can mean several pieces of glass that are regarded as a single unit within the lens.

**Emulsion:** The light-sensitive coating, principally silver halides suspended in gelatin, on film or paper.

**EVS:** Exposure value system.

**Exposure:** The quantity of light allowed to strike the film or paper, a product of intensity (controlled by the $f$/number) and time (controlled by the shutter).

**Exposure factor:** A factor (multiplier) to be used when a condition requires increased exposure, as with filters over the camera lens.

**Exposure index:** A number rating given the film for purposes of figuring

exposures. Film speed is generally the ASA number of the film; an exposure index is any other number the photographer has arbitrarily assigned the film. However, photographers frequently refer to an exposure index as a film speed and, in fact, seldom use the term exposure index.

**Exposure value (EV):** A number in a series (usually 2 to 18) for establishing exposures. The numbers in the exposure value system take into account both shutter speed and aperture. The higher the number the less the exposure; thus, 13 is one-half the exposure of 12, which is twice the exposure of 11. Each EV has a number of equivalent exposures in terms of shutter speeds and $f$/numbers. EV 12 could be either 1/30 at $f$/11, 1/60 at $f$/8, 1/125 at $f$/5.6, etc. For a time some cameras and meters were being made with EV scales, but the idea failed to catch on and has been largely abandoned. Also called light value.

**Extension:** Maximum distance possible between lens and film. Double extension indicates this maximum distance is twice the lens-film separation when the lens is focused at infinity, and at double extension the image is the same size as the object. Extra extension for closeup photography is achieved either with bellows or with extension tubes placed between lens and camera.

**F:** Flash synchronization setting for gas-filled, fast-peak bulbs; no longer common.

**Farmer's reducer:** A solution of potassium ferricyanide and hypo (sodium thiosulfate) used in bleaching; named for E. H. Farmer.

**Ferrotype plate:** A chromium-plated or black-enameled sheet of steel, or mirror-plated glass, used to dry prints to a high gloss.

**Fill light:** Light directed into shadows to reduce lighting contrast.

**Film speed:** The sensitivity of film to light; film speed is given in numbers; the higher the number, the more sensitive or faster the film. See *ASA*.

**Fish-eye lens:** A lens that has an angle of view of about 180 degrees.

**Fixed-focus lens:** A lens that has been permanently focused for an intermediate distance at time of manufacture.

**Fixing bath or fixer:** The bath for film or paper that dissolves the unused silver halides, thus eliminating the light sensitivity of the emulsion. Also called hypo. The principal fixer ingredient is sodium thiosulfate.

**Flat:** Too low in contrast.

**$f$/number:** Number used to indicate the size and thus the light-passing ability of the diaphragm opening in the lens. The $f$/number expresses the size of the aperture as a fraction of the focal length: $f$/2 means the aperture diameter is one-half the focal length of the lens.

**Focal distance:** Distance from the lens to the plane of the focused image.

**Focal length:** Distance from the lens to the point where the lens focuses the image when the lens is set on infinity. Focal length determines image size at a given lens-to-subject distance.

**Focal-plane shutter:** A curtain with a slit that exposes the film as the slit moves across the film at the film (focal) plane.

**Fog:** Creation of silver deposits (densities) in the developed emulsion by extraneous light or chemical action, not part of the normal image.

**Forced development:** Development prolonged beyond the normal time, usually to compensate for underexposure.

**Frame:** One individual picture. Frames of 35-mm film are numbered for identification; the numbers followed by *A* are for identification of shots taken with a half-frame camera.

**Gamma:** Image contrast as a function of development.

**Gradation:** The rate of increase in density and thus the number of different tones in the image between black and white.

**Grain:** Sand-like or granular appearance in an image, stemming from clumps of silver in the film.

**Gray scale:** Strip of film or paper showing densities ranging from white to black in a series of steps. Also called step tablet.

**Groundglass:** The glass viewing screen in some cameras.

**Guide number:** The number used to figure flash exposures. The flash-to-subject distance in feet divided into this number gives the *f*/number to be used with a previously determined shutter speed. The greater the light output of the flash the higher this number.

**Halation:** Halo of light around the heavily exposed image of a point source of light, usually caused by light penetrating the film base and reflecting back. Modern films have anti-halation backing, a dyed gelatin layer on the back of the film to absorb this light, or contain halation absorbing dyes within the base itself.

**Halftone:** Term for the gray tones between white and black. Also the product of the halftone engraving process used to reproduce photographs in printed media.

**Halides:** Compounds of the halogens: fluorine, chlorine, bromine, and iodine. The chlorides, bromides, and iodides of silver are light-sensitive compounds used in photographic emulsions.

**H and D Curve:** A characteristic curve for a film or paper showing its response to exposure and development. Named for its inventors, F. Hurter and V. Driffield.

**Hard:** Usually means excessive contrast, or at least high contrast.

**Hardener:** A chemical used for toughening the emulsion, usually alum, chrom alum, or formalin. Most commonly used in fixing baths.

**Highlights:** Brightest areas in a print (darkest in the negative) that have noticeable detail. Not specular reflections.

**Hydroquinone:** A reducing agent in many developers. Also known as paradihydroxybenzene. It produces high contrast in the image and

usually is used in developers with metol, another reducing agent, to produce what are called MQ developers.

**Hyperfocal distance:** Distance from the camera to the nearest point in acceptable focus when the lens is focused on infinity. It is the near edge of the depth of field when the lens is focused at infinity. Focusing the lens on hyperfocal distance will give a depth of field stretching from one-half hyperfocal distance to infinity.

**Hypo:** Fixing bath made from sodium thiosulfate.

**Hypo clearing agent:** A bath used to reduce final washing time for films and papers by converting the chemical residue from fixation to compounds that dissolve more readily.

**Hypo eliminator:** A bath used to remove all traces of hypo from prints that are to be preserved for a long time. Often used to mean washing aids or hypo clearing agents.

**Incident light:** Light falling on the subject.

**Interchangeable lens:** A lens that can be removed from the camera and replaced by another.

**Inverse square law:** The intensity of the light at any point on the subject varies inversely with the square of the distance from a given source. This is only completely true of a point source of light.

**Kelvin degrees:** Used for measuring color temperatures of light sources. The Kelvin scale begins at absolute zero, so 0° Celsius is 273° Kelvin. Sunlight is generally assumed to be about 5000° Kelvin; sunlight plus blue skylight is assumed to be 6000° to 6500° K. Named after W. T. Kelvin.

**Key:** The prevailing tone of a print: low-key, mostly grays and dark tones; high-key, mostly white and light gray tones.

**Key light:** Principal light when more than one flood or flash light is being used.

**Latent image:** Photochemical change created in silver halide emulsion by the action of light; it is invisible but forms the basis for the developed visible image.

**Latitude:** The range between the least and the greatest exposures that give acceptable negatives. Latitude is indicated by the length of the straight-line portion of the characteristic curve. Generally the faster the film the greater the latitude, and the less the subject contrast the greater the latitude.

**Leader:** A strip of film or paper at the beginning of a roll of film that is used to load the film into the camera.

**Lens hood:** Device attached to front of the lens to shade it from direct light coming from outside the picture area; helps reduce flare light. Also called lens shade.

**Lens speed:** The largest aperture available with a given lens. A "fast" lens can transmit more light at its largest aperture than a "slow" lens at its largest aperture.

**Light value system:** See *Exposure value.*

**Litho film:** High-contrast film made for graphic art work.

**Long lens:** A lens of longer than normal focal length, with normal being defined as a length approximately the same as the diagonal of the negative frame involved.

**LVS:** Light value system. See *Exposure value.*

**M:** Flash synchronization marking; M for medium-peak, wire-filled bulbs.

**Manual override:** The feature on an automatic camera that lets the photographer set the exposure manually if he prefers to do so.

**Mat:** A frame, usually cardboard, that provides a border around a picture.

**Matte:** Surface texture that is nonglossy; a dull finish.

**Meniscus:** A simple lens with one side convex, the other concave.

**Metol:** The reducing agent p-methylaminophenol sulfate. Also known by other trade names, such as Elon. It produces low contrast and is generally used in combination with hydroquinone, which produces high contrast in what are called MQ developers.

**Microprism:** Center spot in the viewing screen of single-lens reflex camera consisting of many tiny prisms. When the image is unfocused, the part in the microprism area appears fractured and shimmery. At exact focus the image is sharp and steady.

**Mired values:** Another way, other than degrees Kelvin, of expressing color temperatures. Mired stands for micro-reciprocal degrees. The mired value of a light source is its color temperature in degrees Kelvin divided into 1,000,000. Thus a color temperature of 5000° K would be 200 mireds (1,000,000/5000) or 20 decamireds, since one decamired equals 10 mireds.

**MQ developer:** One that contains both the reducing agents Metol and hydroquinone or similar agents.

**Multi-coating:** A technique of covering a lens with several layers of anti-reflection coatings to increase light transmission and reduce flare. See *Coated lens.*

**ND:** Neutral density.

**Neutral density filter:** A gray filter that reduces the intensity of the light, intended for use over the camera lens to reduce exposures without changing the color of the exposing light.

**Normal lens:** A lens with a focal length approximately equal to the diagonal of the negative.

**One-shot development:** Using a developing solution just once, then discarding it.

**Open flash:** Keeping the shutter open for a time exposure while the flash is fired separately.

**Orthochromatic:** Sensitive to blue and green but not to red light. Ortho (from Greek) really means straight, correct, or proper.

**Overexposure:** Too much light; produces a dense negative but a washed-out positive transparency (slide).

**Pan:** Abbreviated form of panchromatic.

**Panchromatic:** Film that is sensitive to all the wavelengths of light. Pan is a combining form meaning all or every.

**Parallax:** The difference between what is seen through the viewfinder and what is recorded on the film, particularly evident at close subject distances when viewfinder and lens are separate. There is no parallax with a single-lens reflex camera because viewing is done through the lens.

**Pentaprism:** Five-sided prism in viewfinders of single-lens reflex cameras to turn the image right side up and properly oriented laterally.

**pH value:** One of the numbers from 1 to 14 that form a scale indicating the acidity or alkalinity of solutions. Pure water, which is neutral, has a pH value of 7. Any number higher than 7 indicates alkalinity, and the strongest alkali has a pH value of 14. Any number lower than 7 indicates acidity, and the concentration of acid is greatest at 1. The stronger the alkali, or the higher its pH value, the greater the developer activity. Developers with sodium hydroxide have a pH of approximately 12 and are extremely active; those with borax have a pH of about 9 and are slow developers.

**Preservative:** Chemical in processing solutions to retard oxidation of the reducing agent on contact with the air, usually sodium sulfite.

**Preset lens:** A lens that can be used wide open for bright viewfinding and focusing through the lens and then quickly closed manually to a preset f/number.

**Print quality:** See *Technical quality.*

**Pushing the film:** To prolong the time of development or to develop at the time prescribed for 68° F but at a higher temperature, say 80°. Same as forced development. Used to compensate for known underexposure.

**Rapid fix:** Fixer or hypo that eliminates the unused halides somewhat faster than regular hypo; it contains ammonium thiosulfate instead of the sodium thiosulfate used in regular fixers.

**Ready light:** Light on electronic flash unit that indicates capacitor has been recharged.

**Reciprocity failure:** Failure of the reciprocity law, which can occur at low light intensities or at relatively long time periods. Particularly significant with color films.

**Reciprocity law:** Exposure equals intensity of the light multiplied by the time. According to this law, no matter what the intensity of the light involved or the time involved, if the product of the two is constant, exposure will be constant.

**Recycling time:** Time needed after an electronic flash unit has been fired for the capacitor to refill to the level needed for a given light output.

**Reducing:** Usually refers to the lowering of densities in a negative or print by using a chemical solution (a reducer) that removes some of the image silver.

**Reducing agent:** The principal chemical ingredient of developing solutions, since it provides electrons that "reduce" the positive charge of the silver ion in the silver halide crystals, thus forming atoms of silver and the visible image.

**Reflex camera:** A camera equipped with a mirror that reflects the image onto a glass where it can be focused and composed.

**Register:** Superimposing two images of the same subject, one on top of the other, so that they match exactly.

**Relative aperture:** The diameter of the opening in the diaphragm of the lens as compared with the focal length of the lens. Dividing the focal length by the diameter of the opening gives the relative aperture or the $f/$number.

**Replenisher:** Chemical added to some developers after film has been processed to replace the chemicals used in the developing process, thus keeping the strength of the developer relatively constant for future use.

**Resolution:** Sharpness of the image.

**Resolving power:** Ability of the lens or the light sensitive emulsion to reproduce fine detail. The resolution (sharpness) of an image depends upon the resolving power of both.

**Reticulation:** Cracking or distorting of the film emulsion during processing caused by wide temperature differences between solutions or by harsh chemical treatment.

**Sabbattier effect:** Partial reversal of image tones caused by exposure to light after partial development. Named after Armand Sabbattier, who discovered it in 1862.

**Safelight:** Darkroom light fitted with a filter to screen out light rays to which emulsions are sensitive. Different emulsions require different safelights.

**Sharpness:** The degree of definition of detail in an image; distinctness of outline, detail, and texture.

**Sheet film:** Film supplied in individual pieces the size of a single frame. Also called cut film.

**Silver halides:** Light sensitive salt formed by the combination of silver and one of the halogens.

**SLR:** Single lens reflex camera.

**Sodium thiosulfate:** Fixing agent or hypo used in photography to dissolve the unexposed silver halides left in the emulsion after development, making it safe to expose the developed image to ordinary light.

**Soft:** Describes an image that lacks sharpness or an image with less than normal contrast.

**Solarization:** Popular term for Sabattier effect, a partial reversal of image tones, although it originally meant a complete reversal of image tones caused by extreme overexposure.

**Spotmeter:** An exposure meter that reads light reflected from a small area of the subject represented by an angle of view of one to three degrees.

**Spotting:** Retouching a print with pencil or paint to hide blemishes.

**Stabilization:** Alternative process to fixing, usually used when prints are needed in a hurry. The unused silver halides are converted to colorless and relatively stable compounds. Stabilized images will not last indefinitely.

**Stock solution:** A concentrated form of a processing chemical that is diluted for use.

**Stop:** The aperture or $f$/number. To stop down means to reduce the size of the aperture. Stop is also used sometimes as a short form of stop bath.

**Stop bath:** An acid rinse, usually a weak solution of acetic acid, used to stop development.

**Strobe:** Contraction of stroboscope, a light that flashes repeatedly, automatically, and rapidly. Strobe light is often used, however, to refer to electronic flash units used in still photography that do not automatically repeat.

**SW:** Single weight (paper).

**Technical quality:** Those qualities of the image that are the result of the photographer's knowledge—or lack thereof—of technique or craftsmanship. Usually refers to such things as sharpness of the image, contrast, lack of blemishes such as pinholes in the negative, uneven development, non-image spots on the print or other surface blemishes, and adequate detail in highlights and shadows.

**Thin-emulsion film:** A film coated with a thinner than normal layer of emulsion, relatively slow in speed but high in image resolution with fine grain.

**Thin negative:** One that is underexposed or underdeveloped (or both) so the image lacks normal densities. A thin negative is usually flat.

**Thyristor:** An electronic switch used in automatic electronic flash units that quenches the light when a given exposure has been achieved as measured by light reflected back from the subject.

**Time exposure:** Any manually timed exposure longer than one second.

**Tone:** The degree of lightness or darkness in an area of a print; also called value. Cold tones are bluish and warm tones are brownish.

**Tungsten light:** Light from an electric lamp with a tungsten filament that emits light when the filament is heated by the electric current. Tungsten light has less of the short wavelengths of light and thus looks yellowish by comparison with daylight.

**Underexposure:** Too little light; produces a thin, flat negative, a dark positive transparency or slide, or a flat, muddy-looking print.

**Vignetting:** Printing the central area of a picture while shading the edge areas gradually into white.

**Warm tones:** Brownish-looking tones in the black-and-white print.
**Washed out:** Highlight areas lack detail or texture.
**Washing aid:** See *Hypo clearing agent.*
**Wide-angle lens:** One that has a shorter focal length and a wider field of view than a normal lens.
**Working solution:** Any processing solution, as opposed to stock or storage solutions.

**X:** Flash synchronization for electronic flash.

**Zoom lens:** One in which the focal length can be adjusted.

Space does not permit an exhaustive listing of the extensive literature of photography. This list is a limited guide to further exploration. It does not include many specialized books and manuals, nor does it include any selections from the vast periodical literature. Some of the books listed are out of print but are still available in many libraries.

For an extensive bibliography, look for *Photographic Literature* by Albert Boni in the reference section of the nearest library.

# Bibliography

## General

Strongly recommended are the Basic Photo Series books by Ansel Adams that include *Camera and Lens, The Negative, The Print, Natural-Light Photography*, and *Artificial-Light Photography*, all published by Morgan & Morgan. The Adams' Zone System of exposure is covered in *The Negative*. Also, for a detailed explanation of the Zone System see *Zone System Manual* by Minor White (Morgan & Morgan, 1961). The multi-volume Life Library of Photography is exceptionally well illustrated, see especially the volume titled *The Camera* for basic concepts. Those interested in further experimentation with darkroom manipulations will probably find *Creative Darkroom Techniques*, an Eastman Kodak publication, a useful guide. Also, *Darkroom Magic* by Otto Litzel (Amphoto, 1967).

DESCHIN, JACOB. *Say It with Your Camera: An Approach to Creative Photography.* Ziff-Davis, 1960.
FEININGER, ANDREAS. *The Complete Photographer.* Prentice-Hall, 1966.
———. *Total Picture Control.* Amphoto, 1970.
LOOTENS, J. GHISLAIN. *Lootens on Photographic Enlarging and Print Quality*, 7th ed. Edited and revised by L. H. Bogen. Chilton, 1967.

For more advanced level technical discussion and theory read:

LARMORE, LEWIS. *Introduction to Photographic Principles.* Prentice-Hall, 1958.
NEBLETTE, C. B. *Fundamentals of Photography.* Van Nostrand Reinhold, 1970.

## Photojournalism

A beginner's guidebook with laboratory exercises is *Introductory and Publications Photography* by C. William Horrell and Robert A. Steffes (Kenilworth Press, 1959, revised in 1969). *Photojournalism: Pictures for Magazines and Newspapers* by Arthur Rothstein (Amphoto, 1956, revised

in 1969) presumes some basic knowledge of photography and its techniques. *Press Photography: Reporting with a Camera* by Robert B. Rhode and Floyd H. McCall (Macmillan, 1961) treats camera and darkroom techniques for the newspaper photographer. The book is illustrated with pictures taken by professional newspaper photographers. An exceptionally useful guide for the photographer as well as the editor is *Visual Impact in Print* by Gerald D. Hurley and Angus McDougall (American Publishers Press, 1971). Theory and principles are emphasized in *Words and Pictures: An Introduction to Photojournalism* by Wilson Hicks (Harper, 1952) and in *Photography Is a Language* by John R. Whiting (Ziff-Davis, 1946); both are somewhat outdated but are still useful. Also see *Memorable Life Photographs* (Museum of Modern Art, 1951) and *The Best of Life* (Time-Life Books, 1973) for reproductions of some of the photographs first printed in Life magazine. Interesting account by a participant photographer in the early development of magazine photojournalism in Europe (mostly Germany) is *Modern Photojournalism Origin and Evolution, 1910–1933* by Tim N. Gidal (Macmillan, 1973).

ARNOLD, EDMUND C. *Feature Photos That Sell.* Morgan & Morgan, 1960.
BERGIN, DAVID P. *Photojournalism Manual.* Morgan & Morgan, 1967.
Life Library of Photography. *Photojournalism.* Time-Life Books, 1971.
SCHUNEMAN, R. SMITH. *Photographic Communication.* Hastings House, 1972.
WOOLLEY, A. E. *Camera Journalism.* A. S. Barnes, 1966.

Documentary photography can be found in many books. The historical viewpoint is taken in *Early Documentary Photography* by Gail Buckland (New York Graphic Society, 1974). An interesting example appears in a study first published in 1933, *The Darkness and the Light* by Doris Ulmann (Aperture, 1974), a report on blacks in South Carolina.

Legal problems in photography are discussed in *Photography and the Law*, 4th ed., by George Chernoff and Hershel Sarbin (Chilton, 1971). This book is useful for all photographers, but especially so for press photographers.

Student photographers working for a newspaper or yearbook will find *Creative School Photography* by Irvin Lloyd (American Yearbook Co., 1962) helpful, as well as *Better Pictures for a Better Yearbook* by Otha C. Spencer (Henington, Wolfe City, Tex., 1959).

## History of Photography

BRAIVE, MICHAEL F. *The Photograph: A Social History.* McGraw-Hill, 1966.
DOTY, ROBERT. *Photography in America.* Ridge Press, 1974.
GERNSHEIM, HELMUT. *The History of Photography to 1914.* Oxford University Press, 1955.

Newhall, Beaumont. *The History of Photography from 1839 to the Present Day.* Museum of Modern Art, 1964.

——and Nancy Newhall. *Masters of Photography.* George Braziller, 1958.

## Color Photography

Fundamentals of color are covered in *An Introduction to Color* by Ralph M. Evans (John Wiley and Sons, 1948). The book requires no particular background in the sciences or mathematics and gives extensive references to additional material. Another book by the same author, *Eye, Film, and Camera in Color Photography* (John Wiley and Sons, 1959), is still a useful guide to color photography as a creative medium. Several of the books listed elsewhere in this bibliography include chapters on color photography.

For extensive details on theory, materials, and techniques see *Colour Photography in Practice* by D. A. Spencer, revised in 1966 by L. Andrew Mannheim and Viscount Hanworth (Focal Press). Andreas Feininger covers much of the same material in *The Color Photo Book* (Prentice-Hall, 1969) but he also goes beyond technical material to discuss "seeing" in terms of photography.

Also useful, although brief, are:

Eastman Kodak Co. *Color As Seen and Photographed.* Eastman Kodak Co., 1962.

Rothstein, Arthur. *Creative Color in Photography.* Chilton, 1963.

## Composition

Barber, E. Gordon. *Pictorial Composition in Monochrome and Colour.* Fountain Press, 1949.

Bethers, Ray. *Composition in Pictures.* Pitman, 1956.

Clements, Ben, and David Rosenfeld. *Photographic Composition.* Prentice-Hall, 1974.

Wolchonok, Louis. *The Art of Pictorial Composition.* Harper and Row, 1961.

## Science and Theory

A number of books explore the realm of light and its behavior. The photographer who lacks an extensive background in science will find the following books readable and informative:

Cook, J. Gordon. *We Live by the Sun.* Dial, 1957.

Le Grand, Yves. *Light, Colour, and Vision.* John Wiley and Sons, 1957.

Mueller, Conrad G., and Mae Rudolph. *Light and Vision.* Time, Inc., 1966.

Ruechardt, Eduard. *Light: Visible and Invisible.* University of Michigan Press, 1948.

For photochemistry on a basic level we recommend Kodak's *Basic*

*Chemistry of Photographic Processing* (Eastman Kodak publication No. Z-23-ED, 1971), a workbook in two parts in programmed instruction format for self-study. Books, basic enough for the nonscientist, on the science of photography include:

BAINES, H. *The Science of Photography.* Revised by E. S. Bomback. John Wiley and Sons, 1967.
WALLS, H. J. *How Photography Works,* Macmillan, 1959.

For more on sensitometry, not really difficult, try Kodak's *Basic Photographic Sensitometry Workbook* (Kodak publication Z-22-ED), programmed instruction format for self-study, and *Practical Densitometry* (Kodak pamphlet No. E-59).

Requiring some background in science is *Fundamentals of Photographic Theory,* 2d ed., by T. H. James and George C. Higgins (Morgan & Morgan, 1960. Difficult for the nonscientist but the classic treatise in the field of latent image and development theory is the work edited by C. E. Kenneth Mees and T. H. James, *The Theory of the Photographic Process,* rev. ed. (Macmillan, 1966). A valuable short work on the chemistry of photography is *Photo Chemistry in Black-and-White and Color Photography* by George T. Eaton (Eastman Kodak, 1957).

A classic reference on optics in photography, frequently revised and brought up to date is *Optics: The Technique of Definition* (Focal Press). Also valuable are:

GREENLEAF, ALLEN R. *Photographic Optics.* Macmillan, 1950.
LOCKETT, ARTHUR. *Camera Lenses,* 2d ed. Revised by H. W. Lee Pitman, 1947.

## Pictures for Study

Many books and magazines contain photographs worthy of study and analysis. Listed below are a few such books, along with several autobiographies of famous photographers.

ABBOTT, BERENICE. *Photographs.* Horizon Press, 1970.
ADAMS, ANSEL. *Born Free and Equal.* U.S. Camera, 1944.
——. *This Is the American Earth.* Sierra Club, 1960.
AVEDON, RICHARD. *Observations.* Simon and Schuster, 1954.
BISCHOF, WERNER. *Japan.* Simon and Schuster, 1954.
——. *The World of Werner Bischof.* Dutton, 1959.
BOURKE-WHITE, MARGARET. *Portrait of Myself.* Simon and Schuster, 1963.
CALLAHAN, SEAN. *The Photographs of Margaret Bourke-White.* New York Graphic Society, 1972.
CAPA, CORNELL (ed.) *The Concerned Photographer.* Grossman, 1968.
——. International Fund for Concerned Photography's series called "Li-

brary of Photographers." Slim paperback volumes have been published on such photographers as Lewis W. Hine, Werner Bischof, Dan Weiner, and David Seymour (Chim).

CAPA, ROBERT. *Images of War.* Grossman, 1964.

——. *Slightly Out of Focus* (Holt, Rinehart and Winston, 1947).

CARTIER-BRESSON, HENRI. *The Decisive Moment.* Simon and Schuster, 1952.

——. *The World of Henri Cartier-Bresson.* Viking, 1968.

DAVIDSON, BRUCE. *East 100th Street.* Harvard University Press, 1970.

DUNCAN, DAVID DOUGLAS. *Yankee Nomad.* (Holt, Rinehart and Winston, 1966.

——. *Self Portrait: U.S.A.* Harry N. Abrams, 1969.

EISENSTAEDT, ALFRED. *Witness to Our Time.* Viking, 1966.

EVANS, WALKER. *American Photographs.* Museum of Modern Art, 1938.

FRANK, ROBERT. *The Americans.* Grossman, 1969.

HALSMAN, PHILIPPE. *Halsman Sight and Insight.* Doubleday, 1972.

KARSH, YOUSUF. *In Search of Greatness.* Alfred A. Knopf, 1962.

LANGE, DOROTHEA. *An American Exodus,* with Paul Taylor. Reynal Hitchcock, 1939.

NORMAN, DOROTHY. *Alfred Stieglitz: Introduction to an American Seer.* Duell, Sloan and Pearce, 1960.

PENN, IRVING. *Moments Preserved.* Simon and Schuster, 1960.

SCHULTHESS, EMIL. *Africa.* Simon and Schuster, 1959.

——. *China.* Viking, 1966.

STEICHEN, EDWARD. *The Family of Man.* Simon and Schuster, 1955.

——. *A Life in Photography.* Doubleday, 1963.

SZARKOWSKI, JOHN. *The Photographer's Eye.* Doubleday, 1966.

WESTON, EDWARD. *My Camera on Point Lobos.* Houghton Mifflin, 1950.

## Reference

Valuable reference sources for the photographer's personal library are the *Focal Encyclopedia of Photography* (McGraw-Hill, 1965) and the *Photo-Lab-Index.* The *Index*, published by Morgan & Morgan, includes data on films and other photographic materials plus technical charts and formulas. Quarterly supplements keep the material up to date.

For an extensive glossary of terms see *Dictionary of Contemporary Photography* by Leslie Stroebel and Hollis N. Todd (Morgan & Morgan, 1974).

# Index